Making Choices: 1929
1939
1948
1955

Making Choices: 1929 1939 1948 1955

Peter Galassi Robert Storr Anne Umland

The Museum of Modern Art
New York

Published in conjunction with *Making Choices,* a cycle of twenty-four exhibitions at
The Museum of Modern Art, New York, March 16–September 26, 2000.

Published by the Department of Publications
The Museum of Modern Art, New York

Edited by Joanne Greenspun
Designed by Antony Drobinski, Emsworth Design, Inc.
Production by Christopher Zichello
Printed and bound by Passavia Druckservice, Passau, Germany
This book was set in ITC Officina and is printed on 150 gsm Biberest Allegro.

Library of Congress Catalogue Card Number: 00–130452
ISBN: 0-87070-030-8 (clothbound, MoMA/Thames & Hudson)
ISBN: 0-87070-029-4 (paperbound, MoMA)
ISBN: 0-8109-6213-6 (clothbound, Abrams)

Published by The Museum of Modern Art, New York
11 West 53 Street, New York, New York 10019

Clothbound edition distributed in the United States and Canada by Harry N. Abrams, Inc., New York

Clothbound edition distributed outside the United States and Canada by Thames & Hudson Ltd, London

Front cover: Jean (Hans) Arp. *Two Heads* (detail). 1929. Painted wood relief, 47 ¼ x 39 ¼" (120 x 99.7 cm).
Purchase. See plate on p. 41

Back cover: Orson Welles. *The Lady from Shanghai*. 1948. 35mm, black and white, sound, 87 minutes.
Orson Welles, Rita Hayworth. See plate on p. 255

Frontispiece: Robert Rauschenberg. *Bed* (detail). 1955. Combine painting: oil and pencil on pillow, quilt,
and sheet on wood supports, 6' 3 ¼" x 31½" x 8" (191.1 x 80 x 20.3 cm). Gift of Leo Castelli in honor of
Alfred H. Barr, Jr. See plate on p. 341

Printed in Germany

Note to the Reader

All of the works reproduced in this book are in the collection of The Museum of Modern Art. For the
most part, titles are given in English only. A foreign-language title has been retained if it is untrans-
latable or if the work is best known by that title. Dimensions are given in feet and inches, and in
centimeters, height preceding width and followed, where relevant, by depth. Dimensions for prints
denote plate or composition size unless otherwise indicated.

Contents

Foreword

Making Choices is the second of three cycles of exhibitions organized by The Museum of Modern Art under the banner *MoMA2000* to mark the millennium. Selected entirely from the Museum's extensive collection and presented over a seventeen-month period, these cycles of exhibitions have been conceived to explore issues and themes in modern art through the filter of the Museum's holdings. Modern*Starts* focused on the period 1880 to 1920, and is now followed by *Making Choices*, which deals with the period 1920 to 1960. The concluding cycle, *Open Ends*, will examine the period from 1960 to the present. All three cycles take a multidisciplinary approach and include works of art from all of the Museum's curatorial departments: architecture and design, drawings, film and video, painting and sculpture, photography, and prints and illustrated books, presented in a series of synthetically organized exhibitions.

The chronological framework of the cycles is intended only as a convenient means of loosely organizing a considerable body of material into a coherent group of exhibitions. Over the last seventy years, The Museum of Modern Art has argued for an understanding of modern art through a carefully articulated history of this still-evolving tradition. By establishing a reading of modern art based on critical dates, styles, schools, and key artists, the Museum sought to make sense of the often competing and contradictory forces of this tradition. Modern*Starts*, *Making Choices*, and *Open Ends* build on this work but endeavor to provide a more interdisciplinary approach to the material. Each cycle explores relationships and shared themes as well as divergent movements and conflicting points of view by juxtaposing works of art in new and challenging ways. Individual exhibitions within each cycle concentrate on issues germane to the period under consideration, but the works of art chosen for these exhibitions often span the century in order to reveal how themes from one moment either respond to earlier questions or effect later decisions.

Taken together Modern*Starts*, *Making Choices*, and *Open Ends* are meant to provoke new responses and new ideas about modern art. They are not meant to be overarching or definitive statements about modern art or even about the nature of The Museum of Modern Art's collection, but rather interrogatory ones that can help shape future issues and concerns to be dealt with as the next century unfolds. The ability of The Museum of Modern Art to embark on this initiative is the result of several generations of collecting that have allowed the Museum to acquire holdings of unparalleled richness and complexity. Indeed, many of the most important historical developments in modern art that have emerged over the last one hundred years are represented in the Museum's collection.

Alfred H. Barr, Jr., The Museum of Modern Art's founding director, spoke of the Museum's collection as being metabolic and self-renewing. While he meant this in terms of the Museum's ability to constantly acquire new works of art through the selective deaccessioning of its more historical holdings, the idea of an institution capable of considering and reconsidering itself in response to an on-going and continuous inquiry about modern art is central to any understanding of the Museum. There is within the Museum a lively debate about which artists to collect, which works of art to display, which exhibitions to mount. At the heart of these discussions is always the question of how to display our collection, what issues and themes to focus on, what juxtapositions and relationships to highlight or emphasize. Given the cost and complexity of making significant architectural changes to the Museum's galleries in order to create spaces that allow for different kinds of presentations of the collection, the changes effected by these

debates can take years to be realized. Modern*Starts*, *Making Choices*, and *Open Ends* are thus a unique opportunity for the Museum to literally reconfigure many of its galleries and explore its collection in a way that is almost impossible to do on an ordinary basis. Each cycle should be seen as an experiment designed to offer a different reading or understanding of modern art while providing a more thorough investigation of the depth and breadth of our collection. In doing so we hope we will have turned the Museum into a laboratory where the arguments and counter-arguments, issues, and ideas of modern art can meet and be explored in a way that allows for the emergence of new approaches to our history, and, by extension, the history of modern art. This becomes especially important as the Museum prepares for a major architectural reconstruction, scheduled to begin when *MoMA2000* closes.

The idea for this series of exhibitions began more than four years ago when a retreat was held with seven chief curators of the Museum to consider what might be done in recognition of the closing of the century that saw the birth of modern art as well as the founding of The Museum of Modern Art in 1929. After extensive discussion we felt that for an extended period of time we should concentrate on our own collection, devoting to it the attention we would normally give to the development of a major loan show. We were attracted to this idea because it afforded us the opportunity to reconsider the way we present our collection to the public as well as the chance to look back, from the vantage point of the end of the century, over one hundred years of modern art while posing questions that would guide our thinking about modern art into the next century. We quickly realized that despite the synthetic dimensions of The Museum of Modern Art's collection, no exhibition or series of exhibitions could ever hope to provide a genuinely comprehensive account of a tradition that is still very much alive and evolving. This led to the recognition that the greatest contribution that we could make at this time would be to show as much of the collection as possible, including both familiar and unfamiliar works of art, in new and imaginative ways that opened up possibilities for us, and our public, to examine in the future.

Given the magnitude of this task the entire curatorial staff embarked on an extended review of the collection and worked together to create a comprehensive overview of what the Museum had acquired over the last seventy years. Subsequently, smaller working groups were asked to study specific aspects of the collection and report back to the full staff on their findings. Other research departments of the Museum, including conservation, education, the library, and the archives, were also invited to participate in these discussions. Eventually we decided that in order to examine the collection to the extent that we wished, we needed to use the Museum's galleries for this project and to divide the project into three separate cycles of exhibitions, each anchored around a chronological moment equal to roughly a third of the period covered by our holdings.

The organization of each cycle was entrusted to an interdepartmental team. Each of the teams was encouraged to pursue its own interests and ideas and to articulate them in unique and different voices. Taken together Modern*Starts*, *Making Choices*, and *Open Ends* are not meant to be read as a continuum, as if each were part of a larger, seamless whole; rather, they are meant to provide three separate and distinct "takes" on modern art as represented by our collection.

As noted above, *MoMA2000* evolved out of lengthy discussions with the Museum's seven chief curators, all of whom—Mary Lea Bandy, John Elderfield, Peter Galassi, Terence Riley,

Margit Rowell, Kirk Varnedoe, and Deborah Wye—made important contributions to the form it took. Its overall coordination was provided by John Elderfield (from 1996 to 1998) and Mary Lea Bandy (since 1999) in the capacity of Deputy Director for Curatorial Affairs, and by Beatrice Kernan, Assistant Deputy Director for Curatorial Affairs, assisted by Sharon Dec and Amy Romesburg, and working closely with Jennifer Russell, Deputy Director for Exhibitions and Collections Support, Michael Maegraith, Publisher, and Jerome Neuner, Director of Exhibition Design and Production. *Making Choices* has been skillfully and insightfully directed by Peter Galassi, Chief Curator, Department of Photography, and Robert Storr, Senior Curator, and Anne Umland, Associate Curator, Department of Painting and Sculpture, with Beth Handler, Curatorial Assistant, and Carina Evangelista, Research Assistant, Department of Painting and Sculpture; and Josiana Bianchi, Public Programs Coordinator, Department of Education.

Glenn D. Lowry
Director, The Museum of Modern Art

Acknowledgments

Making Choices forms the second of a three-part series of exhibitions, titled *MoMA2000*, that will explore the entire range of The Museum of Modern Art's collection. These exhibitions owe their existence to the leadership of the Museum's Director, Glenn Lowry, and chief curators, Mary Lea Bandy, John Elderfield, Peter Galassi, Terence Riley, Margit Rowell, Kirk Varnedoe, and Deborah Wye; to the energetic support of Jennifer Russell and Beatrice Kernan; and to the encouragement of the Museum's Board of Trustees, especially its President, Agnes Gund, and Chairman, Ronald S. Lauder.

The exhibition cycle *Making Choices*, its accompanying publication and education programs, owe their existence to the efforts of a great many individuals at The Museum of Modern Art. We are particularly indebted to those who joined us as collaborators in conceiving and organizing the more than twenty distinct exhibitions that comprise *Making Choices*: M. Darsie Alexander, Michael Carter, Starr Figura, Virginia Heckert, Kristin Helmick-Brunet, Paulo Herkenhoff, Sarah Hermanson, Laura Hoptman, Jytte Jensen, Matilda McQuaid, Harper Montgomery, Anne Morra, Christopher Mount, Peter Reed, and Wendy Weitman. Kathleen Curry and Laura Rosenstock, in the final months of the project, made substantial contributions in these same areas.

Throughout the preparation of the exhibition program and this publication, we benefited from the work and ideas of many other curators, especially Mary Corliss, Fereshteh Daftari, Judith Hecker, Steven Higgins, Bevin Howard, Audrey Isselbacher, Laurence Kardish, Susan Kismaric, Kynaston McShine, Robyn Reisenfeld, Eva Respini, Cora Rosevear, Adrian Sudhalter, and Lilian Tone. Invaluable administrative and research assistance was provided by our dedicated interns Deniz Artun, Ann Baldoni, Benjamin Lima, Reyes Mayeranoff, and Mafalda Rodriguez. We are especially grateful for the support of Pierre Adler, Ramona Bronkar Bannayan, Charles Carrico, Delphine Dannaud, Terry Geesken, Wendell Hafner, Jane Hait, Madeleine Hensler, Claire Henry, Natalie Hirniak, Cornelia Knight, Angela Lange, Joanna Lehan, Cary Levine, Elaine Mehalakes, David Moreno, Jasmine Moorhead, Victoria Noorthoorn, Avril Peck, Jennifer Roberts, Carol Smith, Willo Stuart, Sarah Suzuki, Carlos Yepes, and Michelle Yun. We also thank the educators Amy Horschak, April Kim, Jennifer Malone, Cynthia Nachmani, Joyce Raimondo, Francesca Rosenberg, Patterson Sims, and Janet Stewart.

The publication *Making Choices* is parallel in spirit to, but different in conception from, the exhibitions it accompanies. Presenting works from all of the Museum's curatorial departments, it has drawn on the expertise and good will of many of those already acknowledged and many others. A special debt of gratitude is due to those who made this publication possible under the most trying of circumstances: Antony Drobinski, Joanne Greenspun, Christina Grillo, Michael Maegraith, Gina Rossi, and Christopher Zichello. For their grace under pressure, we also especially thank those who photographed or arranged for the photography of the works that are illustrated here: Jennifer Bott, Mikki Carpenter, Jon Cross, Susan Fisher, Thomas Griesel, Kate Keller, Paige Knight, Erik Landsberg, Christopher Lesnewski, Jacek Marczewski, Kimberly Pancoast, Jeffrey Ryan, Eden Schulz, Erica Staton, and John Wronn. Nancy Adelson, Stephen Clark, and Remi Silverman graciously helped to secure permissions to reproduce these works. Michelle Elligott and Amy Horschak are due special thanks for their archival research. Charles A. Wright, Jr., with meticulous attention to detail and great enthusiasm, guided the publication to completion.

The preparation of the exhibitions was unusually demanding for the Museum, and was only made possible by the support of many people, whom we gratefully acknowledge. They include

the exhibition administrators: Kathy Bartlett, Maria DeMarco, and Linda Thomas; those who helped us design the exhibitions: Andrew Davies, Elizabeth Gray, Jerome Neuner, Mari Shinagawa, and Mark Steigelman; those who helped us prepare and install them: Chris Engel, Diane Farynyk, Pete Omlor, Terry Tegarden, Jennifer Wolfe, and the preparators; and the conservators: Anny Aviram, Karl Buchberg, James Coddington, Lee Ann Daffner, Michael Duffy, Roger Griffith, Patricia Houlihan, Per Knutas, Erika Mosier, Ellen Pratt, and Lynda Zycherman. We would also like to thank the museum's expert framers, led by Peter Perez; carpenters, led by Attilio Perrino; painters, led by Santos Garcia; and electricians, led by Peter Geraci.

The funding that supported this publication and its accompanying exhibitions was secured through the efforts of Monika Dillon, Michael Margitich, and Rebecca Stokes. Those who helped publicize the project and assist the visitors include Elizabeth Addison, Elisa Behnk, Andrea Buzyn, Daniela Carboneri, Stefanie Cohen, Harris Dew, Kena Frank, Jessica Ferraro, Paulino Garcia, Maria Clara Gomez, Anna Hammond, Joe Hannan, Kim Mitchell, Melanie Monios, Lynn Parish, Owen Santos, Diana Simpson, Mark Swartz, and Mary Lou Strahlendorff. Those who designed and produced its graphic components include John Calvelli, Hsien-Yin Ingrid Chou, Claire Corey, Stacy Danon, Patricia Espinosa, Burns Magruder, Ed Pusz, and Jill Weidman. Its opening celebrations were managed by Ethel Shein and the staff of Special Programming and Events. We thank all these colleagues most sincerely for their support.

We offer particular thanks to those collectors who generously lent us works that are promised gifts to the Museum's collection.

Finally, we acknowledge those who have generously given financial support to our programs.

Making Choices is part of *MoMA2000*, which is made possible by The Starr Foundation.

Generous support is provided by Agnes Gund and Daniel Shapiro in memory of Louise Reinhardt Smith.

The Museum gratefully acknowledges the assistance of the Contemporary Exhibition Fund of The Museum of Modern Art, established with gifts from Lily Auchincloss, Agnes Gund and Daniel Shapiro, and Jo Carole and Ronald S. Lauder.

Additional funding is provided by the National Endowment for the Arts and by The Contemporary Arts Council and The Junior Associates of The Museum of Modern Art.

Education programs accompanying *MoMA2000* are made possible by Paribas.

The publication *Making Choices: 1929, 1939, 1948, 1955* is made possible by The International Council of The Museum of Modern Art.

The interactive environment of *Making Choices* is supported by the Rockefeller Brothers Fund.

Web/kiosk content management software is provided by SohoNet.

Among the many participants in this enterprise, we must single out those who have been most intimately involved with it—Josiana Bianchi, Carina Evangelista, and Beth Handler—to whom we and the Museum are inexpressibly indebted. Josiana Bianchi has been a valued member of our team since its inception, ably replaced during a brief leave of absence by Amy

Horschak. Her imaginative planning and efficient coordination of *Making Choices*'s education programs have been crucial, immeasurably enriching our visitors' experiences and providing a key link between art and audience. Carina Evangelista has contributed to virtually every aspect of this project. Her unwavering commitment and mettle, extending from the most detailed tasks to those requiring resourceful problem solving, proved essential to the accomplishment of what seemed a nearly impossible task. Beth Handler has been a model of professionalism, talent, and intelligence and a collaborator in the truest sense. We have relied on her curatorial judgment, managerial brilliance, and impeccable diplomacy in every phase of this endeavor. Without her critical support, neither the exhibitions nor the book would have been possible. She made it all happen, and she made it fun.

Peter Galassi
Robert Storr
Anne Umland

Introduction

History does not come ready-made. Things happen. Things are made to happen. They turn out as expected. They turn out as no one could have expected. What seemed important yesterday fades. What went unnoticed yesterday suddenly flashes brightly in the mind's eye.

History is flux. Its rhythms may be sharp and staccato or they may be long and plangent. In the modern era they have tended to be abrupt rather than harmoniously paced, but in the background of fast-breaking news one can sometimes feel the pull of great tides. When history is written, it reverberates with these compound cadences. When history is rewritten, early renditions resound against the contrapuntal rhythms of the passing present from which the writer looks back. Consequently, there is no definitive version of events, only layerings; no privileged vantage point from which to report, only overlapping vectors of greater or lesser distance from the object of one's interest. The best histories acknowledge this truth, often by adopting a frankly singular outlook.

History is also shown, and in the visual arts it *must* be shown as well as written. An exhibition, a display of works selected from a museum's collection, or a book of reproductions of those works—these are all forms of history. Think of the curator, perhaps, as a historian whose vocabulary is made up not of words but of works of art—except that all of them are nouns. The aim of this book is to set forth the challenges of history as they are embodied in the works that make up the collection of The Museum of Modern Art.

The resources of a curator are, in the first instance, based on the conclusions drawn by previous curators and by the collectors and patrons who have helped to shape a museum's collection. What we call the canon is this chain reaction of conclusions drawn and redrawn, of works judged important and by repeated showings confirmed—but constantly reevaluated—in their importance. In simple terms, think of the number of times that certain paintings, sculptures, drawings, prints, photographs, design objects, or films have been seen, and of the number and variety of contexts in which they have appeared.

Think, for example, of Jackson Pollock's *Number 1, 1948* (p. 192). Once the most radical of works and, because of its radicality, the most disturbing to people who thought that modern art was Pablo Picasso or Henri Matisse, *Number 1, 1948* has become an icon of its era and one of the prized paintings in The Museum of Modern Art. Few people would now question its preeminence, but the process of its being remembered came in stages, and its vividness partially eclipsed other images that had filled the imaginations of those who thought they knew all about modern art before seeing it. Take another picture: Andrew Wyeth's *Christina's World,* also painted in 1948 (p. 193). It, too, is an icon of American art, but it represents an entirely different view of what art is and of what America is. Were you to write a history of painting in this country that began with one of these two pictures, it would not be the same history you would write if you began with the other.

But, of course, both of these pictures are historical, and, in a strictly chronological sense, neither one is more of the moment than the other. To start with one rather than the other is already to influence the process of sorting out and grouping the plurality of available works into a particular order. Each order gives us a different perspective, and each is based on a different set of criteria. One order may explain how an idea was born, developed, and found its greatest expression. Within this order, major and minor works are brought together to shed light on an evolutionary process, but major works that played no role in the process are

◀ **Edward Weston** (American, 1886–1958). *Cypress, Point Lobos* (detail). 1929. Gelatin silver print, 7½ x 9⅛" (19 x 23.8 cm). Gift of David H. McAlpin. See plate on p. 40

excluded. Another order may ignore the evolution of tradition so as to concentrate on the best individual works—or, rather, on one person's judgment of which are the best. Within this order, lesser works, no matter how instructive or curious or engaging, disappear from the lineup, and one witnesses the confrontation of masterpieces representing divergent, sometimes wholly incommensurable, realities and ambitions. It could well be that these singular works bear little resemblance to one another, in which case one finds oneself comparing apples to oranges—but under circumstances in which both the apples and the oranges are extraordinary.

One might write a history of a single medium—photography, say, or film—reviewing in turn many divergent and overlapping artistic ideas but only rarely considering works in other mediums. Alternatively, one could trace the effects of a single major idea on many mediums. Starting from such a premise, one might consider how the development of pure geometric art affected first painting, then sculpture, then architecture, then photography, and then film. Even the sequence in which the mediums appear in the preceding sentence suggests a structure; rearrange the order of the sentence, and the result would be a different history. That one *can* do this—that a curator may take license to scramble the evidence simply on the hunch that a fresh and informative angle may open up as a result—is proof enough that one should do it. Describing the past is as much an imaginative undertaking as an investigative one, as much about wondering "what if" as it is about researching and asserting a demonstrable truth.

In fact, there is no such thing as pure, geometrical art. A square may be a simple idea in the mind, but each of its physical manifestations is different from the others. Moreover, what that square may signify varies with the setting in which it appeared. Take three instances from the years following World War I: If you were the Dutch artist Piet Mondrian, your squares were perfectly balanced and symbolized an ideal reorganization of a chaotic world. If you were a Russian Suprematist such as Kazimir Malevich making your squares in the middle of a political revolution, they tended to be dynamic, even violent (if a square can be violent), and symbolized a hopeful and heroic disequilibrium. Meanwhile, at the Bauhaus in Germany, the designer Anni Albers was realigning the fine and the applied arts—specifically, painting to weaving—based on a radical reduction of their shared formal repertoire. Thus, no two or three squares are created equal. The distinctions among them are not, at the highest level, ones of worth, but of meaning. Every time a curator rearranges exemplary works in a gallery, or on a catalogue page, he or she adds a new layer of meaning to the accumulation that began with the artist's initial intention, was altered and augmented by the execution of that idea, and was further amplified and changed as the work entered the world and was seen in the company of other similar or dissimilar works of its time and of later or earlier times.

In absolute terms, history, or in this context, art history, is a vast matrix almost inconceivably extensive and almost inconceivably dense. Drawing coordinates from one point to another on this grid creates different shapes, different images of history, and there is no theoretical limitation to their number or variety. The images that seem most satisfying tend to be the ones that integrate the most points with the greatest economy—the ones that are memorably ample and memorably clear—though, of course, no single variant is absolutely more true than another simply because it constitutes the most easily grasped gestalt.

These remarks are offered as a prelude to this book and as an expression of the spirit of the group of exhibitions that it accompanies. *Making Choices* is the title of both the book and the group of exhibitions, but the two are not at all the same. The exhibitions form the second of three cycles of *MoMA2000*, an extensive exploration of modern art, from a variety of perspectives, through the collection of The Museum of Modern Art. *Making Choices* focuses on the years between 1920 and 1960—a period of considerable social and political turmoil, when original visions of modern art were reconsidered and a number of competing alternatives arose. Lively arguments over the direction that modern art should take, the varying traditions of particular places and the varying possibilities of particular mediums, and the irreducible individuality of

artistic endeavor conspired to foster a great multiplicity of expression. More than twenty exhibitions—widely varied in size, point of view, and range of chronology and medium—address aspects of the art of this period. Their sole common denominator is the principle that any attempt at a comprehensive overview would be destined to diminish the vitality it meant to set forth and examine.

This book uses a different method to apply the same principle. To delve deeper into the essential variety of the period 1920 to 1960, it decisively restricts the scope of its inquiry; instead of surveying forty years, it focuses on four: 1929, 1939, 1948, and 1955. The rules were simple: In the chapter on 1939, for example, a work that could not be dated more precisely than 1938–40 was eligible for inclusion, but a superior work by the same artist, securely dated either 1938 or 1940, was not. And, again, all the works are in the Museum's collection.

With the generous help of our colleagues in all six of the Museum's curatorial departments—architecture and design, drawings, film and video, painting and sculpture, photography, and prints and illustrated books—we cast our net wide within each of the four years we had selected. Some years, we found, were extraordinarily rich in a certain type of art or in art in a given medium. For example, the release of Hollywood classics such as Victor Fleming's *The Wizard of Oz* (p. 114) and *Gone with the Wind* (p. 117), and the making of Jean Renoir's tragic-comic meditation on human folly and social class, *The Rules of the Game* (p. 146), made 1939 one of film's richest moments between the two world wars, while from the same perspective other years were leaner. In all the years we have chosen, we have been struck by the irrepressible heterogeneity of artistic endeavor as much as by harmonies among works made at the same time in different places and in different styles. Some of the generalizations that are commonly advanced to account for and evaluate this diversity proved their usefulness. We found, however, that the multiplicity of patterns suggested by combinations of related or divergent works was occasionally of far more sustaining interest. And so, on the one hand, close comparison of formally similar objects at times confirmed the expectation that they belonged together and at times accentuated qualities that distinguish superficially similar things. On the other hand, startling contrasts between paintings and sculptures or photographs and films, as well as equally startling contrasts between paintings and photographs or design objects and sculptures, threw the underlying tensions among the works of a given moment into striking relief. For example, the aesthetic consonance that exists between a painted wood relief by Jean Arp (*Two Heads*, 1929; p. 41) and an Edward Weston photograph of the roots of a cypress tree (*Cypress, Point Lobos*, 1929; pp. 12, 40) is as arresting as the dissonance created by placing a hard-edged abstract painting by Piet Mondrian (*Composition, II,* 1929; p. 24) next to a Surrealist picture by René Magritte (*The Palace of Curtains, III,* 1928–29; p. 25).

Beginning with a vast array of images for each year, we eliminated obvious duplications—closely related works by the same artist or different artists—and we trusted our instincts in giving the nod to unusual or unfamiliar works. Indeed, one of the pleasures of reviewing the Museum's collection has been to see things that have long been in storage come surprisingly to life. Balancing this tenderness for the overlooked with our admiration for works that have earned their fame, and having arrived at a manageable number of images, we shuffled our deck, spread our cards on the table, and began to look for resonant or provocative pairings and clusters.

In short, we have made choices. But the range of those choices was deliberately and rather severely limited by the rigid decision to examine only four particular years within the four decades we were charged to explore. The aim of this limitation was to focus attention on two other sets of choices: the choices made by the artists who created the works, and the choices made by the reader, or viewer, who opens a book or walks into a museum.

History unavoidably strips away as it evaluates and makes order of the past, and part of what it strips away is the full diversity of the choices faced by the artist—and often their urgency as well, for the artist's unknown future has become the historian's familiar past.

Which medium to select, which path to follow, in which direction to chart a new path? What to do after getting out of bed in the morning? In limiting the scope of our inquiry to four narrowly framed samples, we have aimed within each to suggest the essential multiplicity of modern art at any one moment. The purpose is not so much to celebrate the variety of the works we have received from the past (although the book does also have that purpose) as to evoke the challenges and uncertainties and dreams and contentions and alliances from which that variety arose. Of course, by asking you to consider the motives of choices made then, we simultaneously ask you to consider the implications of choices you might make now—of the varying configurations you might now draw—among the wide range of works we have chosen to set before you.

At this point, perhaps a few words are called for about our reasons for choosing the four years to which this book is devoted, for naturally we have stacked the deck. Nineteen twenty-nine, the year of the stock market crash, was, of course, a watershed in modern history. It also happened to have been the year in which The Museum of Modern Art was founded. From this crucial juncture, Alfred H. Barr, Jr., the Museum's director, and his staff looked both backward to the origins of modern art in the nineteenth century and forward to its future. What matters here, however, is what they could have seen that was being made at that exact time—what was then new and of the present.

With the outbreak of World War II, in September, 1939 was also a year of dramatic upheaval. After the near conquest of Europe by Fascism, and under the threat of global conflict, many people were persuaded that the first great chapters of European modernism had come to an end, and that the hopes of those committed to modern art rested in the Western Hemisphere. By that time, the Museum had already acquired a history of its own and could reflect on its first efforts at presenting a comprehensive picture of modern art. The critical reexamination this retrospective view entailed became a factor in how the Museum looked ahead, but once again, what counts in this book is the work that 1939 itself produced.

Nineteen forty-eight, the year of the Soviet blockade of West Berlin and the responding Western airlift, might be elected as the onset of the cold war; and Charles Eames's Chaise Longue of that year (p. 251) might be said to embody the domestic tranquility that America set out to defend. But 1948 first recommended itself to us because two famous paintings of that year state radically divergent views of modern art with unmistakable clarity. The works in question are the two mentioned at the beginning of this introduction—Pollock's *Number 1, 1948* and Wyeth's *Christina's World*. That pairing was only the beginning, however, for 1948 also saw the creation of Pininfarina's Cisitalia 202 GT car, which announced the sleek prospects of post-war Italian design (p. 197), Vittorio De Sica's *Bicycle Thief,* which helped to establish the very different aesthetic of Italian Neorealist cinema (p. 226), a small sculpture by Alberto Giacometti that came to signify the urgent anxieties of Existentialism (p. 205), and a deftly ironic drawing by the young Andy Warhol (p. 194), which hinted at an American art very different from the ones represented by Pollock and Wyeth.

That the rules of the game conspired to bring Warhol into the picture before Jasper Johns or Robert Rauschenberg is one of the piquant surprises that we have enjoyed in assembling this book. The curator is not an artist, but he or she nonetheless can reap the unpredictable rewards that arise from the constraints of a given form. In any case, Johns and Rauschenberg do both appear; indeed, the radical implications of works they made in 1955 (pp. 325, 338, 341) were part of the reason we chose that year, but only part. Ludwig Mies van der Rohe's Seagram Building was being built in 1955 (p. 272), providing an unsurpassable symbol of the promise of corporate America, while Robert Frank cast a fierce eye on the rest of the country, making many of the photographs that would appear in *The Americans* (pp. 277, 339) and turn the comforting assumptions of documentary photography upside down. Meanwhile, in *Rebel without a Cause* (p. 284) and *East of Eden* (p. 336) James Dean personified the rebellious younger generation

who shared Frank's impatience with America's complacent self-regard. Alain Resnais's documentary *Night and Fog,* also from 1955, looked back to the holocaust and has since remained among the most painful reminders of Nazi persecution of the Jews in Europe (p. 289), while Satyajit Ray looked forward, opening the eyes of the world to modern, newly independent India in his Apu Trilogy, the first part of which, *Pather Panchali* (p. 295), premiered in 1955. (Regrettably this book can only hint at the fullness of these and other films through still images.)

In principle, almost any four years could have served our purpose equally well. Had we chosen others, the resulting cross sections would have emphasized different aesthetic currents, introducing or amplifying the accomplishments of some artists while diminishing or entirely eliminating the work of artists who play prominent roles here. As it is, we have deliberately spread out the dates, allotting one to each decade, with the greatest distance between them being ten years and the shortest seven years. Treat the compilations of images as core samples of the Museum's collection and as time capsules of the moments they represent. As such, they do not really constitute histories, but rather provide raw materials for creating histories. The short texts that introduce our selections for each of the four years are intended as invitations to imaginative interpretation rather than as guides to definitive readings. In that spirit, they zigzag through the reproductions without respect to the order in which they appear.

Inevitably, thanks to the richness of the collection, certain broad, familiar developments do make themselves felt. For just a few examples: in painting, sculpture, drawing, and print-making, the evolution of the vocabularies of abstraction, the themes of Surrealism, and the interplay between the two; in architecture, the elaboration and dissemination of the International Style; in design, the inventive application of industrial innovation to the wants of domestic comfort; in film, the consolidation of the Hollywood studio system and the simultaneous emergence of a truly international art, surely more culturally and geographically diverse than any other collected by the Museum; in photography, the enrichment of both eye-witness reportage and high-style illustration in the printed press. And, although the book has been conceived independently of the diverse exhibitions that together also bear the title *Making Choices*, some of the page spreads in the former by chance encapsulate some of the latter. The paintings by Mondrian and Magritte that are paired on pages 24 and 25, for example, represent the opposing terms of the exhibition *The Dream of Utopia/Utopia of the Dream*. The Stenberg brothers' poster on page 30 and Aleksandr Rodchenko's photograph on page 31 together evoke the shared aesthetic that is surveyed in the exhibition *Graphic-Photographic*. The sophisticated artlessness of Milton Avery's print on page 162 and the refined self-taught aesthetic of Morris Hirshfield's painting on the following page represent the paradoxes that are explored in *The Raw and the Cooked*. Robert Ryman's *Untitled (Orange Painting)* and Johns's *Green Target* (pp. 324, 325) suggest the complexities of the radically simple aesthetics surveyed in *How Simple Can You Get?*

But for every evocation of the exhibitions that we and an extensive roster of our curatorial colleagues have devised to reopen the adventures of the past to the curiosity of the present, and for every confirmation of a recognized movement or trend, this book contains the germ of many other potential recognitions and reconfigurations of the art of the 1920s through the 1950s.

Modern art is, by its very nature, many things. The variety of mediums in which artists have expressed themselves has dictated this, and the competing ideas of what modern art should be, and should do, have reinforced that multiplicity. A museum is a place to stop and consider the almost overwhelming number of options artists have faced in the modern era, and the wide-ranging decisions that inform the work with which they have confronted each other and the public. The Museum of Modern Art is, above all, a place where the choices that artists have made in the past reverberate with the choices that artists are facing right now.

1929

The first long trajectory of modern art begins late in the nineteenth century and ends with World War I. The second bridges the period 1918—the armistice in Europe—to 1939—the onset of the next great conflict. In the middle of those two decades came the jolt of 1929. Although it was a few years before the full impact of the New York stock market crash of that year was felt elsewhere, the economic and political crises of the 1930s that the crash initiated or exacerbated were many, and so too were the consequences for art. But even before artists began to absorb the shock of the Great Depression and to face hard choices between violently opposed ideologies, they found themselves questioning their past optimism while at the same time continuing to develop future-oriented ideas born in circumstances quite different from the ones in which they suddenly found themselves.

This is not the place to attempt a synopsis of what happened in 1929, but it is worthwhile taking note of some of the key facts or contingencies bearing on the artistic production of that moment. For example, 1929 was the twelfth year of the Bolshevik Revolution in Russia and the second year of Joseph Stalin's first Five-Year Plan. Under state patronage, Russian avant-garde artists had been given unprecedented freedom to experiment in all mediums, and they wholeheartedly threw themselves into the task. The extraordinary energies unleashed in the process can be felt in the visually animated photographs, cinematography, and graphic design produced before repression brought an end to this intense utopian effort. Georgii and Vladimir Stenberg's poster for Dziga Vertov's *Man with a Movie Camera* (pp. 18, 30) matches the antic exuberance of the film with equally abrupt breaks and shifts in its use of montage. With its cropped pipe and mirror image of the photographer, Aleksandr Rodchenko's photograph *Chauffeur* (p. 31) parallels the Stenbergs' style in its conflation of fragmentary forms and the inclusion of the camera "eye" as a central feature of the picture. To some, El Lissitzky's poster for the Russian exhibition at the Kunstgewerbe Museum Zurich (p. 33) powerfully epitomizes the same revolutionary Constructivist aesthetic; to others, its grand monolithic human presences, harsh contrasts, and aggressive typography suggest Stalin's rapid consolidation of power. The image reverberates disconcertingly with the German designer Ludwig Hohlwein's militaristic poster *Und Du? (And You?)* (p. 32)—making a pair that reminds us that the rhetoric of propaganda is double-edged and that superficially similar forms of public address may serve utterly dissimilar causes.

Hohlwein's *Und Du?* is a harbinger of Fascism, but before Fascism took hold in Germany, advanced modernist ideas were systematically worked through and taught at the Bauhaus, which superceded the pre–World War I art academy in Weimar and subsequently moved to Dessau and finally Berlin, before being reconstituted in exile in the United States. Like the Russian Constructivists, the Bauhaus artists not only strove to see the world afresh, but to remake it anew. Working in Germany before the war, the Russian painter Vasily Kandinsky had been among the very first artists anywhere to explore the possibilities of complete abstraction. The war had forced him to return to Moscow, but in the early 1920s he took a teaching position at the Bauhaus, where he was joined by Paul Klee and Josef Albers, whose three-part portrait of Klee faces Kandinsky's etching *Fourth Annual Offering for the Kandinsky Society* (pp. 36, 37).

The striated delicacy of Klee's own etching, *Old Man Figuring* (p. 46), in certain respects parallels the combed, quasi-abstract figures in *Birds above the Forest* (p. 47) by Max Ernst, who, like many Bauhaus figures, was German though he spent the better part of his career in Paris

◀ **Vladimir Stenberg** (Russian, 1899–1982) and **Georgii Stenberg** (Russian, 1900–1933). *Man with a Movie Camera* (detail). 1929. Lithograph, 39½ x 27¼" (100.5 x 69.2 cm). Arthur Drexler Fund and Purchase. See plate on p. 30

and the years during and just after World War II in the United States. In paintings, drawings, and prints characterized by great graphic ingenuity, Ernst gave intricate, sometimes childlike, expression to the Surrealist principle of world-transforming fantasy. Using all the tricks of academic illusionism, Salvador Dali, by contrast, gave it a singular baroque perversity. Surrealism sought to change the world less by remaking it than by dreaming it. Essential to Surrealism was the cultivation of the aberrational and the extraordinary, but also important to its methodology was a keen appreciation of the magical dimension of things that otherwise seem completely ordinary. Through Surrealist eyes, commonplace objects or apparently mundane images assumed a revelatory aspect. W. Grancel Fitz's *Cellophane* (p. 49) was made for publicity purposes, and it represents the same enthusiasm for modern technology that brought Sven Wingquist's Self-Aligning Ball Bearing (p. 52) into the Museum's collection. But Fitz's photograph has just the sense of wonder and of uncanniness that the Surrealists prized, as if the refractions of the then-miraculous material cellophane were a distorting lens through which to look at the world. At the extreme, what that world looked like can be seen in Salvador Dali's *Illumined Pleasures* (p. 48), though the distortion here has less to do with optics than with the precise transcription of nightmarish emanations from the subconscious.

These two images do not belong together in any conventional art-historical or formal sense, but looking at one alters the way one sees the other. Such a play of associations follows the logic of Surrealism. There can be a fantastic element to modernist architecture as well. For example, Le Corbusier's Villa Savoye is an archetype of the thoroughly rational "machine for living" (p. 27) but the forms of its upper-level sundeck echo the sensuous curves of Man Ray's *Sleeping Woman* (p. 26), who might be dreaming Dali's dream. Or consider Frank Lloyd Wright's streamlined but pre-space-age apartment and office towers, St. Mark's–in-the-Bouwerie Towers, New York (p. 54). Science fiction once looked like this, but the elegance of Wright's forms touch an entirely different level from what is to be found in any set designer's maquettes. Alvar Aalto's Stacking Side Chair (p. 55) has an elegant curvilinear design similar to what one finds in Wright's buildings, but a simpler articulation. The utilitarian aspect of these chairs also sets them apart; spareness of form, economy of technical means, and efficiency of manufacture, use, and storage distinguish them.

While the Surrealists saw beauty in found objects and images, industrial designers in this period rendered basic necessities with an almost classical geometric purity. Wingquist's Ball Bearing is a case in point. Patrick Henry Bruce's abstract *Painting* (p. 53) might also have been machine-tooled, but for the subtle tactility of the painted surface and cool buzz of the picture's pastel colors. Bruce, a former student of Henri Matisse, developed a refined version of Cubism in the late 1920s that anticipated hard-edge painting of the 1950s and 1960s. And, while this canvas does not describe the machine age, it is as much of the machine age as the work of Russian contemporaries such as Rodchenko and Lissitzky—or as the sleek deployments of tubular steel with which Bauhaus designers revolutionized modern furniture (pp. 74, 90).

A jump cut in film moves from one image to the next without transition. This will be a jump cut *to* film beginning with images of two sinister screen sirens. The first is the American actress Louise Brooks in G. W. Pabst's classic film *Pandora's Box* (p. 59), a tale of decadence and retribution suitable to the end of the Jazz Age. Facing her is Anny Ondra, in Alfred Hitchcock's early sound thriller *Blackmail* (p. 58). Standing at the head of a long line of lovely but possibly

lethal Hitchcockian leading ladies, Ondra seems to have been caught in the act. Two film stills that rhyme in another way come from Luis Buñuel's *Un Chien Andalou* and Leo McCarey's *Wrong Again* (pp. 70, 71), featuring Stan Laurel and Oliver Hardy. Both films portray pairs of beleaguered men, horses or donkeys, and pianos. In keeping with their slapstick style, the Laurel and Hardy film reverses expectations in a comic way, making the comedians beasts of burden who hold up a piano on top of which stands a horse. Buñuel's macabre fantasy puts two dead donkeys inside the piano and two men on the floor hauling away at ropes attached to the piano legs. The first is good-natured fun, the second unpleasant teasing, but both films traffic in absurdity and remind us that humor, even surrealist black humor, frees the imagination by refusing to respect conventional logic.

Paris in the 1920s was a magnet for artists of every nationality and stylistic stripe. One of the essential facts of the School of Paris was its heterogeneity. Americans who were in Paris about the time that George Gershwin was composing "Rhapsody in Blue" (1924) included Stuart Davis, Walker Evans, Berenice Abbott, Alexander Calder, and Josephine Baker, the African-American star of the so-called *La Revue Nègre* and the subject of Calder's bent wire portrait (p. 86). The lightness and whimsy of Calder's sculpture are in stark contrast to the ominous weight and rigid abstraction of Jacques Lipchitz's totemic *Figure* (p. 87). Lipchitz had been born in Lithuania and died in the United States, but in the 1920s and 1930s, like Marc Chagall, Ossip Zadkine, Chaim Soutine, and a host of other Jewish expatriates from Russia, Poland, and other parts of Eastern Europe, he was quintessentially Parisian. The gaiety of Stuart Davis's *Place Pasdeloup No. 2* (p. 77) contrasts in a similar fashion to the soberness of Georges Rouault's *Suburb of the Long Sorrow (Cul-de-sac)* from *La Petite Banlieue* (p. 76). Together they depict the extremes to be found inside the city limits of Paris after World War I and on the eve of the Great Depression. There, once again, it was "the best of times and the worst of times."

Soutine's *Portrait of Maria Lani* (p. 83) suggests the sophisticated melancholy of his artistic milieu, while in brisk, cursory strokes Balthus's pen and ink study for *The Street* (p. 82) evokes the mysterious encounters that might occur on any corner in the popular quarters of the French capital. If Maria Lani is a woman of the world, Jean Cocteau, as seen in Germaine Krull's photograph, is by all appearances her male counterpart (p. 84). We know this by the elegance of his attire and the languor of his gesture; the power of such a detail to stand for the whole was one of the discoveries of photographic modernism of the 1920s. Like all true dandies, Cocteau was someone whose "superficial" affectations of dress and deportment revealed the inner truth of his nature in the exact proportions in which he wished them to be known. Edward Steichen's *Maurice Chevalier Does a Song and Dance* (p. 85)—a magazine illustration whose high artifice contrasts with the concentrated realism of Krull's portrait—likewise depicts a man about town, but not in repose. Chevalier was the hardest-working performer of the Parisian music halls and the epitome for Americans of French savoir faire. Cocteau was the hardest-working showman of the Paris salons, though in keeping with his aristocratic style he acted as if he wasn't working at all.

The image of America in this period owes a great deal to early modernists who began their careers before or just after World War I. Foremost among them, perhaps, is Edward Hopper, whose watercolor *Ash's House, Charleston, South Carolina* (p. 92), has all the directness and vibrancy of his full-scale oil paintings. This is naturalism utterly devoid of moralizing or

sentimentality. A decade younger than Hopper, Louis Lozowick also grappled with the problem of painting the American scene, but Lozowick brought to the challenge the lessons taught by Cubism and Constructivism. In fact, Lozowick had been to the Soviet Union, where he had the opportunity to see Russian Modernism in situ and to meet with Russian artists such as Rodchenko. His lithograph *Doorway Into Street* (p. 93) synthesizes a geometric grid with the straightforward description of light falling through a glass doorway onto the running board and hubcap of a car by the curb. The juxtaposition of Peter Blume's study for *Parade (Waterfront, Manhattan)* with Charles Demuth's *Corn and Peaches* (pp. 78, 79) points out the differences between the work of another first-generation American Modernist, Demuth, and that of a younger artist, Blume, whose rendition of the industrial skyline is, like Lozowick's street scene, heavily indebted to Cubism. The contrast is also evident in their choice of subject matter: Demuth's still life evokes an almost timeless rural America while Blume's drawing is a mannerist interpretation of the contemporary urban landscape. Georgia O'Keeffe's *Lake George Window* (p. 94) uses details of American vernacular architecture in combination with a simple play of planar shapes in a way that recalls Demuth's earlier, more modernist paintings of the 1910s. O'Keeffe's picture is realism verging on abstraction, an image of an archetypal American home translated into cool geometries. The home belonged to her husband, Alfred Stieglitz, who was pursuing the same convergence of plain fact and transcendent form in his photographic studies of the sky (p. 96). But O'Keeffe's painting is equally comfortable next to *The Little Tree* by German photographer Albert Renger-Patzsch (p. 95).

The mix of acute observation and aesthetic detachment—in Germany this broad tendency was called the New Objectivity—is prevalent throughout the period between the two world wars, showing up in places quite distant from one another and without any suggestion of direct influence. The photography display at the ambitious *Film und Foto* exposition in Stuttgart in 1929 (which included an American section organized by Edward Weston and Edward Steichen) contained many unanticipated concordances of this sort, even as it exemplified the divergent aesthetics at work within a single country. (Compare the photographs by August Sander and László Moholy-Nagy on pp. 34, 35.)

Inherited from Cubism, collage was one of the basic formal methods of modern art in the late 1920s, and on into the 1930s. The actual cutting and pasting of disparate graphic elements can be seen in *Karlsruhe* (p. 103) by the Dada master Kurt Schwitters. It was the work of Pablo Picasso, Georges Braque, Schwitters, and others that helped teach Walker Evans to see collage in its "natural state." Evans's photograph *Roadside Gas Sign* (p. 102) does with a click of the shutter what Schwitters achieved with scissors and glue. The collage aesthetic influenced Russian graphic design and prompted a renaissance in poster-making exemplified not only by the Stenbergs' advertisement for *Man with a Movie Camera,* but by Anatoli Belski's *The Pipe of the Communards* (p. 66). Gustav Klucis's poster *Transport Achievement of the First Five Year Plan* (p. 62) and Berenice Abbott's photograph *El at Columbus Avenue and Broadway* (p. 67) use dramatic perspective angles, strong contrasts of light and shade, as well as compositional isolation or conflation of elements to achieve a distinctive collage-like effect not dissimilar to that of the Belski poster with which the Abbott photograph is paired. The mechanized dynamism of Klucis's poster differs sharply from the fleshiness and monumentality of Tina Modotti's portrait *Mother and Child, Tehuantepec* (p. 63). Both, however, represent revolutionary ideals in predom-

inantly agrarian countries, the one anticipating a new industrialization of the land, the other celebrating the strength of the common people. José Clemente Orozco's *Rear Guard* (p. 64) depicts camp followers and soldiers of the Mexican Revolution that had begun in 1910. Opposite Orozco's expressionist rendering of popular insurrection is a still from Lewis Milestone's film version of Erich Maria Remarque's novel of modern trench warfare, *All Quiet on the Western Front* (p. 65). One of the classic antiwar statements, Milestone's Academy Award winning movie, like the book that inspired it, was a searing reminder of what hopeful witnesses and survivors took to calling "the war to end all wars." It wasn't by a long shot. In 1929 the world was poised between two global conflicts—the first never far from memory, the second all too easily imagined.

▲ **René Magritte** (Belgian, 1898–1967). *The Palace of Curtains, III*. 1928–29. Oil on canvas, 32 x 45⅞" (81.2 x 116.4 cm). The Sidney and Harriet Janis Collection

◀ **Piet Mondrian** (Dutch, 1872–1944). *Composition, II*. 1929 (original date partly obliterated; mistakenly repainted 1925 by Mondrian in 1942). Oil on canvas, 15⅞ x 12⅝" (40.3 x 32.1 cm). Gift of Philip Johnson

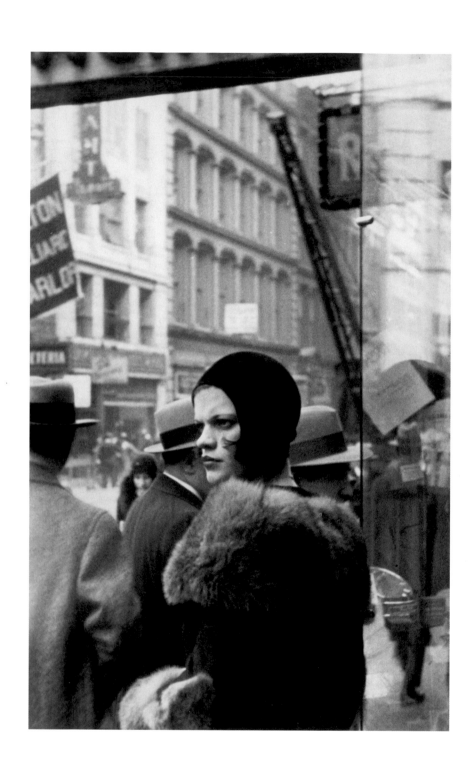

▲ **Walker Evans** (American, 1903–1975). *Girl in Fulton Street, New York.* 1929. Gelatin silver print, 7 5/16 x 4 5/8" (18.6 x 11.8 cm). Gift of the photographer

▶ **John Kane** (American, born Scotland. 1860–1934). *Self-Portrait.* 1929. Oil on canvas over composition board, 36 1/8 x 27 1/8" (91.8 x 68.9 cm). Abby Aldrich Rockefeller Fund

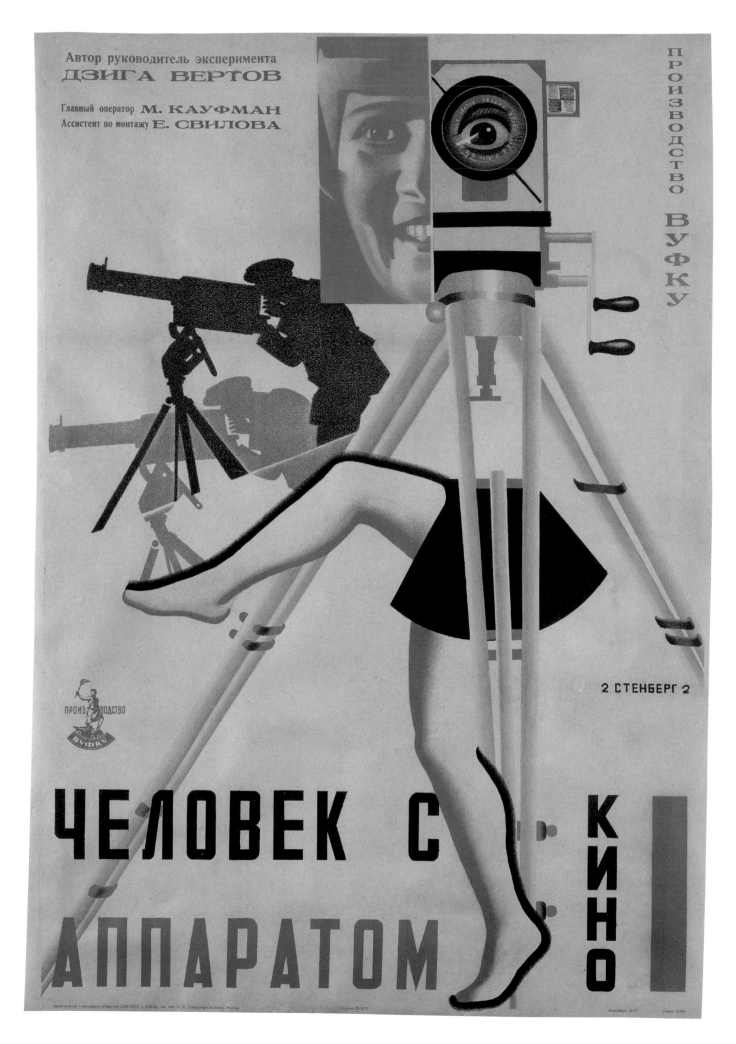

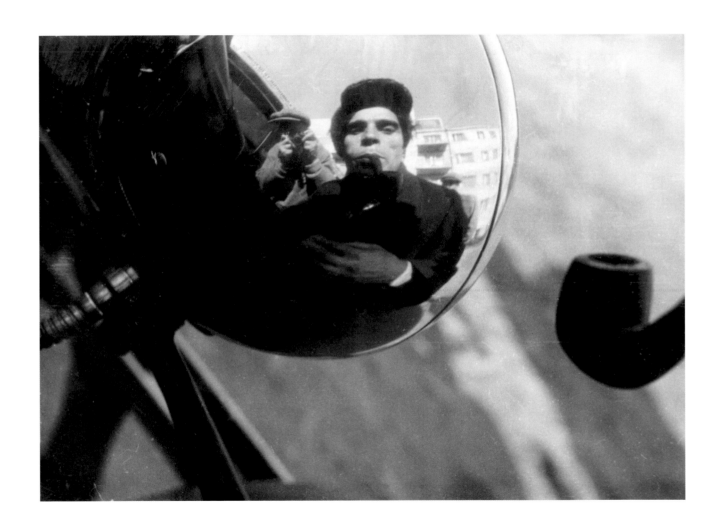

▲ **Aleksandr Rodchenko** (Russian, 1891–1956). *Chauffeur*. 1929. Gelatin silver print, 11¾ x 16⁷⁄₁₆" (29.8 x 41.8 cm). Mr. and Mrs. John Spencer Fund

◄ **Vladimir Stenberg** (Russian,1899–1982) and **Georgii Stenberg** (Russian, 1900–1933). *Man with a Movie Camera*. 1929. Lithograph, sheet 39½ x 27¼" (100.5 x 69.2 cm). Arthur Drexler Fund and Purchase

Ludwig Hohlwein (German, 1874–1949). *Und Du? (And You?)*. 1929. Offset lithograph, sheet 47 x 32¼" (119.4 x 82 cm). Purchase Fund

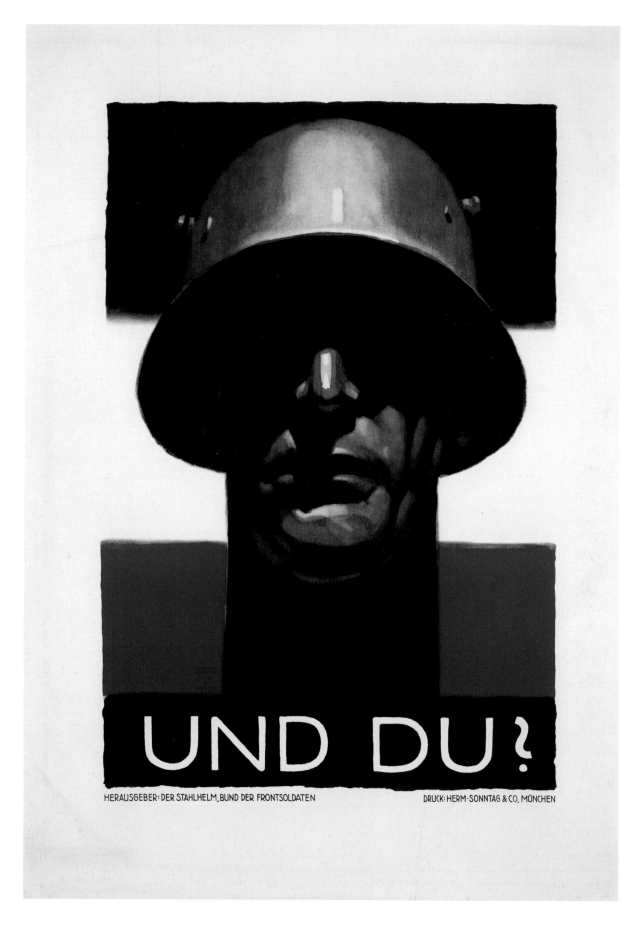

El Lissitzky (Lazar Markovich; Russian, 1890–1941). *U.S.S.R. Russische Ausstellung (U.S.S.R. Russian Exhibition)*. 1929. Gravure, sheet 49⅞ x 35⅝" (126.7 x 90.5 cm). Gift of Philip Johnson, Jan Tschichold Collection

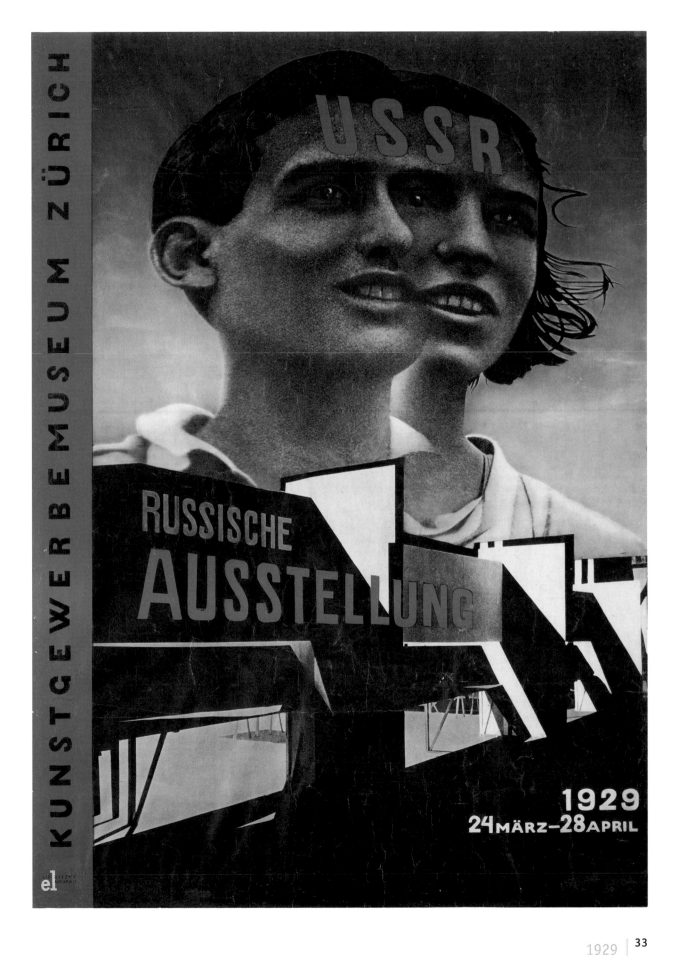

August Sander (German, 1876–1964). *Viennese Jockey.* 1929. Gelatin silver print, 11⅜ x 8⅛" (28.9 x 20.6 cm). Gift of the photographer

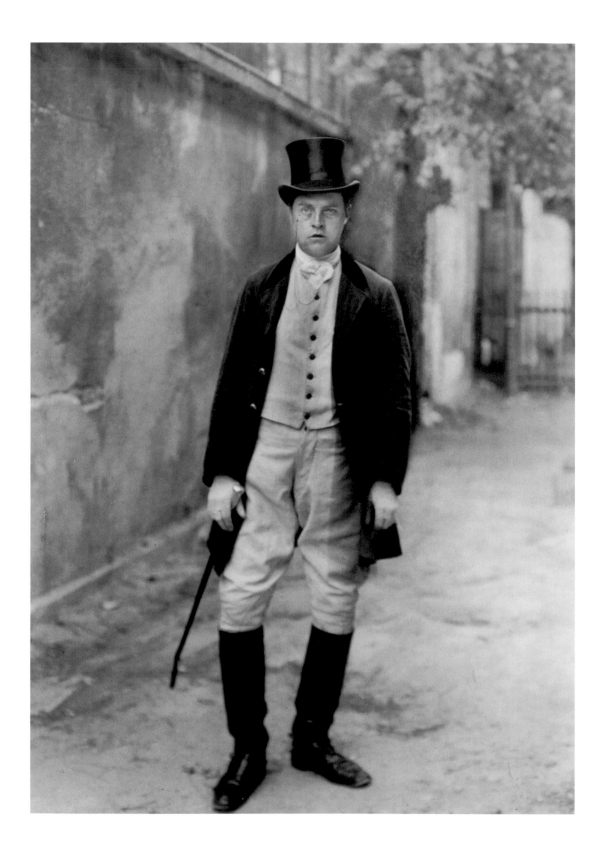

Josef Albers (American, born Germany. 1888–1976). *Paul Klee, Dessau.* 1929. Gelatin silver prints, 6¾ x 15⅞" (17.1 x 40.4 cm) overall. Gift of The Josef Albers Foundation, Inc.

▶ **Vasily Kandinsky** (French, born Russia. 1866–1944). *Fourth Annual Offering for the Kandinsky Society.* 1929. Etching, 7 x 4¹³⁄₁₆" (17.8 x 12.3 cm). Edition: 10. Gift of Neal A. Prince

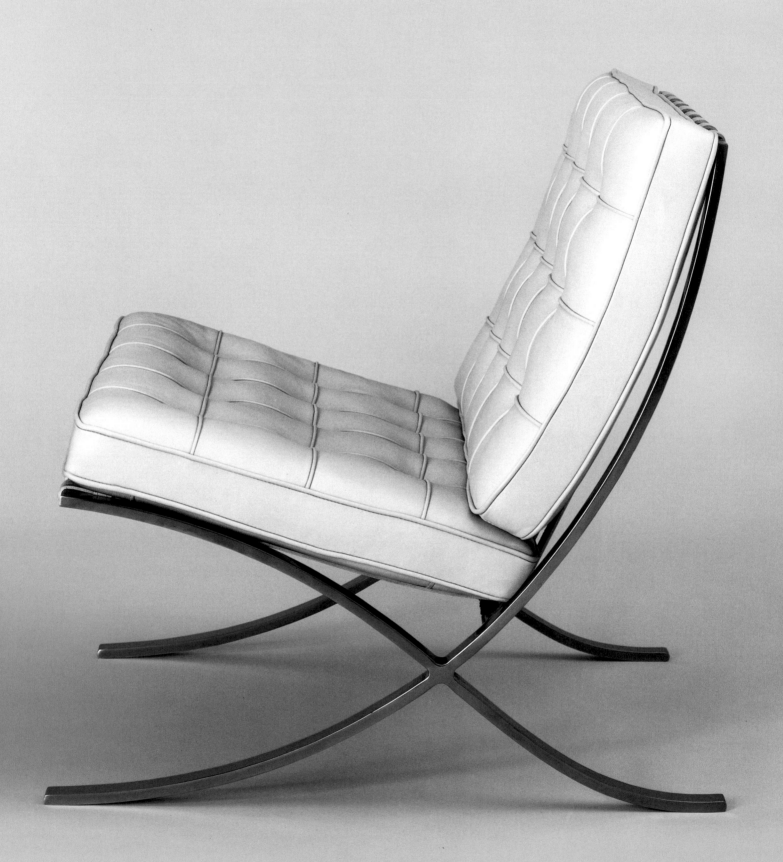

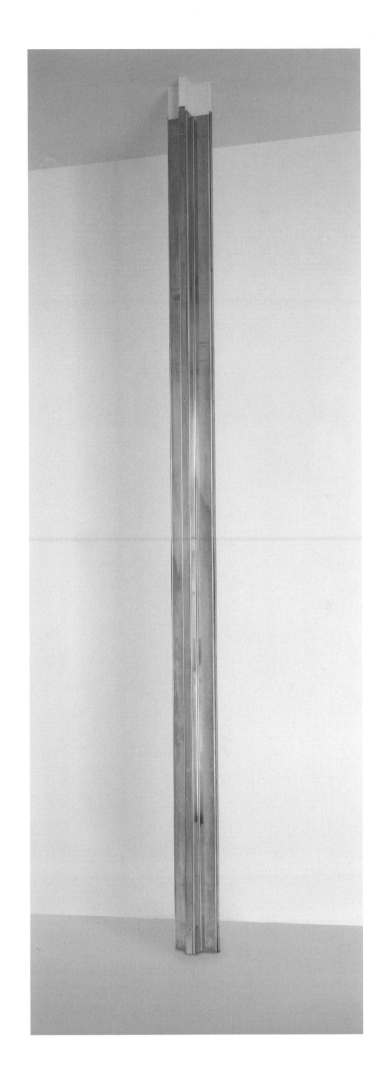

◀ **Ludwig Mies van der Rohe** (American, born Germany. 1886–1969). Barcelona Chair. 1929. Stainless steel bars and leather upholstery cushions, 29 ⅜ x 29 ¼ x 29 ¾" (74.6 x 74.3 x 75.5 cm). Manufacturer: Knoll International, New York. Gift of the manufacturer

▶ **Ludwig Mies van der Rohe** (American, born Germany. 1886–1969). Column for the Pavilion of the German Representation, International Exposition, Barcelona, Spain. 1929 (replica 1985). Chrome-plated metal cladding, 10' 1" (310 cm) high. Purchase

▷ **Jean (Hans) Arp** (French, born Alsace. 1886–1966). *Two Heads.* 1929. Painted wood relief, 47 ¼ x 39 ¼" (120 x 99.7 cm). Purchase

▽ **Edward Weston** (American, 1886–1958). *Cypress, Point Lobos.* 1929. Gelatin silver print, 7 ½ x 9 ⅜" (19 x 23.8 cm). Gift of David H. McAlpin

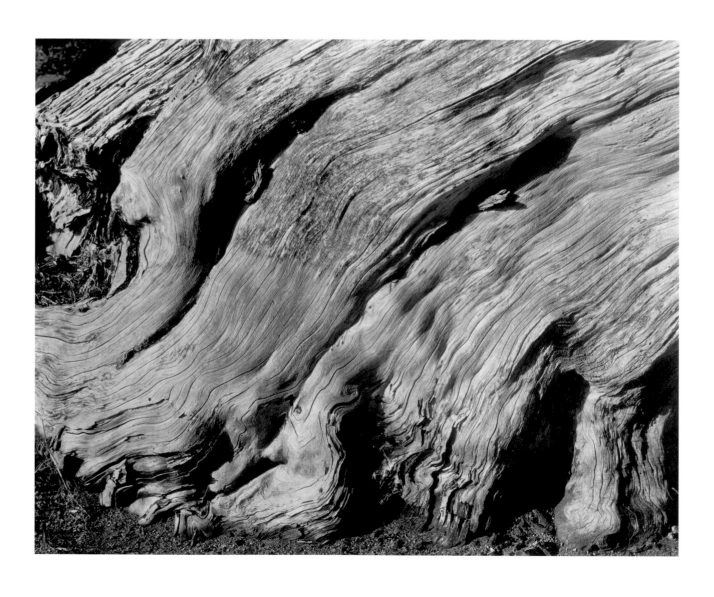

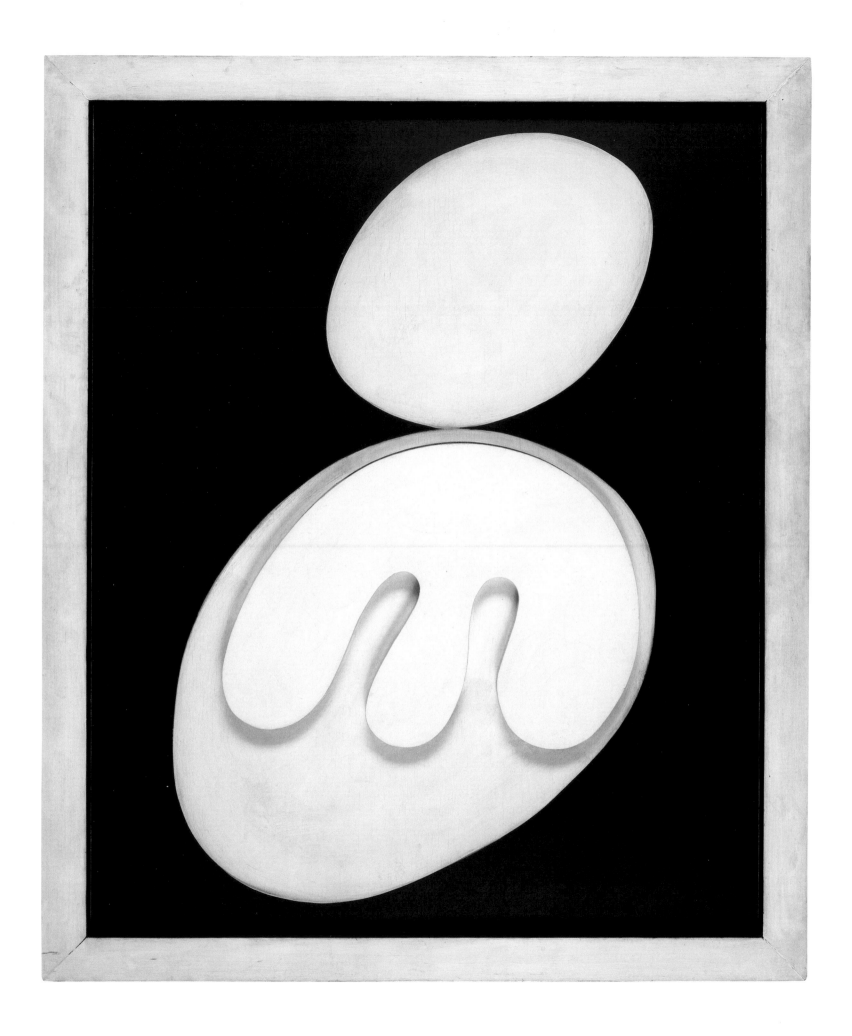

▶ **Joan Miró** (Spanish, 1893–1983). *Portrait of Mistress Mills in 1750.* 1929. Oil on canvas, 46 x 35¼" (116.7 x 89.6 cm). James Thrall Soby Bequest

▼ **Maurice Tabard** (French, 1897–1984). Untitled. 1929. Gelatin silver print, 8¹³⁄₁₆ x 6½" (22.4 x 16.6 cm). Gift of Robert Shapazian

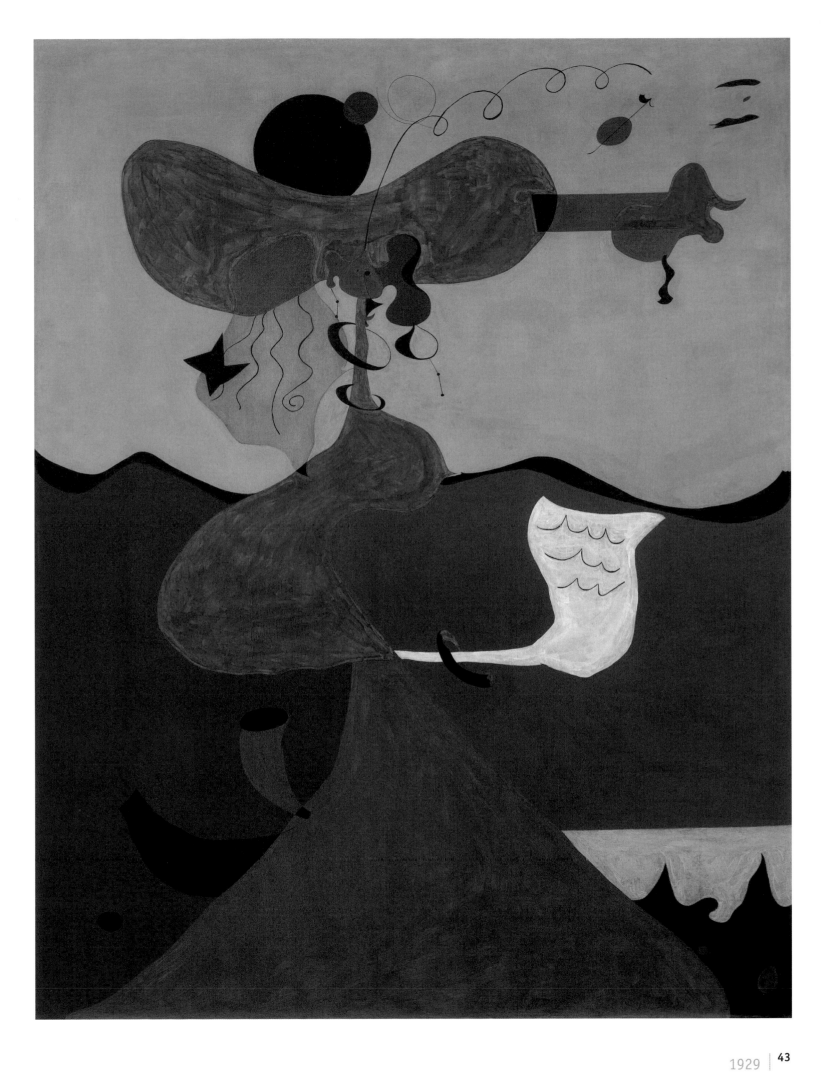

▲ **Man Ray** (Emmanuel Rudnitzky; American, 1890–1976). *Les Mystères du château du dé*. 1929. 35mm, black and white, silent. Acquired from the artist

▶ **Roger Parry** (French, 1905–1977). Untitled. 1929. From *Banalité* by Léon-Paul Fargue. Paris: Nouvelle Revue Française, 1930. Gelatin silver print, 8 9/16 x 6 1/2" (21.8 x 16.6 cm). Purchased with funds given by Lois and Bruce Zenkel

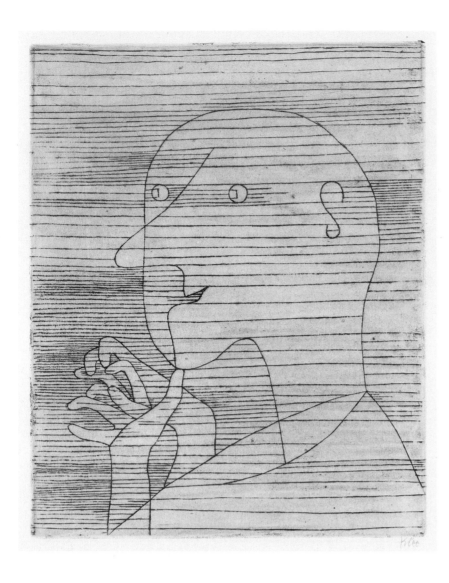

Paul Klee (German, born Switzerland. 1879–1940). *Old Man Figuring.* 1929. Etching 11¾ x 9⅜"
(29.8 x 23.8 cm). Publisher: Schweizerische Graphische Gesellschaft. Printer: H. Klinger, Leipzig.
Edition: 130. Purchase

Max Ernst (French, born Germany. 1891–1976). *Birds above the Forest*. 1929. Oil on canvas, 31¾ x 25¼" (80.6 x 64.1 cm). Katherine S. Dreier Bequest

▶ **W. Grancel Fitz** (American, 1894–1963). *Cellophane*. 1929. Gelatin silver print, 9 3/16 x 7 9/16" (23.3 x 19.3 cm). John Parkinson III Fund

▼ **Salvador Dali** (Spanish, 1904–1989). *Illumined Pleasures*. 1929. Oil and collage on composition board, 9 3/8 x 13 3/4" (23.8 x 34.7 cm). The Sidney and Harriet Janis Collection

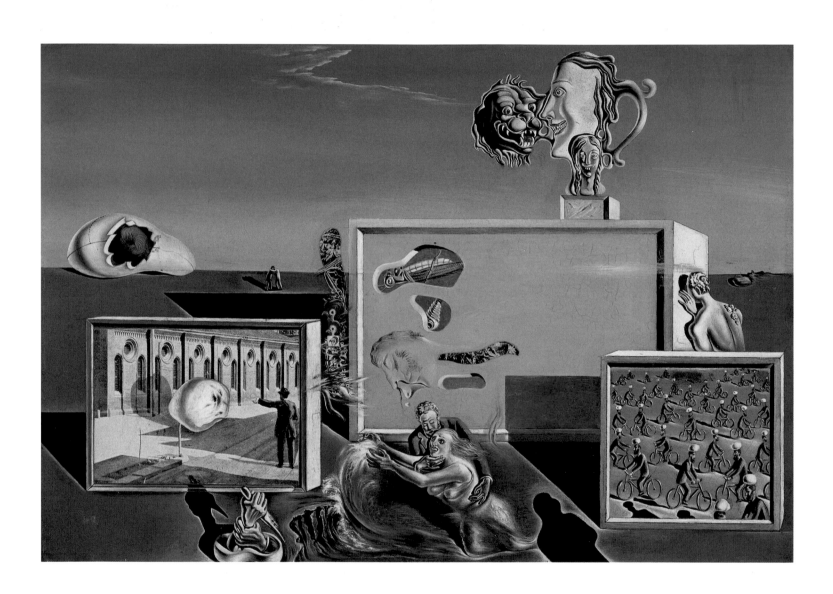

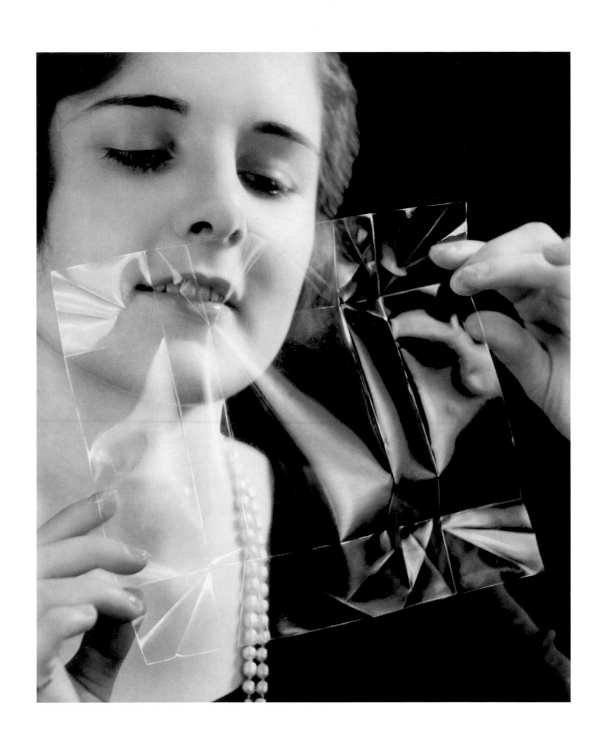

Ernst Lubitsch (American, born Germany. 1892–1947). *The Love Parade*. 1929. 35mm, black and white, sound, 109 minutes. Acquired from Paramount Pictures. Jeanette MacDonald, Maurice Chevalier

Robert Florey (French, 1900–1979) and **Joseph Santley** (American, 1889–1971). *The Cocoanuts*. 1929. 35mm, black and white, sound, 90 minutes. Zeppo Marx, Groucho Marx, Chico Marx, Harpo Marx

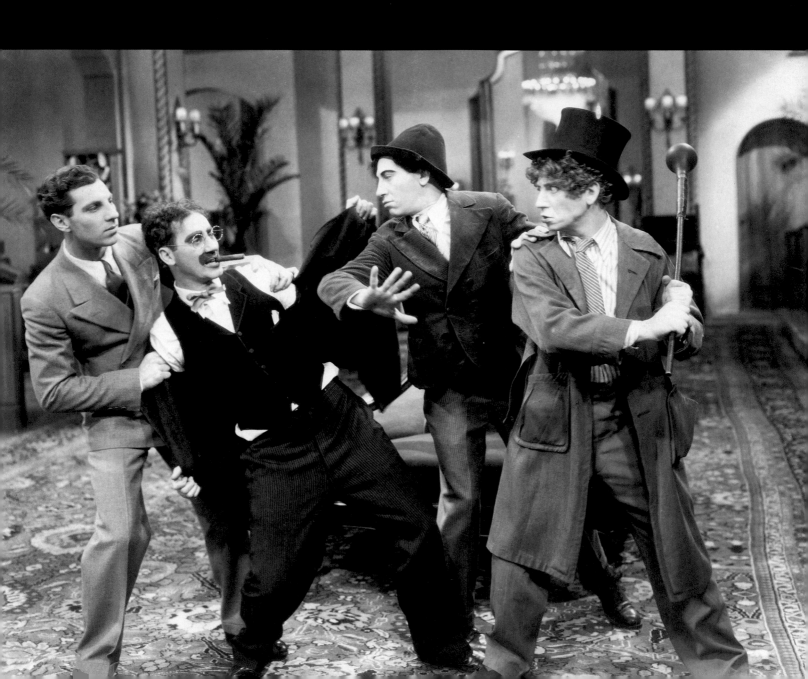

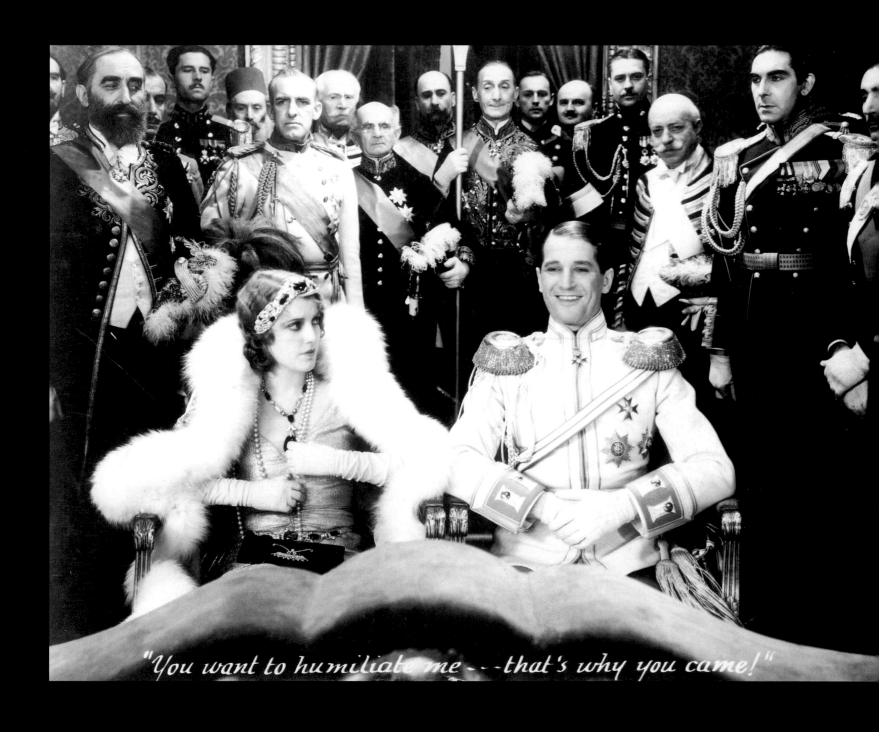

"You want to humiliate me --- that's why you came!"

▶ **Patrick Henry Bruce** (American, 1881–1936). *Painting*. c. 1929–30. Oil and pencil on canvas, 23¾ x 36⅜" (60.3 x 92.4 cm). G. David Thompson, Mrs. Herbert M. Dreyfus, Harry J. Rudick, Willi Baumeister, Edward James, and Mr. and Mrs. Gerald Murphy Funds

▼ **Sven Wingquist** (Swedish, 1876–1953). Self-Aligning Ball Bearing. 1907 (manufactured 1929). AISI bearing steel and chrome-plated steel balls, 1¾" (4.5 cm) high x 8½" (21.5 cm) diam. Manufacturer: SKF Industries, Inc., Hartford, Connecticut. Gift of the manufacturer

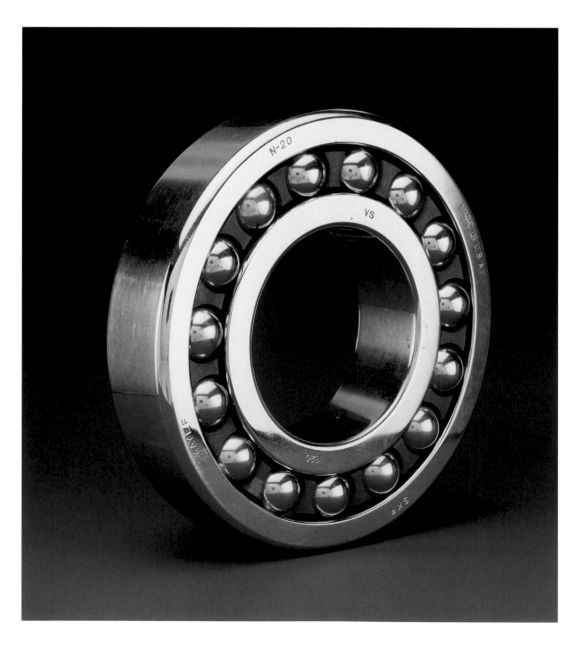

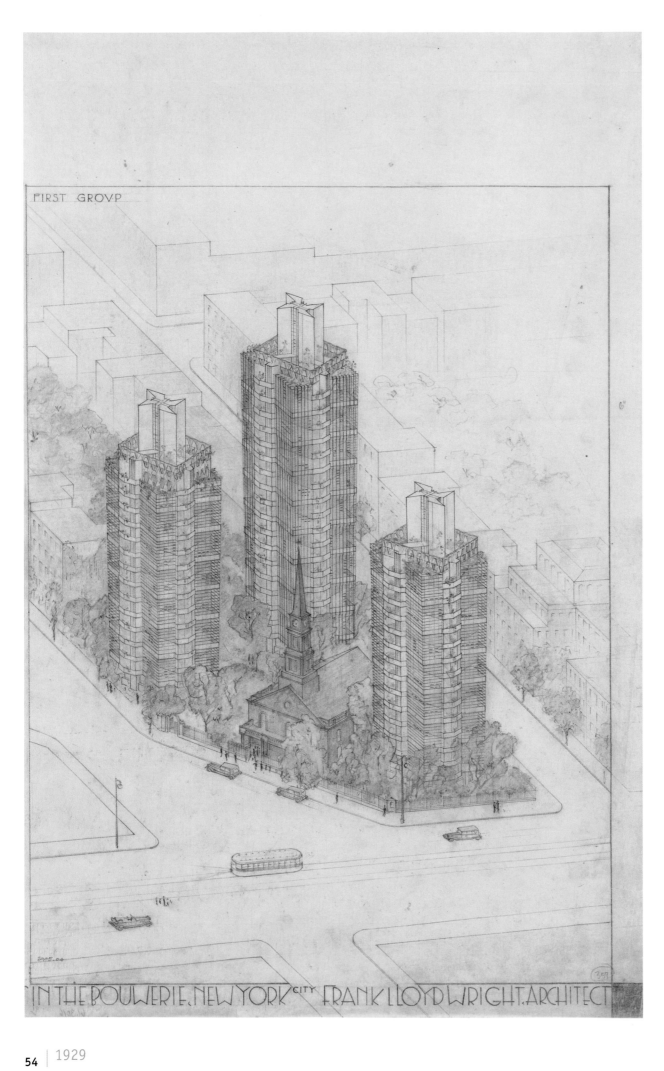

FIRST GROVP

IN THE BOUWERIE, NEW YORK CITY FRANK LLOYD WRIGHT, ARCHITECT

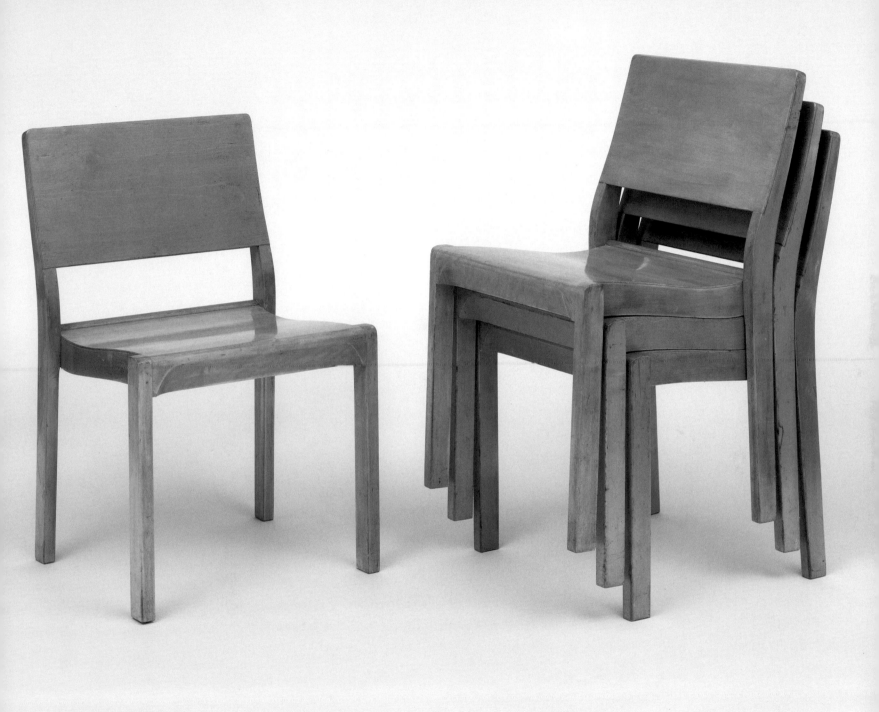

▲ **Alvar Aalto** (Finnish, 1898–1976). Stacking Side Chair. 1929. Solid and laminated birch, 31½ x 19¼ x 19¼" (80 x 49 x 49 cm). Manufacturer: Huonekalu-ja Rakennustyötehdas, Turku, Finland. Gift of Manfred Ludewig

◄ **Frank Lloyd Wright** (American, 1867–1959). St. Mark's-in-the-Bouwerie Towers, Project, New York, New York. 1927–31. Aerial perspective. Pencil on tracing paper, 24 x 15" (61 x 38 cm). Jeffrey Klein Purchase Fund, Barbara Pine Purchase Fund, and Frederieke Taylor Purchase Fund

Florence Henri (American, 1893–1982). *Composition No. 76.* 1929. Gelatin silver print, 10½ x 14⅝" (26.7 x 37.1 cm). John Parkinson III Fund

R. Buckminster Fuller (American, 1895–1983). Floor Plan for Dymaxion House. 1927–29. Graphite and watercolor on paper, 10 x 10" (25.4 x 25.4 cm).
Gift of The Howard Gilman Foundation

▲ **G. W. Pabst** (Austrian, 1885–1967). *Pandora's Box (Die Büchse der Pandora)*. 1929. 35mm, black and white, silent, 115 minutes (approx.). Acquired from Det Danske Filmmuseum. Louise Brooks

◀ **Alfred Hitchcock** (American, born Great Britain. 1899–1980). *Blackmail*. 1929. 35mm, black and white, sound, 86 minutes. Acquired from the artist. Anny Ondra

Erich Salomon (German, 1886–1944). *The Mother of the Defendant*. c. 1929. Gelatin silver print, 11⅛ x 14³⁄₁₆" (28.3 x 36 cm). Gift of Peter Hunter

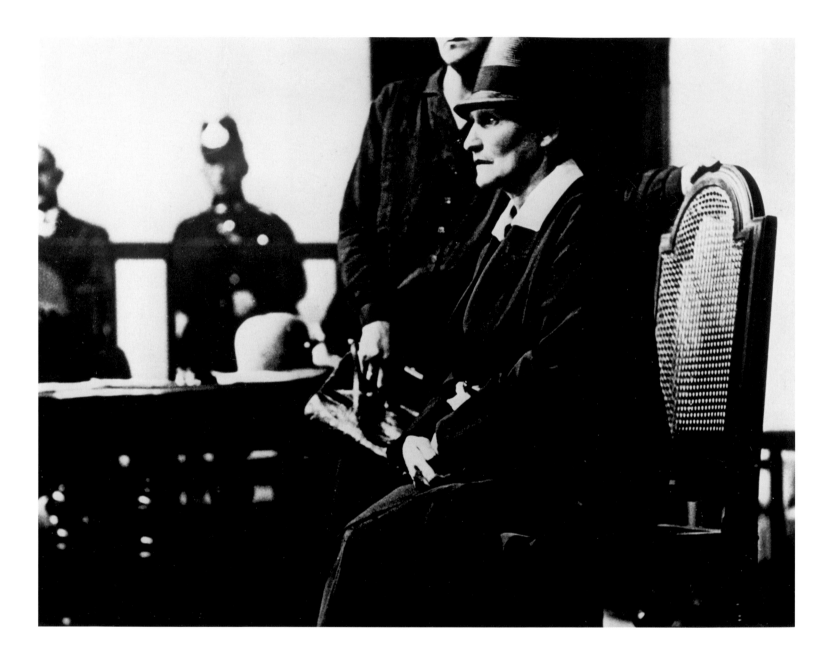

Martin Munkacsi (American, born Hungary. 1896–1963). *Vacation Fun*. 1929. Gelatin silver print, 13¼ x 10¾" (33.7 x 27.3 cm). Purchased with funds given by Lois and Bruce Zenkel

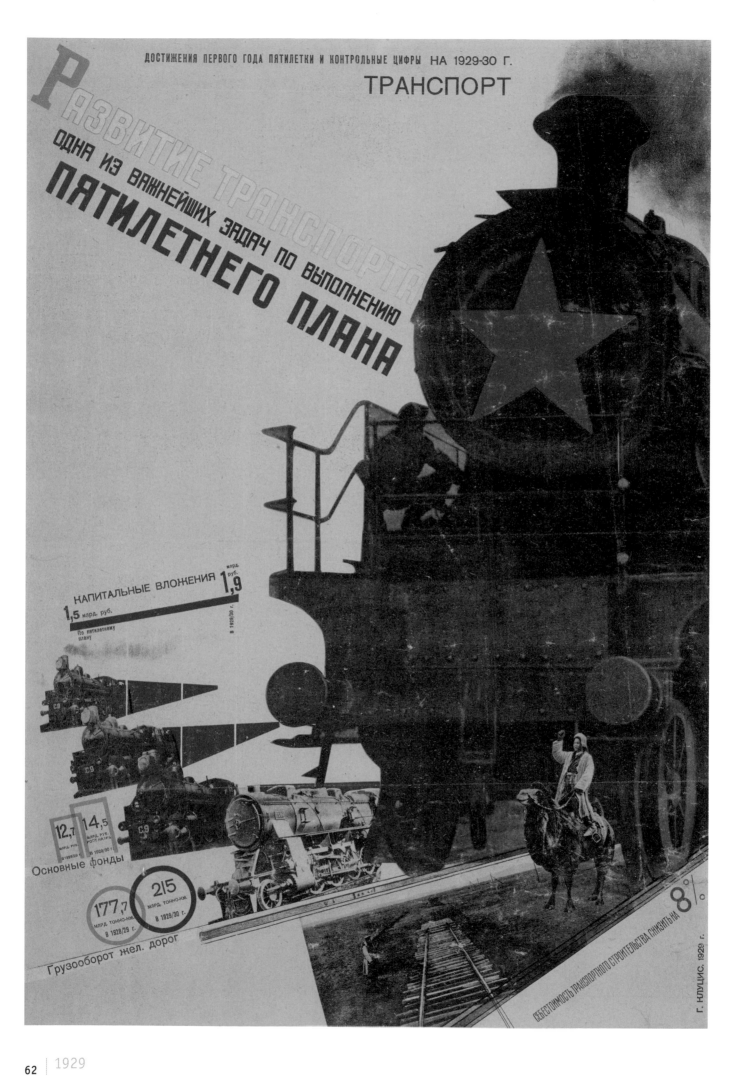

ДОСТИЖЕНИЯ ПЕРВОГО ГОДА ПЯТИЛЕТКИ И КОНТРОЛЬНЫЕ ЦИФРЫ НА 1929-30 Г.

ТРАНСПОРТ

РАЗВИТИЕ ТРАНСПОРТА
ОДНА ИЗ ВАЖНЕЙШИХ ЗАДАЧ ПО ВЫПОЛНЕНИЮ
ПЯТИЛЕТНЕГО ПЛАНА

КАПИТАЛЬНЫЕ ВЛОЖЕНИЯ **1,9** млрд. руб.

1,5 млрд. руб.
По пятилетнему плану
в 1929/30 г.

12,7 млрд. руб. **14,5** млрд. руб.

Основные фонды

177,7 млрд. тонно-км. в 1928/29 г. **215** млрд. тонно-км. в 1929/30 г.

Грузооборот жел. дорог

СЕБЕСТОИМОСТЬ ТРАНСПОРТНОГО СТРОИТЕЛЬСТВА СНИЗИТЬ НА **8°/0**

Г. КЛУЦИС. 1929 г.

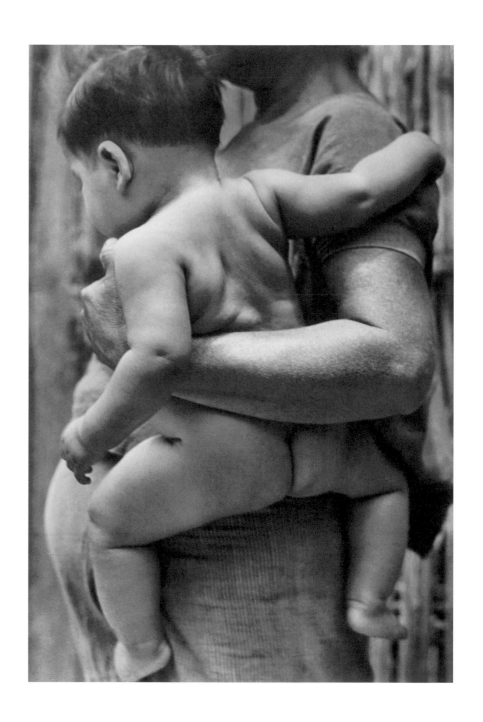

▲ **Tina Modotti** (Italian, 1896–1942). *Mother and Child, Tehuantepec.* c. 1929. Gelatin silver print, 8⅞ x 6" (22.6 x 15.3 cm). Anonymous gift

◄ **Gustav Klucis** (Latvian, 1895–1944). *Transport Achievement of the First Five Year Plan.* 1929. Gravure, sheet 28⅞ x 19⅞" (73.3 x 50.5 cm). Purchase

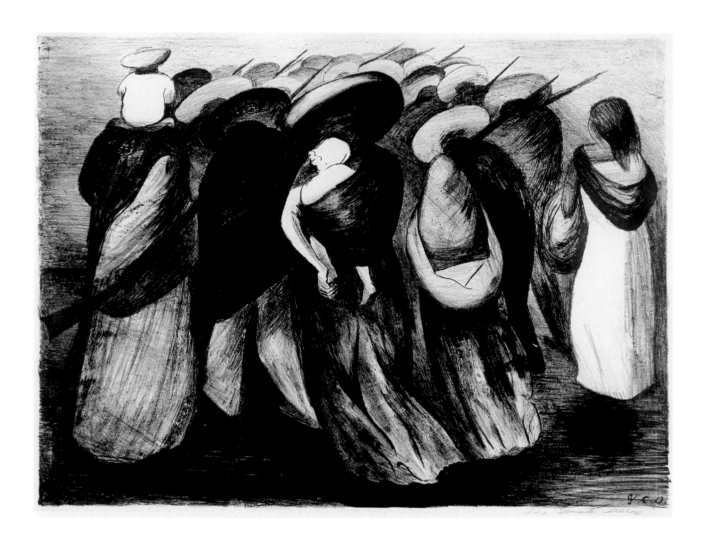

José Clemente Orozco (Mexican, 1883–1949). *Rear Guard*. 1929. Lithograph, 14 x 18¾" (35.6 x 47.7cm). Publisher: Weyhe Gallery, New York.
Printer: George Miller, New York. Edition: 100. Gift of Abby Aldrich Rockefeller

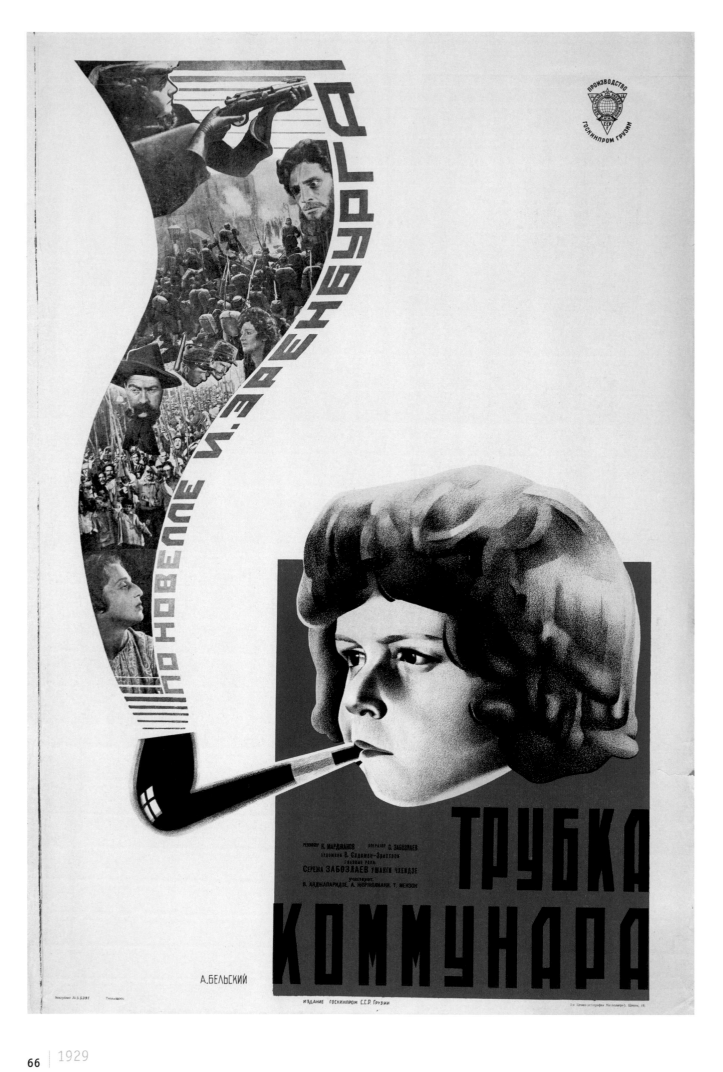

◄ **Anatoli Belski** (Russian, 1896–1970). *The Pipe of the Communards.* 1929. Lithograph, sheet 43 x 29 ¼" (109.2 x 74.3 cm). Gift of The Lauder Foundation, Leonard and Evelyn Lauder Fund

▼ **Berenice Abbott** (American, 1898–1991). *El at Columbus Avenue and Broadway.* 1929. Gelatin silver print, 6 ³⁄₁₆ x 8 ⁵⁄₁₆" (15.7 x 21.2 cm). Purchase

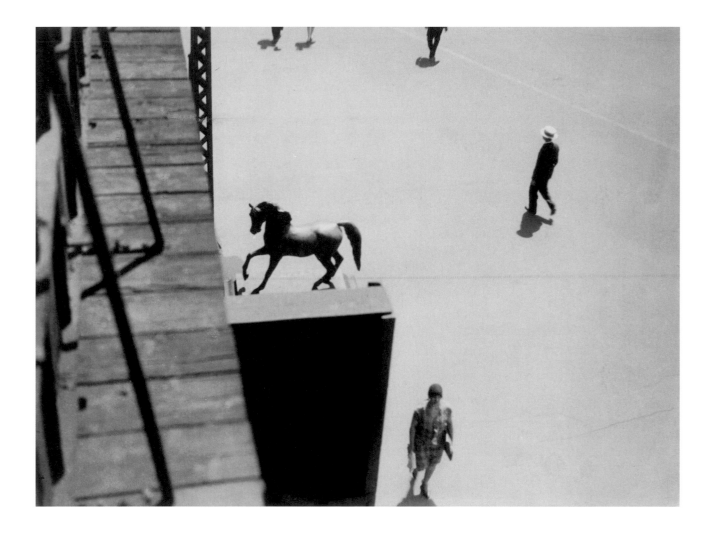

▶ **Henri Matisse** (French, 1869–1954). *The White Fox.* 1929. Lithograph, 20¼ x 14½" (51.4 x 36.8 cm) (irreg.). Edition: 75. The Associates Fund

▼ **Jacques Villon** (French, 1875–1963). *Head of a Young Girl.* 1929. Etching, 10¾ x 8⅜" (27.5 x 26 cm). Edition: 50. Larry Aldrich Fund

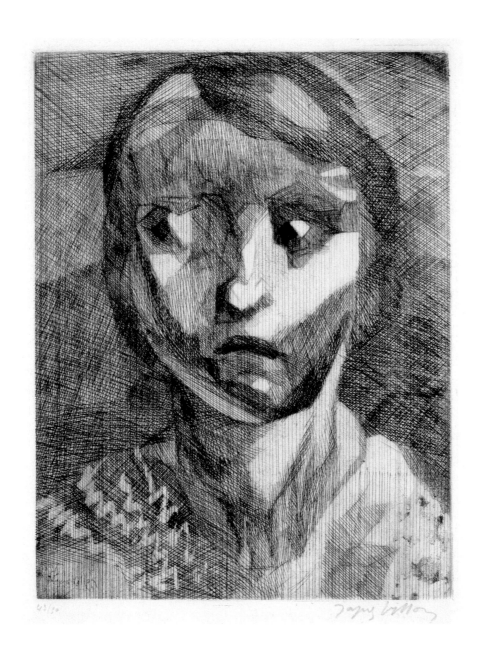

59/75

Henri-Matisse

▲ **Luis Buñuel** (Spanish, 1900–1983). *Un Chien Andalou*. 1929. 35mm, black and white, silent. Acquired from the artist. Pierre Batcheff, Simone Marevil

▶ **Leo McCarey** (American. 1898–1969). *Wrong Again*. 1929. 35mm, black and white, sound, 22 minutes. Stan Laurel, Oliver Hardy

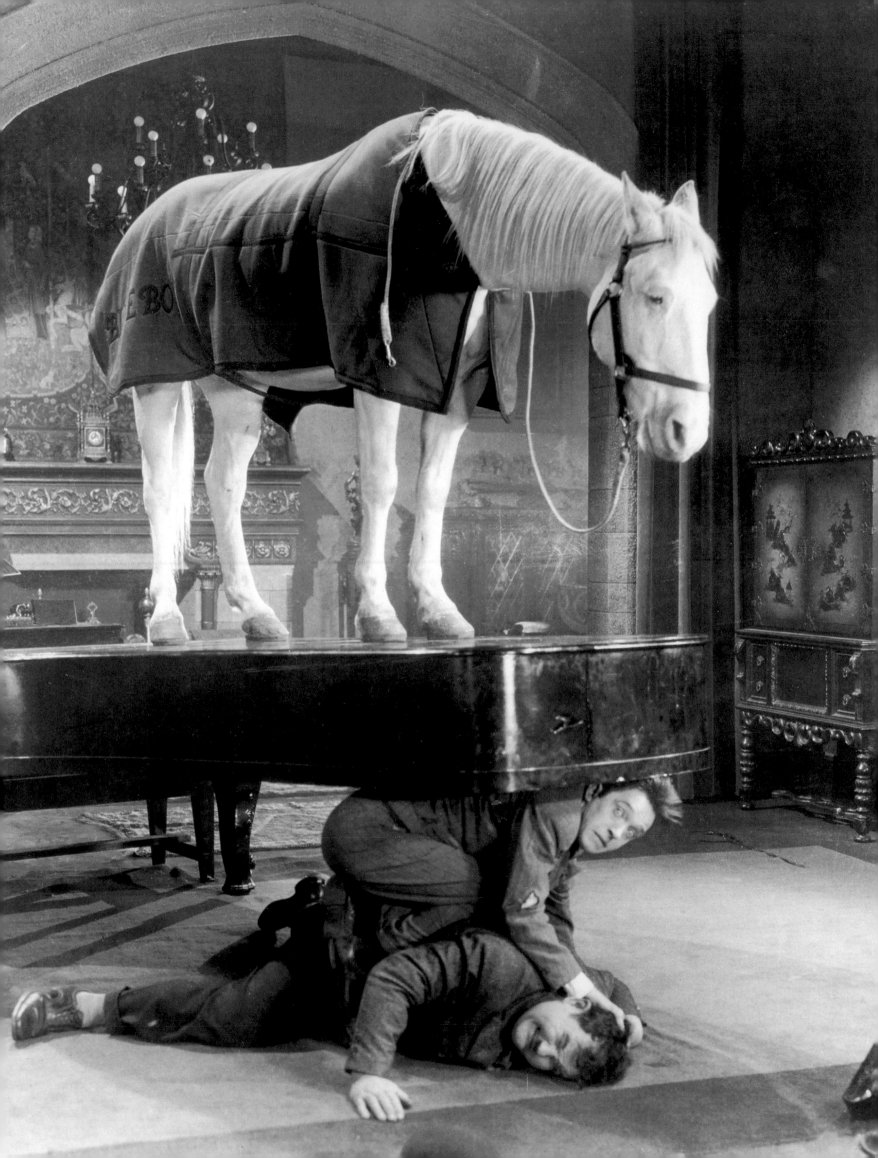

Raoul Dufy (French, 1877–1953). *Window at Nice*. c. 1929. Oil on canvas, 21⅝ x 18⅛" (54.9 x 46 cm). Gift of Mrs. Gilbert W. Chapman

Harry Beaumont (American, 1888–1966). *The Broadway Melody*. 1929. 35mm, black and white, sound, 104 minutes. Acquired from George Eastman House with funding from AT&T. Anita Page, Bessie Love, Charles King

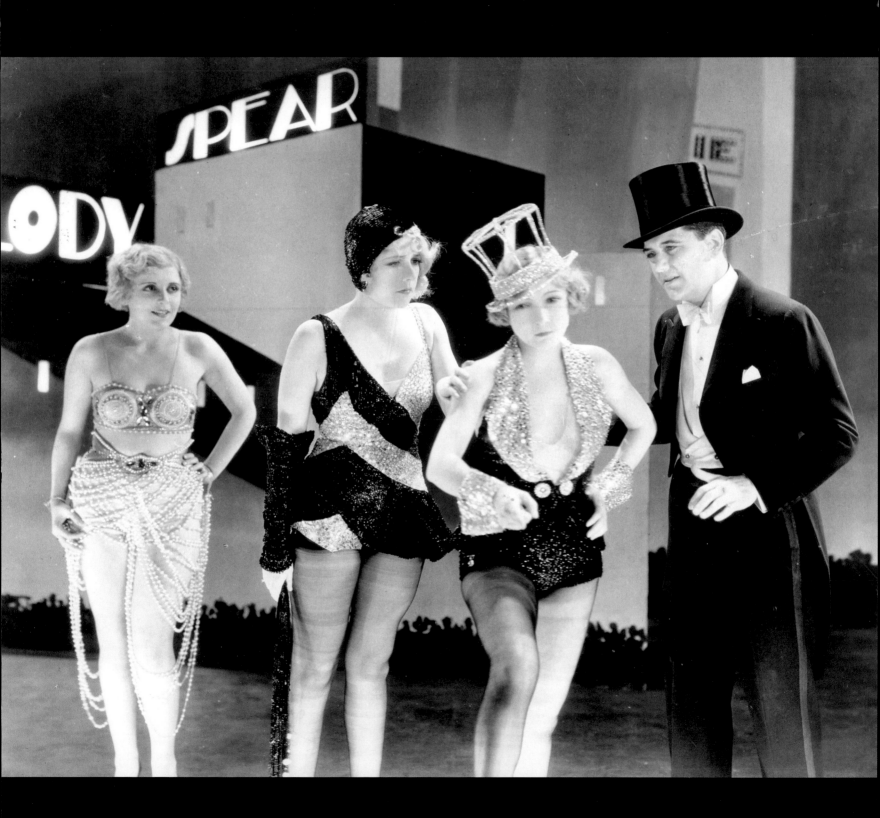

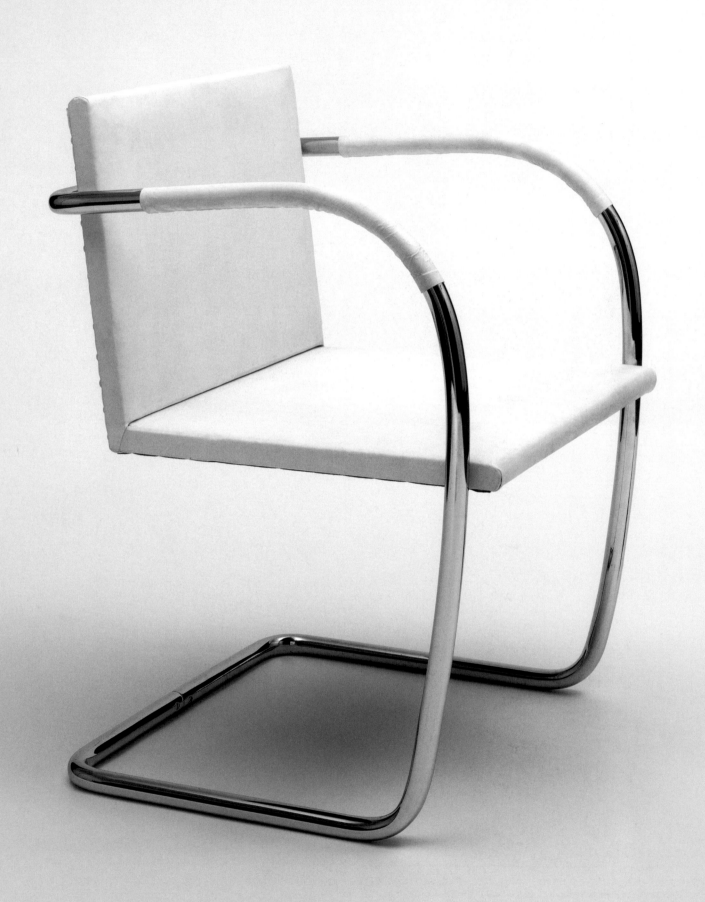

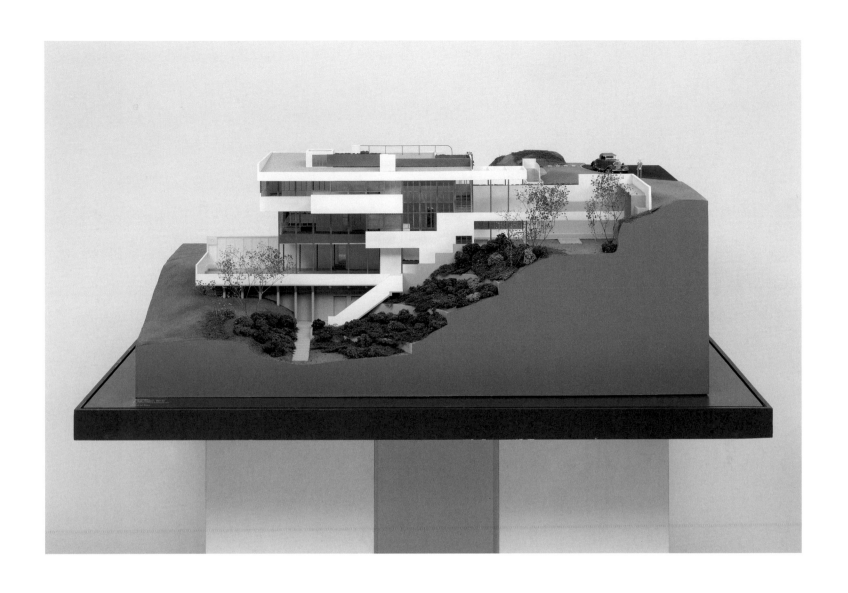

▲ **Richard Neutra** (American, born Austria. 1892–1970). Phillip M. Lovell House, Los Angeles, California. 1927–29. Model: acrylic and wood, 24 x 34¼ x 58¼" (61 x 87 x 148 cm). Modelmaker: Paul Bonfilio (1979). Best Products Company Architecture Fund

◀ **Ludwig Mies van der Rohe** (American, born Germany. 1886–1969). Brno Chair. 1929. Chrome-plated tubular steel and calf parchment, 30⅞ x 21⅝ x 28⅜" (78.4 x 54.3 x 72.1 cm). Manufacturer: Berliner Metallgewerbe, Joseph Müller, Germany. Gift of Philip Johnson

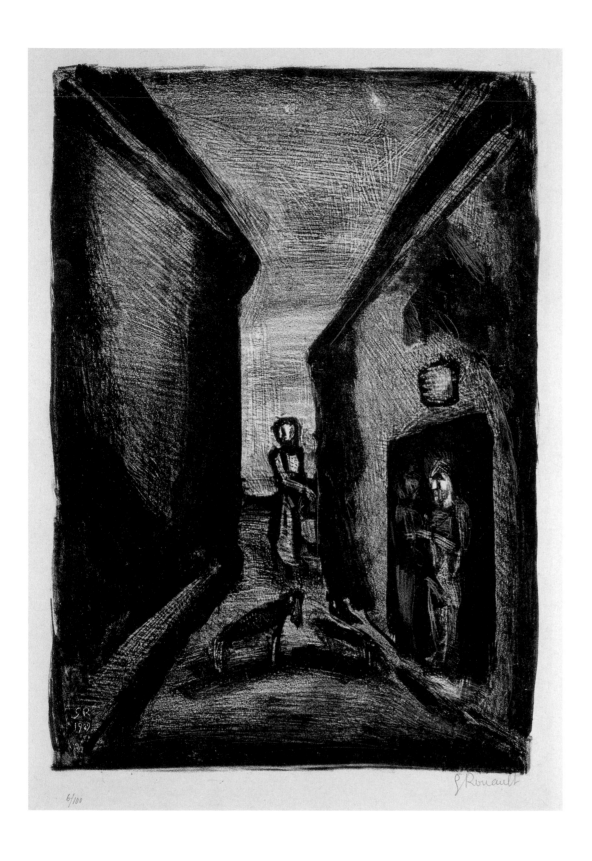

Georges Rouault (French, 1871–1958). *Suburb of the Long Sorrow (Cul-de-sac)* from the suite *La Petite Banlieue*. 1929. Lithograph, 12 13/16 x 8 15/16" (32.6 x 22.7 cm) (irreg.). Publisher: Éditions des Quatre Chemins, Paris. Printer: Éditions Jeanne Bucher, Paris. Edition: 100. The Louis E. Stern Collection

Stuart Davis (American, 1892–1964). *Place Pasdeloup No. 2.* 1929. Lithograph, 13¹¹⁄₁₆ x 10¹⁵⁄₁₆" (34.7 x 27.7 cm). Publisher: the artist. Printer: probably Desjobert, Paris. Edition: 20. Gift of Abby Aldrich Rockefeller

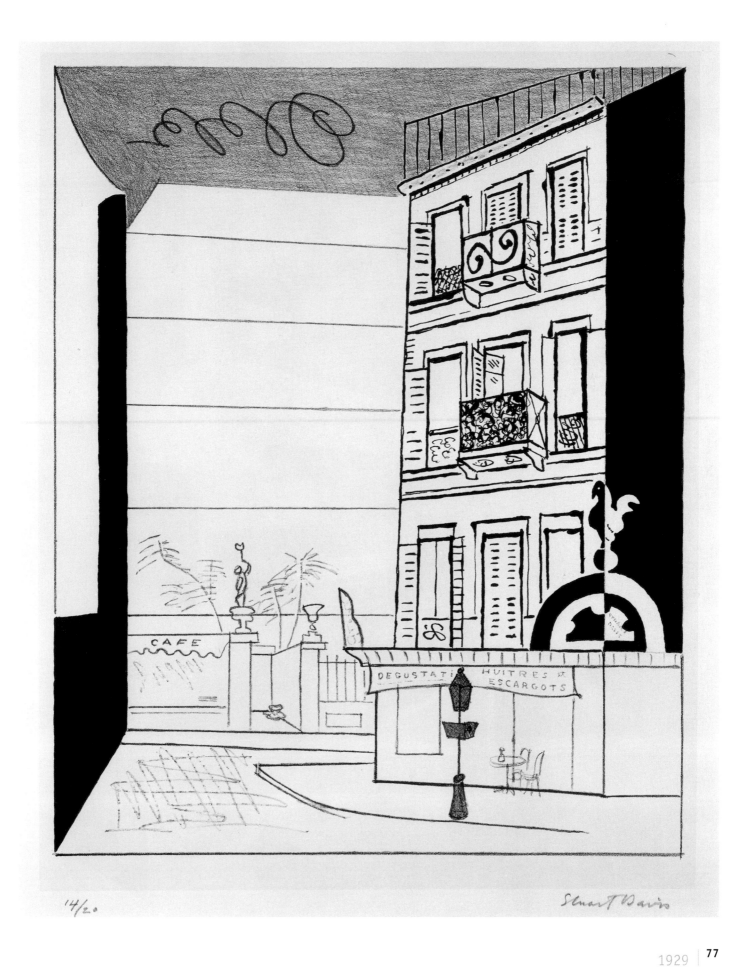

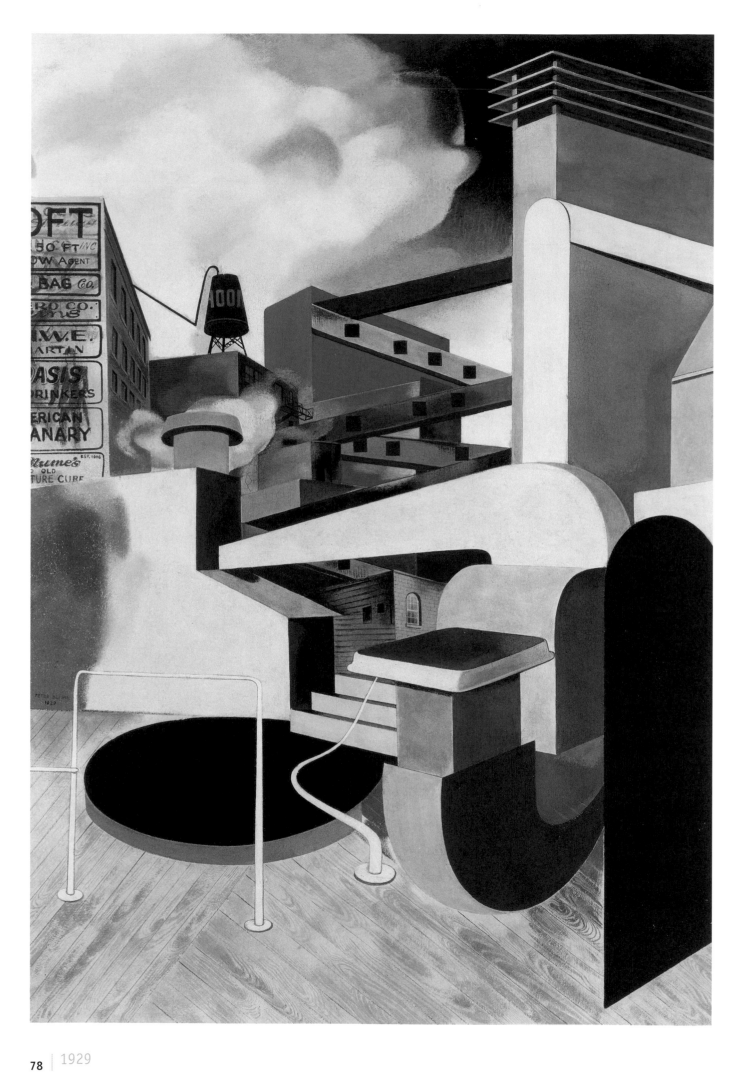

◄ **Peter Blume** (American, born Russia. 1906–1992). Study for *Parade (Waterfront, Manhattan)*. 1929. Gouache and varnish on cardboard, 20¼ x 14" (51.4 x 35.6 cm). Gift of Abby Aldrich Rockefeller

▼**Charles Demuth** (American, 1883–1935). *Corn and Peaches*. 1929. Watercolor and pencil on paper, 13¾ x 19¾" (35 x 50.2 cm). Gift of Abby Aldrich Rockefeller

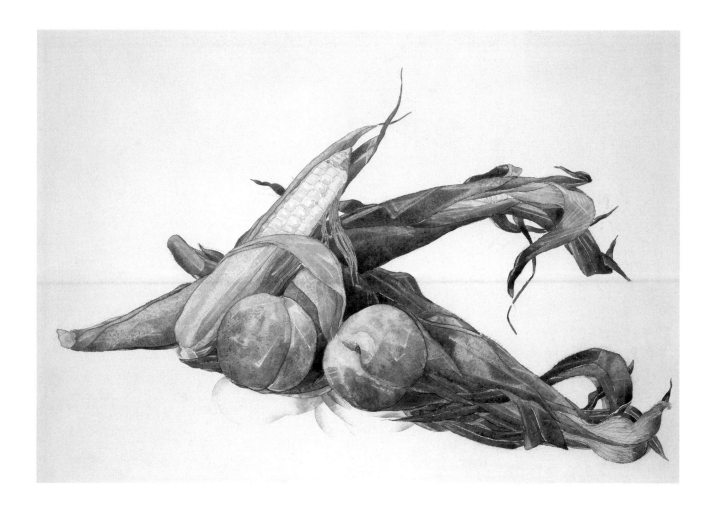

Alexander Dovzhenko (Ukranian, 1894–1956). *Earth* (*Zemlya*). 1929. 35mm, black and white, silent, 62 minutes (approx.). Exchange with Gosfilmofond

King Vidor (American, 1894–1982). *Hallelujah*. 1929. 35mm, black and white, sound, 100 minutes. Acquired from Metro-Goldwyn-Mayer. Nina Mae McKinney, Fannie Belle DeKnight, Daniel Haynes

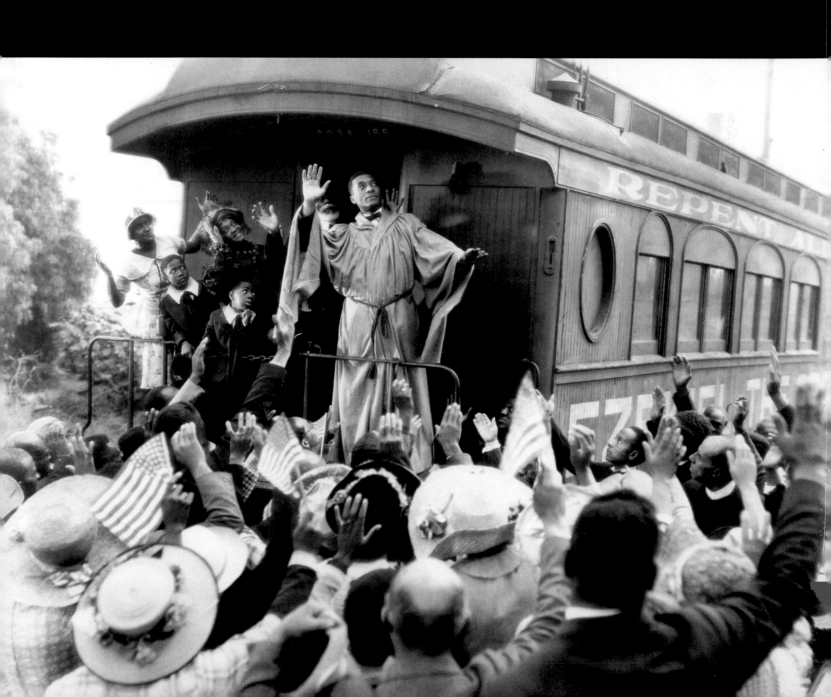

▲ **Balthus** (Baltusz Klossowski de Rola; French, born 1908). Study for *The Street*. 1929. Pen and ink on paper, 6 ⅞ x 8 ⅝" (17.4 x 21.8 cm). Gift of James Thrall Soby

▶ **Chaim Soutine** (French, born Lithuania. 1893–1943). *Portrait of Maria Lani*. 1929. Oil on canvas, 28 ⅞ x 23 ½" (73.3 x 59.7 cm). Mrs. Sam A. Lewisohn Bequest

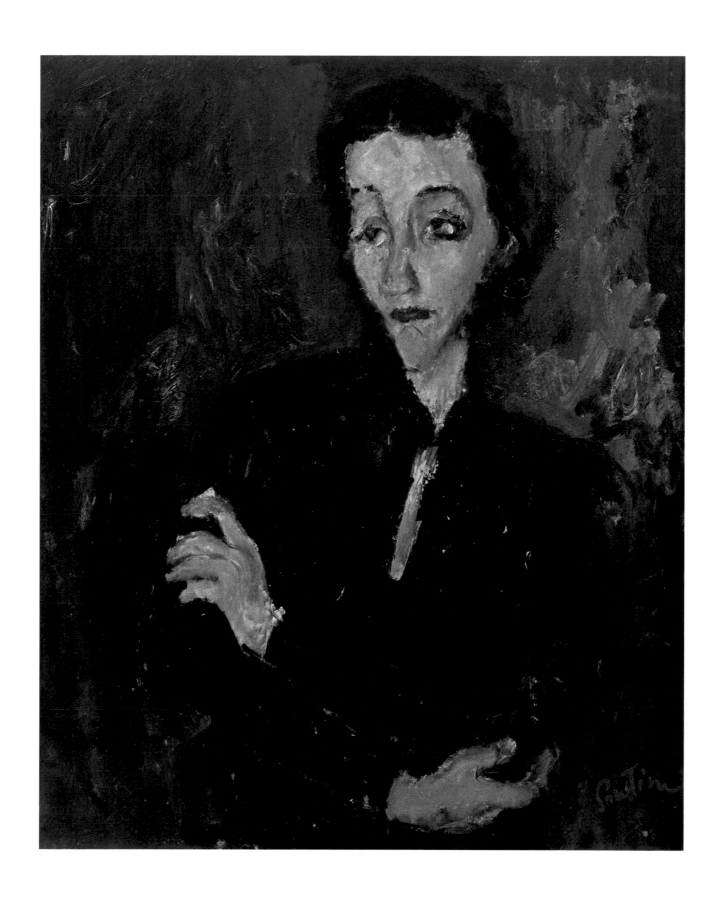

▲ **Germaine Krull** (French, 1897–1985). *Jean Cocteau*. 1929. Gelatin silver print, 8⅞ x 6⅜" (22.6 x 16.2 cm). The Family of Man Fund, The Fellows of Photography Fund, and Anonymous Purchase Fund

▶ **Edward Steichen** (American, born Luxembourg. 1879–1973). *Maurice Chevalier Does a Song and Dance*. 1929. Gelatin silver print, 16½ x 13⅛" (41.9 x 33.3 cm). Gift of the photographer

▲ **Alexander Calder** (American, 1898–1976). *Josephine Baker*. 1927–29. Iron-wire construction, 39 x 22⅜ x 9¾" (99 x 56.6 x 24.5 cm). Gift of the artist

▶ **Jacques Lipchitz** (American, born Lithuania. 1891–1973). *Figure*. 1926–30. Bronze (cast 1937), 7' 1¼" x 38⅝" (216.6 x 98.1 cm). Cast 1 of 7. Van Gogh Purchase Fund

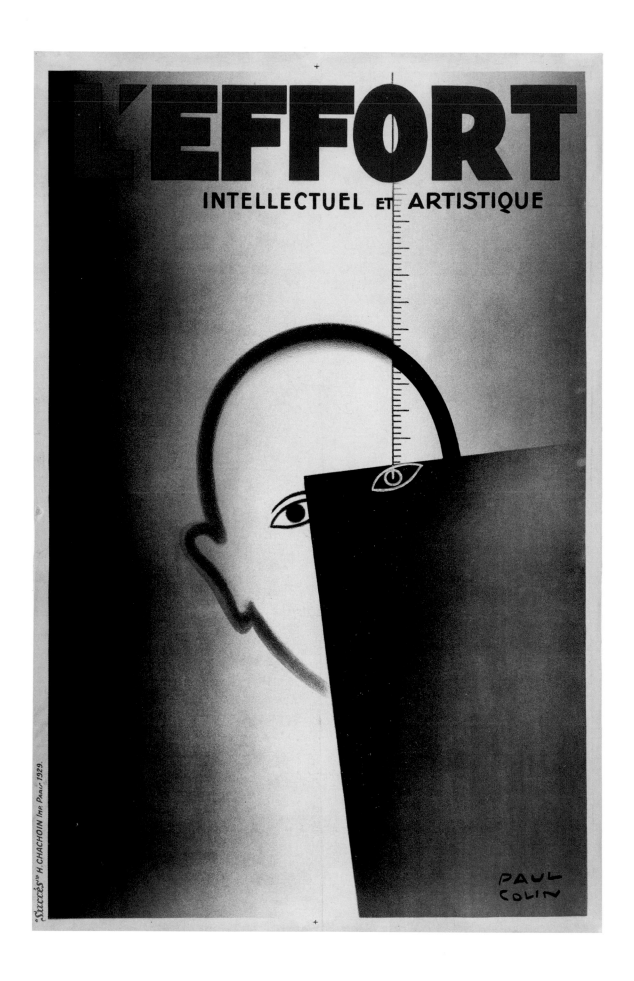

Paul Colin (French, 1892–1985). *L'Effort/Intellectuel et Artistique.* 1929. Lithograph, sheet 50 x 33½" (127 x 85.1 cm). Poster Fund

Le Corbusier (Charles-Édouard Jeanneret; French, born Switzerland. 1887–1965). Plan for Montevideo, Plan for Saõ Paulo. Aerial perspectives. 1929. Ink on paper, 10⅝ x 6½" (27 x 16.5 cm). Emilio Ambasz Fund

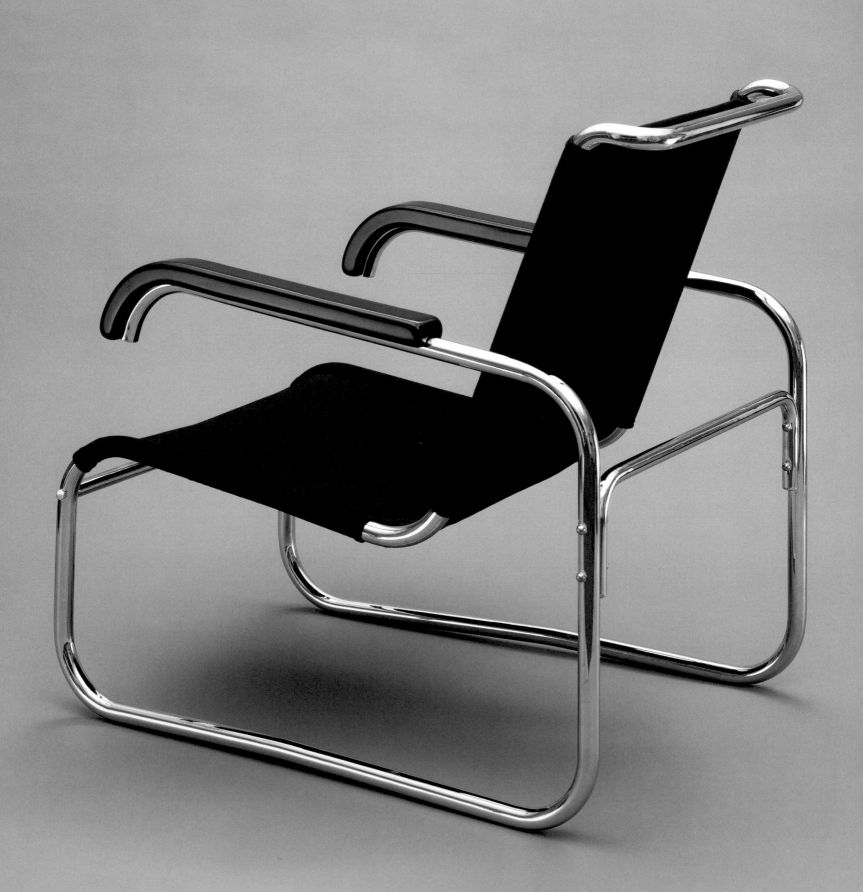

▲ **László Moholy-Nagy** (American, born Hungary. 1895–1946). *Photogram*. 1929. Gelatin silver print, 11¾ x 9⅜" (29.8 x 23.8 cm). Gift of James Johnson Sweeney

◄ **Marcel Breuer** (American, born Hungary. 1902–1981). Lounge Chair. 1928–29. Tubular chromed steel frame, black lacquer arm rests, and canvas, 31½ x 24 x 31½" (80 x 61 x 80 cm). Manufacturer: Gebrüder Thonet A.G., Germany. Estée and Joseph Lauder Design Fund

▷ **Louis Lozowick** (American, born Russia. 1892–1973). *Doorway Into Street*. 1929. Lithograph, 14 1/16 x 6 15/16" (35.7 x 17.6 cm). Publisher: the artist, New York. Printer: George Miller, New York. Edition: 15. Given anonymously in memory of Irving Drutman

▽ **Edward Hopper** (American, 1882–1967). *Ash's House, Charleston, South Carolina*. 1929. Watercolor and pencil on paper, 14 x 20" (35.7 x 50.9 cm). The William S. Paley Collection

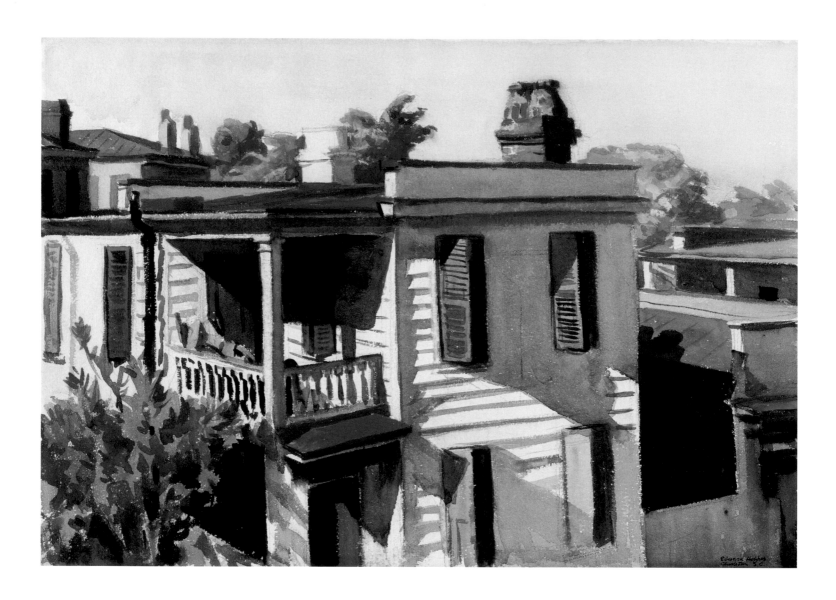

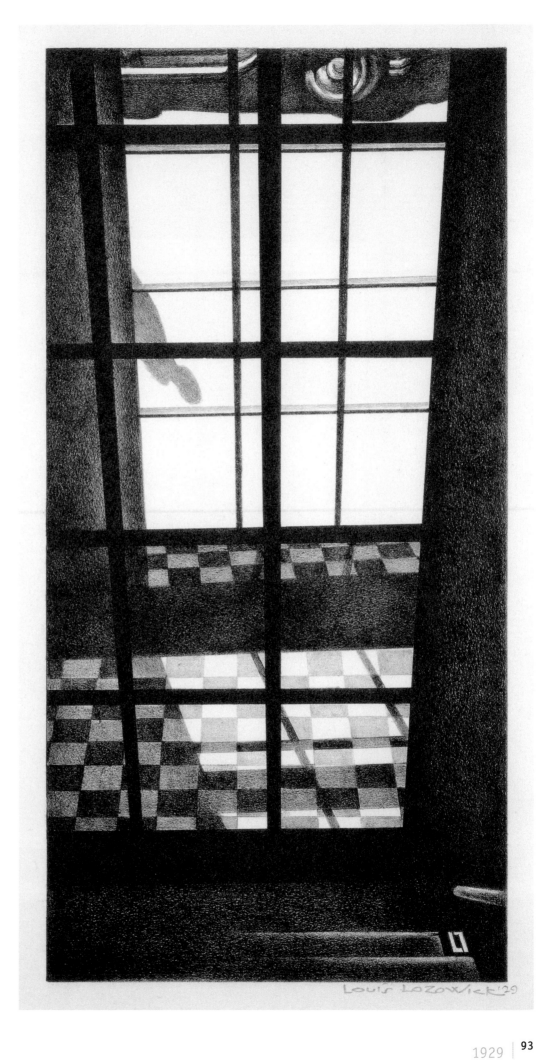

Georgia O'Keeffe (American, 1887–1986). *Lake George Window.* 1929. Oil on canvas, 40 x 30" (101.6 x 76.2 cm). Acquired through the Richard D. Brixey Bequest

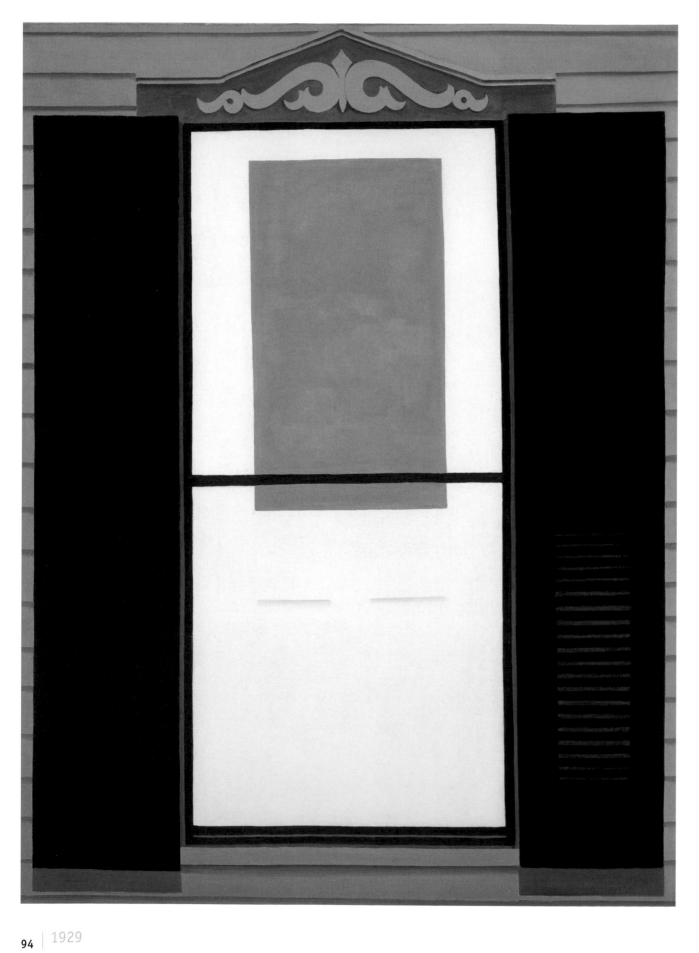

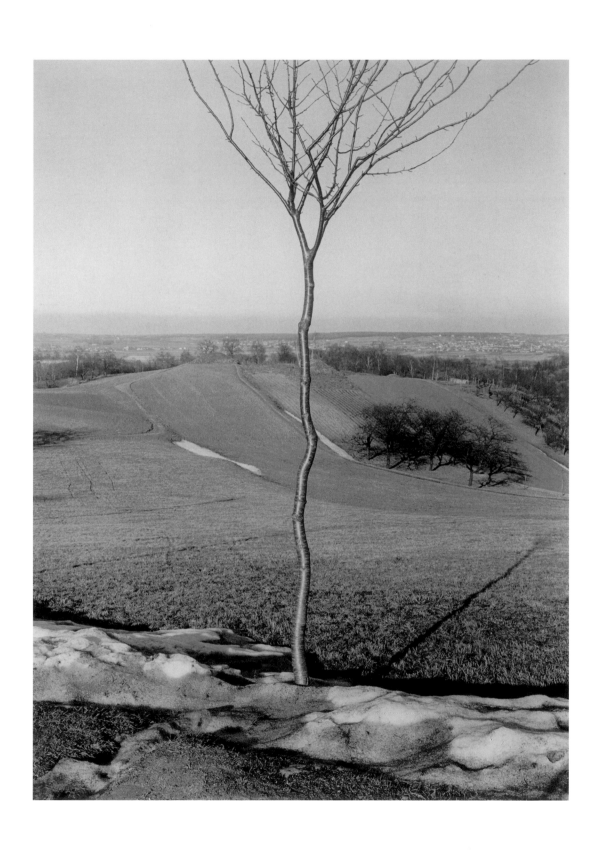

Albert Renger-Patzsch (German, 1897–1966). *The Little Tree.* 1929. Gelatin silver print, 8¹⁵⁄₁₆ x 6⁹⁄₁₆" (22.7 x 16.7 cm). Purchased with funds given by Paul F. Walter

▲ **Alfred Stieglitz** (American, 1864–1946). *Equivalent*. 1929. Gelatin silver print, 3 ⅝ x 4 ⅝" (9.2 x 11.8 cm). The Alfred Stieglitz Collection. Gift of Georgia O'Keeffe

▶ **Paul Strand** (American, 1890–1976). *Leaves II*. 1929. Platinum print, 9 9/16 x 7 9/16" (24.3 x 19.3 cm). Gift of Georgia O'Keeffe

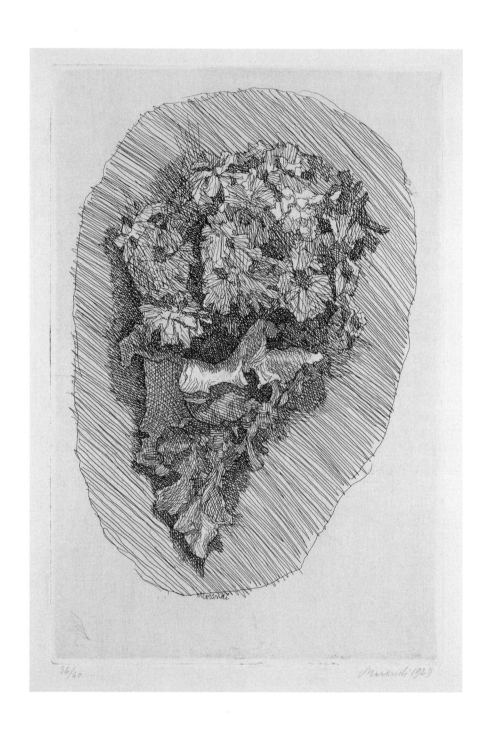

Giorgio Morandi (Italian, 1890–1964). *Flowers.* 1929. Etching, 11¾ x 7¾" (29.8 x 19.7 cm).
Edition: 40. Gift of Mrs. Donald B. Straus

Marianne Brandt (German, 1893–1983). Bowl. 1929. Chrome-plated brass, 2⁷⁄₁₆" (6.2 cm) high x 10¹³⁄₁₆" (27.5 cm) diam. Manufacturer: Bauhaus Metal Workshop, Dessau, Germany. Gift of Howard Dearstyne

▲ **Henri Cartier-Bresson** (French, born 1908). *Head.* 1929–31. Gelatin silver print, 7 x 6¾" (17.8 x 17.1 cm). Anonymous Purchase Fund

▶ **Manuel Alvarez Bravo** (Mexican, born 1902). *The Sympathetic Nervous System.* 1929. Gelatin silver print, 9½ x 7⅜" (24.1 x 18.8 cm). Gift of N. Carol Lipis

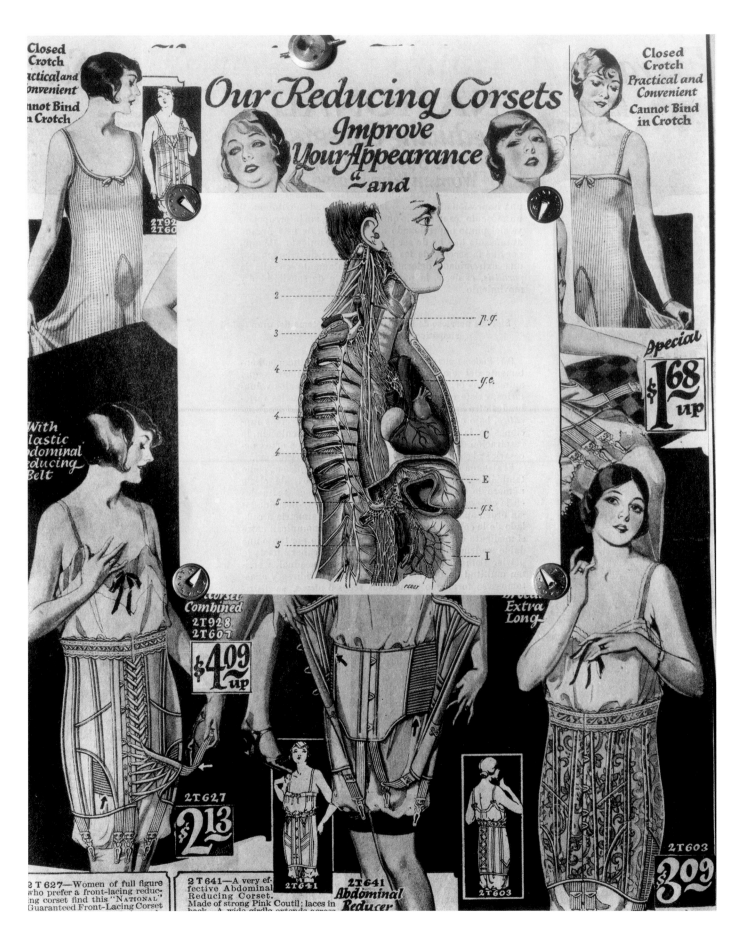

▲ **Walker Evans** (American, 1903–1975). *Roadside Gas Sign*. 1929. Gelatin silver print, 3 ¹⁵⁄₁₆ x 5 ⅞" (10.1 x 15 cm). Purchase

▶ **Kurt Schwitters** (British, 1887–1948). *Karlsruhe*. 1929. Cut-and-pasted printed papers and crayon on printed board, 16 ⅝ x 11 ⅝" (42.3 x 29.6 cm). The Riklis Collection of McCrory Corporation

Theo van Doesburg (C.E.M. Küpper; Dutch, 1883–1931). *Simultaneous Counter-Composition*. 1929–30. Oil on canvas, 19¾ x 19⅝" (50.1 x 49.8 cm). The Sidney and Harriet Janis Collection

Ralph Steiner (American, 1899–1986). *Ford Car*. 1929. Gelatin silver print, 9⁹⁄₁₆ x 7⁹⁄₁₆" (24.3 x 19.2 cm). Gift of the photographer

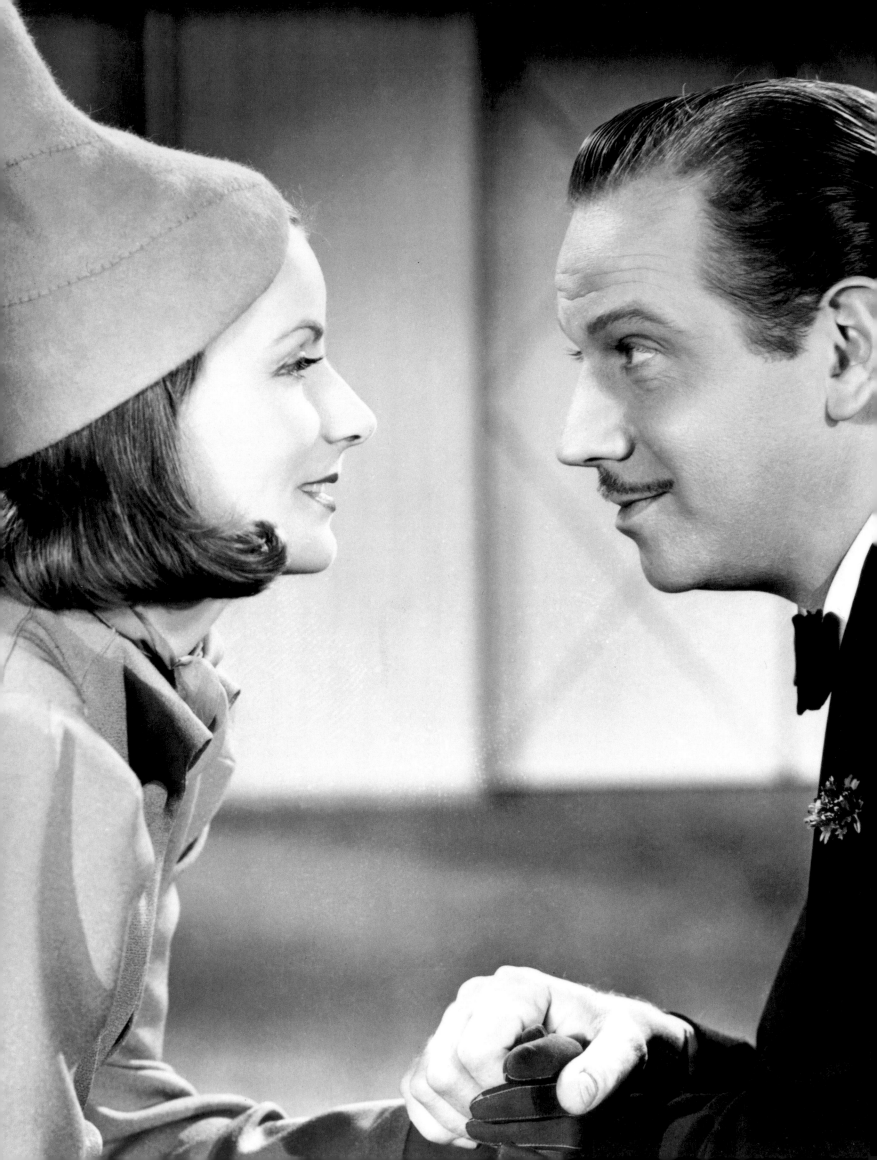

1939

F lip past this introduction to the opening spread for the year 1939 (pp. 112, 113). On the right-hand page you will see a film still of wide-open spaces interrupted only by a narrow column of figures following a serpentine course through parched lands. On the left-hand page is a congested dreamscape dominated by a maze of convoluted fretwork. The first is an image of optimism, of Americans striking out into the wilderness. The second, with its horizon line cut off from view, is a briar patch for the imagination, a place at once marvelous and menacing. John Ford's *Stagecoach*—from which this film still comes—is one of the great heroic Westerns, which is to say an integral part of our national fiction. Oscar Dominguez's *Nostalgia of Space* is a Surrealist dream turning into a Surrealist nightmare. Moreover, the latter is a painting for intimate contemplation and private reverie; the former was meant to be seen on the big screen and to be enjoyed as a collective experience. These two works of art would not normally be mentioned in the same breath, nor are reproductions of them likely to be placed side by side in any context but this, but, curiously, the tension created between a reconstruction of the past that seems to suggest unlimited possibilities in the future—*Stagecoach*—and the poetic inversion of entanglement and freedom of motion that metaphorically evokes a longing for unhindered imagining—*Nostalgia of Space*—represent coordinates along which one can chart the mood of Europe and America in 1939. That one image is outward looking, the other inward turning; one American, the other European, further refines the comparison.

America's isolationist tendencies and the nation's fears that its Garden of Eden was full of snakes were vividly dramatized by Victor Fleming's *The Wizard of Oz* (p. 114), in which the naïve farm girl, Dorothy, travels to a world bigger, more wondrous, and more frightening than her own, and is able to leave only after clicking the heels of her ruby-red slippers and reciting the adage, "There's no place like home." One of the first great color feature films, *The Wizard of Oz* is a utopian vision, a prettied-up distopian warning, and a pure product of Hollywood. No less stylized than the costumes and sets of Fleming's fable, Thomas Hart Benton's *Frisky Day* (p. 115) depicts a Plains homestead similar to the one Dorothy leaves in a swirling tornado. The swelling clouds in the distance of the lithograph suggest that tornadoes are not far from the horizon, if only because melodramatic pictorial effects were seldom absent from even the most pastoral of Benton's descriptions of "just plain" folks. Grant Wood's *In the Spring* (p. 165) mirrors Benton's earnest portrayals of rural Americans, while Ben Shahn's *Handball* (p. 164) does the same for urban dwellers. After the more cosmopolitan 1920s, nationalist themes and nationalist styles increasingly preoccupied artists on both sides of the Atlantic, but, as the traces of Italian Renaissance composition in the Shahn and the Italian Baroque attributes of the Benton attest, self-consciously indigenous American styles were already saturated with European traditions.

Hollywood's response to the back-to-basics impulse includes not only *The Wizard of Oz,* but also Frank Capra's *Mr. Smith Goes to Washington* (p. 151). One of the outstanding expressions of Depression-era populism, the film is a parable of innocence lost and regained, in which a well-meaning but unsophisticated man finds himself in Congress amid cynical politicians who nearly destroy his faith in democracy before he finally fights back and proves that the system can work. It is a story that has been replayed many times, but never before or since has this implausible scenario of grass-roots politics against the backdrop of beltway corruption been played out with such believable sincerity. More austere, certainly, but less sentimental is

Ernst Lubitsch (American, born Germany. 1892–1947). *Ninotchka*. 1939. 35mm, black and white, sound, 110 minutes. Acquired from MGM/UA Entertainment Company. Greta Garbo, Melvyn Douglas. See plate on p. 173

Wright Morris's photograph of a Kansas grain elevator (p. 150). This is classicism in the heartland without an obvious moral, but with a keen appreciation of the simple grandeur of vernacular form. It is a democratic picture made with an aesthete's eye.

Even at the height of the regionalist movement the big city continued to fascinate artists and to give rise to myths and archetypes. One example is Raoul Walsh's *The Roaring Twenties* (p. 137). A landmark gangster movie, it ends—as the film still in this book shows—with good finally conquering evil and the "bad guy" hero, James Cagney, dying on the steps of a church in the arms of his lover, played by Gladys George, under the watchful eyes of a cop. Crime wasn't supposed to pay, but the public found it more exciting than the average story of virtue rewarded—with Capra's morality tales being among the great exceptions to that rule—so the artistic challenge to directors and actors alike was to give people an exhilarating, bullet-riddled cinematic ride before the inevitable John Dillinger-style ending. Nobody did this better than Walsh and Cagney. Fernand Léger's *Study II* for *Cinematic Mural* (p. 136) is a European artist's wide-eyed view of Manhattan in its glory, a Cubist homage to American bigness and brassiness. Unlike some of his compatriots who came to this country before or during the war, Léger did not look down on Americans, but wondered whether or not the vigorous modernity he and other School of Paris artists had devoted themselves to imagining might not be becoming a reality on these shores. Even as the hope of avoiding catastrophe in Europe vanished with the collapse of the Hitler-Stalin pact and Germany's and Russia's simultaneous invasion of Poland, Léger remained among those still committed to envisaging a bright and vigorous present.

The hard-boiled but spectacular style of gangster movies had its equivalent in tabloid photography, which sought the thrills of sensation amid metropolitan grit. Austrian-born Arthur Fellig, who became famous in America under the professional name Weegee, offered one of his typically grim pictures of the New York underworld of genuine tough guys, petty crooks, and hard-luck cases, in *Booked on Suspicion of Killing a Policeman* (p. 135). With the tools of his trade ever ready in the trunk of his car, Weegee generally made it his business to arrive at the scene of the crime ahead of the cops, but in this case the suspect has already been collared and booked at the local precinct station. An item for the front page of the picture press, this is everyday human misery for mass consumption, but its blunt realism has the power of a fable. So, too, does Edward Hopper's more contemplative *New York Movie* (p. 134). The usher at the right is lost in thought as the seated audience at the left is lost in the gray specters projected on the screen.

Among the other members of the European avant-garde who, like Léger, spent the war years in America was Salvador Dali. A favorite of high society, Dali designed the lobster jewelry and decorated the model in Horst P. Horst's photograph (p. 125). This collaboration is an example of Surrealism as fashion, with one of the period's great fashion photographers sharing the honors with one of its most gleefully crowd-pleasing painters. Surrealism in architecture can be seen in the beautiful curves and stagelike interior spaces of Paul Nelson's Suspended House (p. 124). While Surrealist art favored organic shapes and sensual surfaces, early Constructivist art tended toward hard geometries and industrial finishes. By the end of the 1930s, however, Constructivist abstraction was marked by an ever greater refinement combined with fewer explicit references to technology, as can be seen in Theodore J. Roszak's *Pierced Circle* (p. 133) as well as in Ben Nicholson's *Painted Relief* (p. 132). Originating in Eastern Europe, Germany, and the Low Countries, Constructivist art was now also in Diaspora, taking hold in Britain in the group around Nicholson and in the United States with artists such as Roszak. There the distance between the Constructivists and the Surrealists collapsed. Among Nicholson's most important contemporaries was the sculptor Henry Moore, whose laced monolith *The Bride* (p. 131) mixes Constructivist lines of force with Surrealist lumps and bumps. The compound, mutant shapes of Yves Tanguy's untitled drawings (p. 130) are like examples from a transformational grammar of biomorphism.

Tanguy was another member of the European avant-garde to take up residence in the United States following the occupation of Paris by the Nazis. Three artists who remained in France were Pablo Picasso, Henri Matisse, and Pierre Bonnard. Bonnard's *Still Life (Table with Bowl of Fruit)* (p. 118) emanates a calm hedonism of such intensity that it is hard to imagine that it was made under the shadow of war, or, indeed, given its radiant color, in any shadow whatsoever. Picasso's etching and aquatint *Woman with Tambourine* (p. 119) makes no reference to political realities, nor, for that matter, does it illustrate an anecdote or portray a person from the artist's life, as was often the case in his work. However, the sense of furious abandon and physical violence are inescapable. This is a dancing woman, not a weeping woman of the kind he painted several years before while working on *Guernica* (1937), but she seems, all the same, to be dancing on the brink. Picasso's four portraits of Dora Maar (p. 120) are, in their way, personal pictures inasmuch as they depict the Surrealist photographer-turned-painter who was Picasso's lover at the time. The combination of graphic boldness and finesse found in these prints bespeak intense emotion separate from the technical requirements of this tour de force of printmaking even as the subtly modulated—rubbed, scraped, and redrawn—surfaces display both tender regard and forceful possession of the medium and the subject.

While Picasso remained in Paris throughout the war, which began in the fall of 1939, Matisse spent much of his time on the Côte d'Azur, not far from where Bonnard had settled. In *Five Women's Faces* (p. 121), Matisse has drawn on a single plate the faces of five women, which, in their simplified filigree lines, might just as well be five variations on the same face. Where Picasso's reiterative prints are suffused with color, Matisse's friezelike white-on-black image is an exercise in tracery light.

Among Picasso's most important paintings of the 1930s is *Night Fishing at Antibes* (p. 147), a complex orchestration of patterned, semi-abstract, almost cartoonish forms. Jean Renoir's film *The Rules of the Game* (p. 146) is a masterwork of comparable, perhaps greater, magnitude. Picasso's picture is playful, disorienting, and violent; Renoir's film is likewise formally intricate, ironic, and death-haunted. In its way, Renoir's film is a kind of social realism played as a classic French farce, an insider's view of a doomed aristocratic way of life. Marcel Carné's *Daybreak* (p. 144) betrays a romantic realism of the lower classes in which the matinee idol Jean Gabin plays the sort of part generally reserved in the United States for tough-guy actors like Humphrey Bogart.

Walker Evans's first mature photographs are dated 1929 (pp. 28, 102); by 1939 he was at work on his census of passengers on the New York City subway, observed unawares and thus unguarded in emotion (p. 145). During the decade in between, he had contributed as much as any other photographer to the recognition that his medium's obstreperous appetite for unembellished fact could be harnessed as visual poetry without being tamed. "Documentary" was the word that was fixed to this main current of advanced photography of the 1930s, but the label is too narrow to encompass at once Evans's cool reserve, Weegee's theater of mayhem and madness, Dorothea Lange's sympathetic message of social reform (p. 139), and the sometimes almost expressionist effects dealt by the German-born Englishman Bill Brandt, who helped to define the prospects of documentary photography in Europe (p. 142). John Vachon's *Mildred Irwin, Entertainer in Saloon at North Platte, Nebraska* (p. 143), in which both the bawdy singer and her audience seem to have come straight from central casting, is yet another example of the seemingly inexhaustible rewards that thirties photographers discovered as they stalked the world of experience.

Helen Levitt's photographs also belong to the documentary tradition, but the strange masked children in *New York* (p. 148) are less social types than actors on a Surrealist stage. Similarly, the untrained artist Bill Traylor's drawing of a man knocking it back as if there were no tomorrow (p. 149) is mysterious and archetypal, but not stereotypical. Morris Hirshfield was also an untrained artist, but not an awkward one. To the contrary, his finely patterned pictures

have an almost hallucinatory quality, and no lack of decorative subtlety. Hirshfield's version of the "All-American Girl" (p. 163) is a throwback, albeit a bit skewed, to Booth Tarkington's vision of Small Town USA. By contrast, Milton Avery's portrait of his wife, the drypoint *Sally with Beret* (p. 162), is the iconic likeness of an independent bohemian woman in a style that rephrased Matisse with New York accents. Compared to the Hirshfield, this Avery print seems the rougher and less finished of the two, underscoring the fact that formal abruptness is frequently an acquired skill while compulsive refinement is often an aesthetically innocent trait. Louis Soutter's *Head* (p. 168) is outsider art at its fiercest. The countenance that stares out at us from the paper is so hypnotic that one begins to feel as if the intensity of the subject's expression must be comparable to that which took possession of the artist while he drew—as if, in effect, we were eyeball to eyeball with his vision. In *War* (p. 169) Arthur Dove symbolizes the explosiveness of armed conflict with an agitated gesture equivalent to that found in Soutter's work, though, as a rule, Dove was not an Expressionist.

Staring eyes are a recurrent motif in art in the 1930s. In Irving Penn's *Optician's Window, New York* (p. 171) they are photographically reframed found objects. Contemporary critics have repeatedly asked the question, "Who's looking?" The answer, insofar as pictorial conventions are concerned, has usually been "a man." In Paul Delvaux's *Phases of the Moon* (p. 170), where eyeglasses are used to accent optical possession and two male figures seem to be ignoring the nude woman seated on the balcony, the implicit gaze is undeniably male. The game of sexual perspectives is also played in Manuel Alvarez Bravo's photograph of a semi-nude model lying on the ground next to a spiky cactus. The ironic title, *The Good Reputation Sleeping* (p. 122), suggests that she is the embodiment of chastity. But as she is sleeping (and dreaming, in the Surrealist way of things—the picture was commissioned by the doyen of Surrealism, André Breton) is her virtue in oneiric abeyance and her sensuality available to the viewer/voyeur? Leonora Carrington's book *La Dame ovale* (p. 123) is a work of Surrealism by a woman, but the Max Ernst illustration of a cycloptic octopus that graces the frontispiece hardly seems emblematic of female sexual fantasy.

Piet Mondrian's paintings are by no means representations of the grid layout of the modern city, but the rhythms of their crisscrossing lines and expanding and contracting color blocks do vibrate with urban syncopation. The same year that Mondrian completed *Composition in Red, Blue, and Yellow* (p. 154), he made the correlation between pure abstract painting, jazz, and the city explicit as he began work on his most important New York painting, *Broadway Boogie Woogie* (also in the Museum's collection but ineligible for inclusion here because it is dated 1942–43). Georges Vantongerloo's sinuous abstraction *Relation of Lines and Colors* (p. 126) is Mondrian unsprung. In it one can see the curves and arabesques typical of Surrealism, but wholly divested of bodily connotations. The B.K.F. Chair, designed by Antonio Bonet, Juan Kurchan, and Jorge Ferrari Hardoy (p. 127), represents, in a similar fashion, a halfway point between Surrealist biomorphism and geometric abstraction. It is an object in which topological geometry of pliant surfaces supplants Euclidean geometry of rigid planes. A kind of visual syncopation can also be seen in Len Lye's *Swinging the Lambeth Walk* (p. 158), and while Ad Reinhardt's painting studies for the Works Progress Administration (p. 159) should not be read as sequential images, scanning them left to right does animate these forms in a nearly cinematic way. Analyzing motion into discrete bits that together capture the sweep of an action, Harold E. Edgerton's photograph *Swirls and Eddies of a Tennis Stroke* (p. 161) mimics the visual stutter and blur of the moving picture *Swinging the Lambeth Walk*. Alexander Calder, meanwhile, gave static sculpture a spin, replacing the enclosed forms and masses of the modeler and carver with the open contours and floating facets of the engineer (p. 160). All it takes is a gentle breeze for Calder's cascading shapes to inscribe transparent volumes in space.

Aristide Maillol's *The River* (p. 179) is dense, monumental sculpture at its most extreme—although she, too, fights gravity. With his penchant for heavy forms and neoclassical articulations,

Maillol was, in effect, the anti-Calder. Ernesto Bruno La Padula's Palace of Italian Civilization, Rome (p. 178) describes a visionary neoclassicism in which Maillol's sculpture might well have felt at home. With its Romanesque arcades and domineering scale, it is the abstract modern grid reclad in a historical facade. George Platt Lynes's photograph of the blindfolded nude George Tichnor (p. 176) is eroticized neoclassicism in another medium. Pavel Tchelitchew, a member of Lynes's artistic circle, pushed neoclassical drawing toward the romantic and the grotesque (p. 177). The reclining nude in Lynes's photograph seems lost in reverie; Tchelitchew's drawing might be the specter rising in his imagination.

In 1939 Ludwig Mies van der Rohe, recently arrived in the United States, deployed the clarity and geometric simplicity of International Style architecture on a grander scale at the Illinois Institute of Technology than he had achieved in his native Germany (p. 128). The Philip L. Goodwin and Edward D. Stone design for The Museum of Modern Art (p. 184) is a compromise between the transforming vision of the International Style and the conservative style of building of which La Padula's Palace of Italian Civilization is the hypothetical extreme. Marcel Duchamp's *Box in a Valise* (p. 185) is a portable museum whose exotic and very avant-garde treasures are concealed inside a relatively ordinary-looking attaché case. One of the ironies of Duchamp's career was his wry antagonism toward what he called "retinal art" and his subversive treatments of the institutional art object. Yet by advising The Museum of Modern Art on the purchase of paintings, and by assiduously cataloging and conserving images of his own work, Duchamp was, in fact, the ultimate museum man.

The works of David Alfaro Siqueiros and David Smith embody, in their separate ways, the conflicts that swirled around and threatened to engulf modern art in the late 1930s. Conservative in its draftsmanship, radical in its painterly techniques and subject matter, Siqueiros's *Ethnography* (p. 180) reflects the artist's aesthetic ambivalence and personifies the dualism of Mexican identity—the all-pervasive reality of poverty coupled with an awareness of the strength of the indigenous culture represented, in this case, by a campesino wearing a pre-Columbian mask symbolic of his country's ancient glory. David Smith's *Death by Gas* from the series of fifteen bronze reliefs titled Medals for Dishonor (p. 181) is a premonition of worldwide disaster. Almost cartoonlike in its violence, it is a reminder of Smith's debt to Surrealism—a debt sometimes downplayed by latter-day modernists—and of the eloquent vulgarity that is often a feature of modern art of the highest order. Even as war threatened at any moment to break out, Smith persisted in the belief that "masterpieces are made today."

▲ **Oscar Dominguez** (French, born Spain. 1906–1957). *Nostalgia of Space*. 1939. Oil on canvas, 28¾ x 36⅛" (73 x 91.8 cm). Gift of Peggy Guggenheim

▶ **John Ford** (American, 1895–1973). *Stagecoach*. 1939. 35mm, black and white, sound, 92 minutes

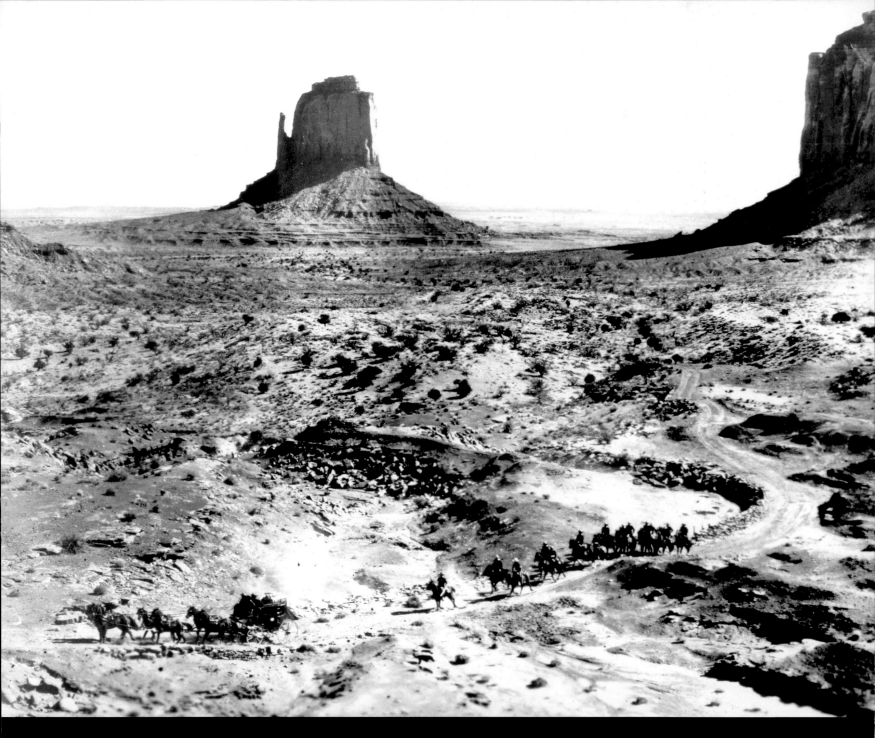

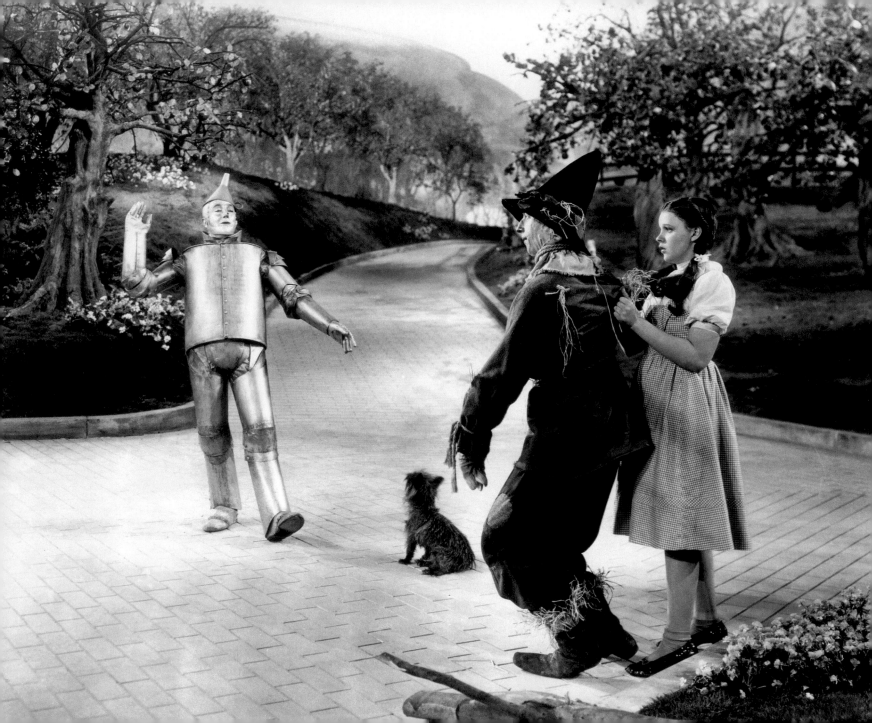

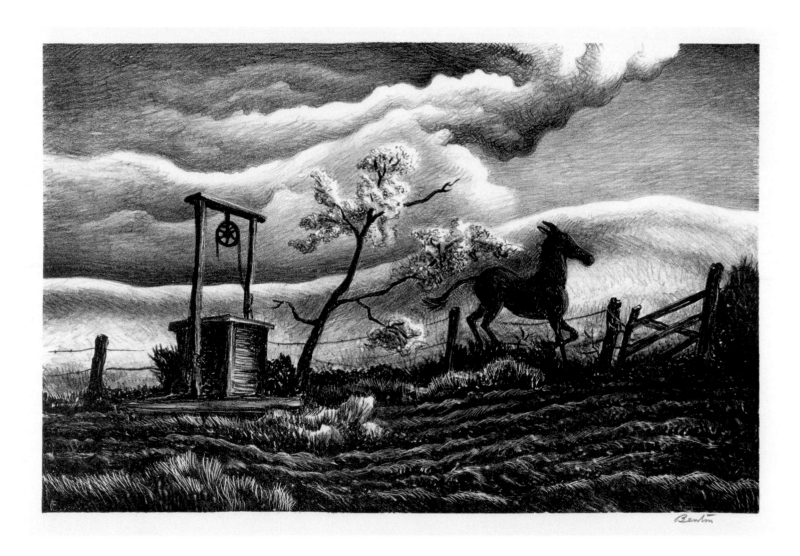

▲ **Thomas Hart Benton** (American, 1889–1975). *Frisky Day*. 1939. Lithograph, 7 13/16 x 12 1/16" (19.9 x 30.7 cm). Publisher: Associated American Artists, New York. Printer: George Miller, New York. Edition: 250. Gift of Kathleen L. Westin

◀ **Victor Fleming** (American, 1883–1949). *The Wizard of Oz*. 1939. 35mm, black and white and color, sound, 101 minutes. Jack Haley, Ray Bolger, Judy Garland

◀ **William Wyler** (American, 1902–1981). *Wuthering Heights*. 1939. 35mm, black and white, sound, 104 minutes. Lawrence Olivier, Merle Oberon

▼ **Victor Fleming** (American, 1883–1949). *Gone with the Wind*. 1939. 35mm, color, sound, 220 minutes. Clark Gable, Vivian Leigh

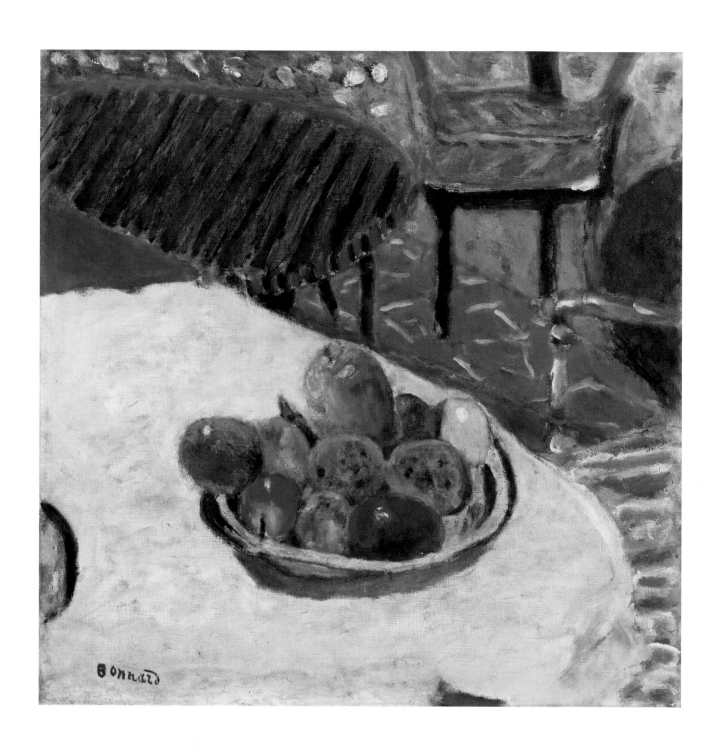

▲ **Pablo Picasso** (Spanish, 1881–1973). *Woman with Tambourine*. State V. 1939, published 1943. Etching and aquatint, sheet 30⅛ x 22¼" (76.5 x 56.5 cm). Publisher: Galerie Louise Leiris, Paris. Printer: Lacourière, Paris. Edition: 30. Acquired through the Lillie P. Bliss Bequest

◀ **Pierre Bonnard** (French, 1867–1947). *Still Life (Table with Bowl of Fruit)*. 1939. Oil on canvas, 21 x 20⅞" (53.3 x 53 cm). The William S. Paley Collection

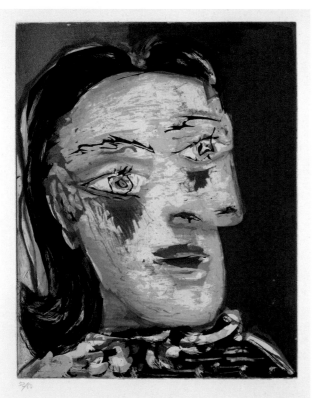

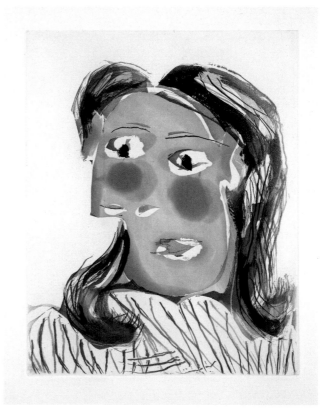

Henri Matisse (French, 1869–1954). *Five Women's Faces*. 1939. Aquatint, 2 x 9¾" (5.1 x 24.8 cm). Edition: 20. Peter H. Deitsch Bequest

top left:
Pablo Picasso (Spanish, 1881–1973). *Head of Woman No. 2, Portrait of Dora Maar*. 1939. Aquatint and drypoint, 11⁹⁄₁₆ x 9⅜" (29.8 x 23.7 cm). Publisher: Ambroise Vollard, Paris. Printer: Lacourière, Paris. Edition: 80. Richard A. Epstein Fund, Miles O. Epstein Fund, Sarah C. Epstein Fund, Philip and Lynn Straus Foundation Fund, and the Robert and Anna Marie Shapiro Fund

bottom left:
Pablo Picasso. *Head of Woman No. 4, Portrait of Dora Maar*. 1939. Aquatint, 11⅞ x 9⁷⁄₁₆" (30.1 x 24 cm). Publisher: Ambroise Vollard, Paris. Printer: Lacourière, Paris. Edition: 80. Gift of Mrs. Melville Wakeman Hall

top right:
Pablo Picasso. *Head of Woman No. 5, Portrait of Dora Maar*. 1939. Aquatint and drypoint, 11¾ x 9⁵⁄₁₆" (29.8 x 23.8 cm). Publisher: Ambroise Vollard, Paris. Printer: Lacourière, Paris. Edition: 80. Lily Auchincloss Fund and The Riva Castleman Endowment Fund

bottom right:
Pablo Picasso. *Head of Woman No. 6, Portrait of Dora Maar*. 1939. Aquatint, 11¾ x 9⁵⁄₁₆" (29.8 x 23.6 cm). Publisher: Ambroise Vollard, Paris. Printer: Lacourière, Paris. Edition: 80. Gift of the Associates of the Department of Prints and Illustrated Books

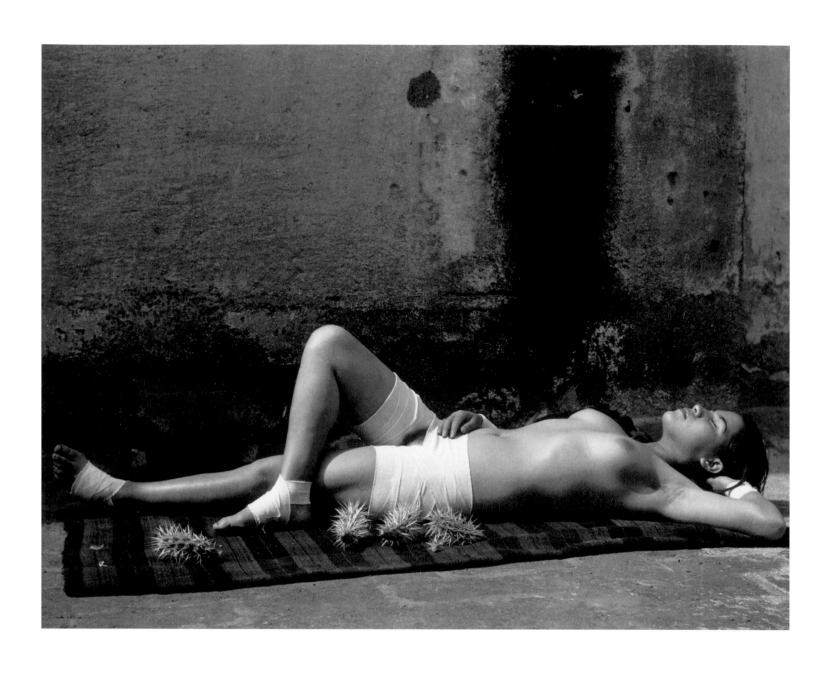

◄ **Manuel Alvarez Bravo** (Mexican, born 1902). *The Good Reputation Sleeping*. 1939. Gelatin silver print, 7 ¼ x 9 ⁵⁄₁₆" (18.4 x 23.7 cm). Purchase

▼ **Max Ernst** (French, born Germany. 1891–1976). Frontispiece from *La Dame ovale* by Leonora Carrington. Paris: GLM [Guy Lévis Mano], 1939. Photolithographic reproduction after collage, page 7 ½ x 5 ½" (19 x 14 cm). Printer: G. L. M. [Guy Lévis Mano], Paris. Edition: 535. William K. Simpson Fund (in memory of Abby Aldrich Rockefeller)

LEONORA CARRINGTON

LA
DAME
OVALE

AVEC SEPT COLLAGES
PAR MAX ERNST

GLM 1939

▶ **Horst P. Horst** (American, 1906–1999). *Costume for Salvador Dali's "Dream of Venus."* 1939. Gelatin silver print, 10 x 7 ½" (25.4 x 19 cm). Gift of James Thrall Soby

▼ **Paul Nelson** (American, 1895–1979). Suspended House. 1936–38 (model, 1939). Model: metal, plastic, and wood, 28 ½ x 36 ½ x 13 ½" (72.4 x 92.7 x 34.3 cm). Mural studies by Joan Miró and Fernand Léger and sculpture by Alexander Calder. Modelmaker: L. Dalbet. Gift of the Advisory Committee

Georges Vantongerloo (Belgian, 1886–1965). *Relation of Lines and Colors*. 1939. Oil on composition board, 28⅝ x 21" (72.6 x 53.3 cm). The Riklis Collection of McCrory Corporation

Antonio Bonet (Spanish, 1913–1989), **Juan Kurchan** (Argentinian, 1913–1975), and **Jorge Ferrari Hardoy** (Argentinian, 1914–1977). B.K.F. Chair. 1939.
Painted wrought-iron rod and leather, 34⅜ x 32¾ x 30" (87.5 x 83.2 x 76.2 cm). Manufacturer: Artek-Pascoe, Inc., USA. Edgar Kaufmann, Jr. Purchase Fund

▲ **Ludwig Mies van der Rohe** (American, born Germany. 1886–1969). Illinois Institute of Technology, Chicago, Illinois. Site plan, early scheme. 1939. Pencil on illustration board, 30 x 40" (76.1 x 101.5 cm). Gift of the architect

▶ **Erik Gunnar Asplund** (Swedish, 1885–1940). Woodland Crematorium, Stockholm, Sweden. 1935–40. Exterior elevation. 1937. Graphite on tracing paper, 11⅝ x 33" (29.5 x 83.8 cm). Purchase

clockwise from top left:

Yves Tanguy (American, born France.
1900–1955). *Untitled*. 1939. Pen and ink on
paper, 12⅜ x 9" (31.4 x 23.1 cm). Kay Sage
Tanguy Bequest

Yves Tanguy. *Untitled*. 1939. Pen and ink on
paper, 12⅝ x 10¼" (32.2 x 26.2 cm). Kay Sage
Tanguy Bequest

Yves Tanguy. *Untitled*. 1939. Pen and ink on
paper, 12¼ x 9" (31.3 x 23 cm). Kay Sage
Tanguy Bequest

Yves Tanguy. *Untitled*. 1939. Pen and ink on
paper, 12¼ x 9" (31.3 x 23 cm). Kay Sage
Tanguy Bequest

▶ **Henry Moore** (British, 1898–1986). *The Bride*.
1939–40. Cast lead and copper wire, 9⅜ x 4⅛ x
4" (23.8 x 10.3 x 10 cm). Acquired through the
Lillie P. Bliss Bequest

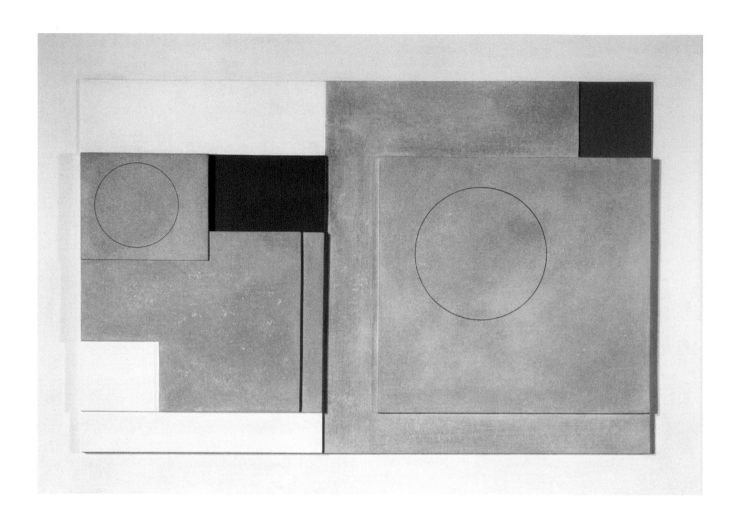

▲ **Ben Nicholson** (British, 1894–1982). *Painted Relief*. 1939. Oil and pencil on composition boards mounted on painted plywood, 32⅞ x 45"
(83.5 x 114.3 cm). Gift of H.S. Ede and the artist (by exchange)

▶ **Theodore J. Roszak** (American, born Poland. 1907–1981). *Pierced Circle*. 1939. Painted wood, plexiglass, and wire, 24 x 23⅞ x 4½"
(60.8 x 60.6 x 11.4 cm). The Riklis Collection of McCrory Corporation

◀ **Edward Hopper** (American, 1882–1967). *New York Movie*. 1939. Oil on canvas, 32 ¼ x 40 ⅛" (81.9 x 101.9 cm). Given anonymously

▼ **Weegee** (Arthur Fellig; American, born Austria. 1899–1968). *Booked on Suspicion of Killing a Policeman*. 1939. Gelatin silver print, 13 ⁹⁄₁₆ x 10 ⅝" (34.4 x 27 cm). Purchased with funds given by Mrs. Armand P. Bartos

Fernand Léger (French, 1881–1955). *Study II* for *Cinematic Mural*. 1938–39. Gouache, pen and ink, pencil and wash on cardboard, 19¾ x 15" (50.2 x 38 cm). Given anonymously

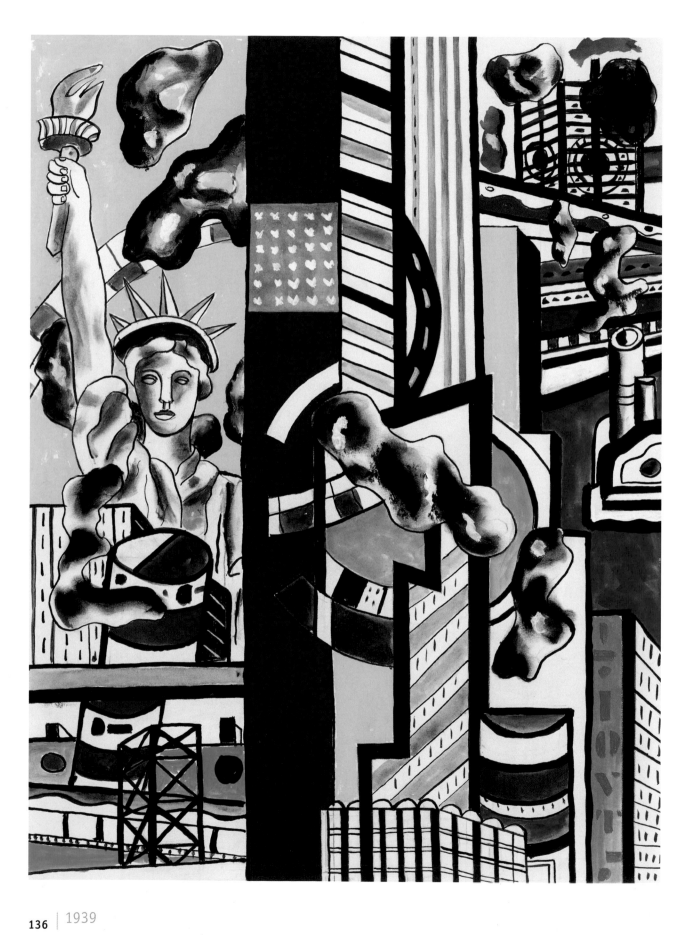

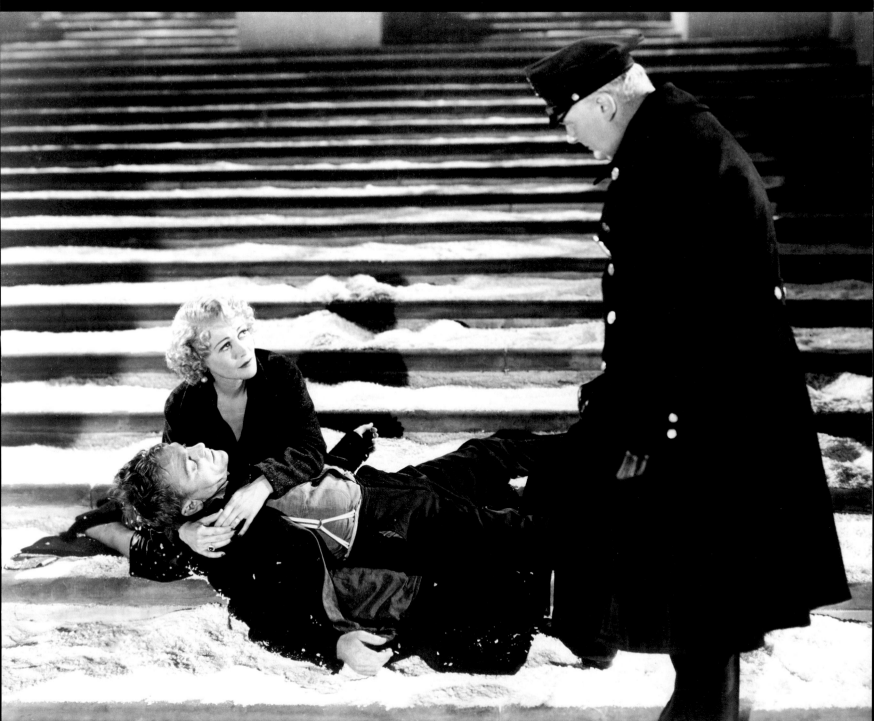

▶ **Dorothea Lange** (American, 1895–1965). *Child and Her Mother, Wapato, Yakima Valley, Washington*. 1939. Gelatin silver print, 7 11/16 x 9 3/8" (19.6 x 23.9 cm). Purchase

▼ **Grigori Kozintzev** (Russian, 1905–1973) and **Leonid Trauberg** (Russian, 1902–1990). *The Vyborg Site (Vyborkskaya Storona)*. 1939. 35mm, black and white, sound, 120 minutes. Exchange with Gosfilmofond

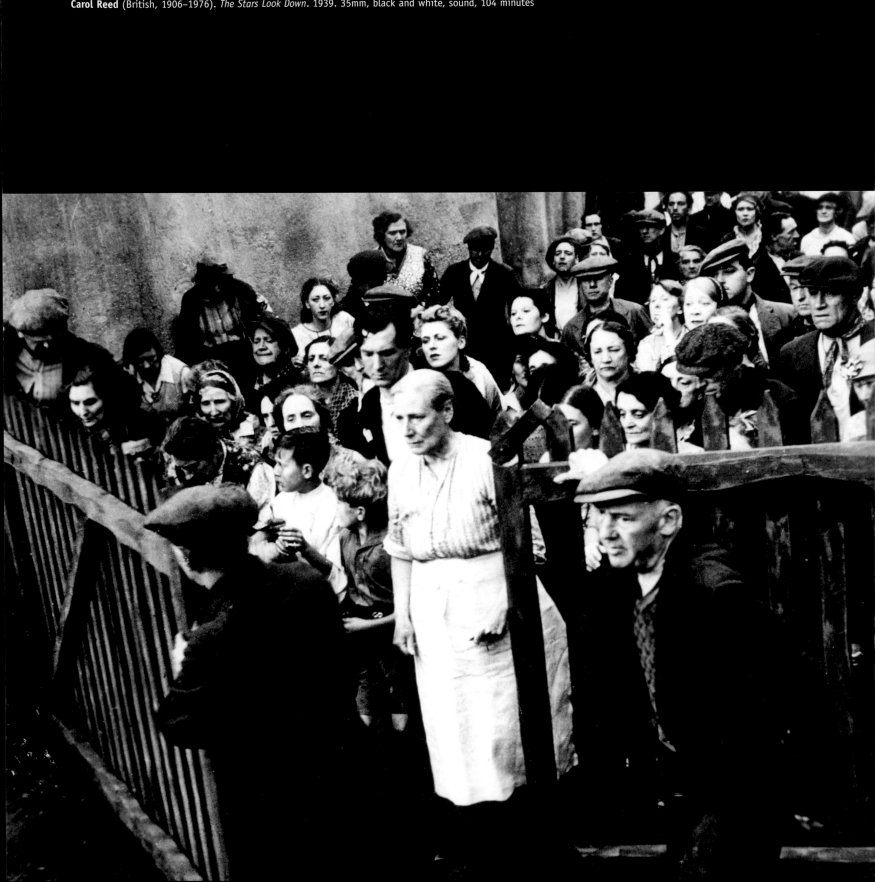

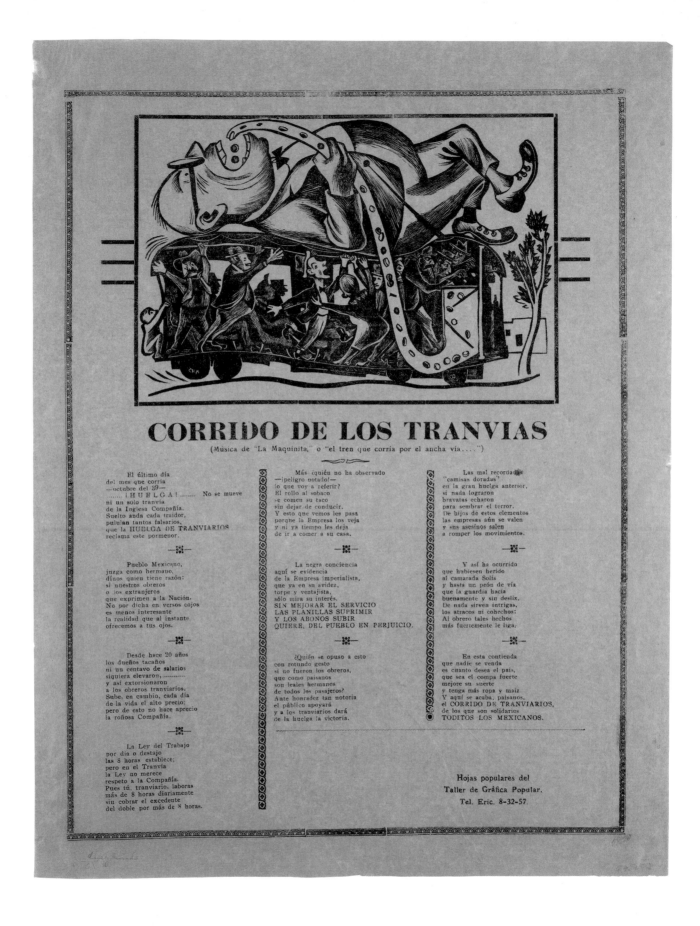

José Chávez Morado (Mexican, born 1909). *Ballad of the Street Cars*. 1939. Linoleum cut, sheet 17³⁄₁₆ x 13³⁄₁₆" (43.5 x 33.5 cm). Publisher and Printer: Taller de Gráfica Popular, Mexico City. Inter-American Fund

◀ **Bill Brandt** (British, born Germany. 1904–1983). *Prisoner in a Cell at Wormwood Scrubb*s. 1939. Gelatin silver print, 14 x 11¹⁵⁄₁₆" (35.5 x 30.4 cm). Purchase

▼ **John Vachon** (American, 1914–1975). *Mildred Irwin, Entertainer in Saloon at North Platte, Nebraska.* c. 1939. Gelatin silver print, 9¾ x 13³⁄₁₆" (24.7 x 33.5 cm). Gift of the photographer

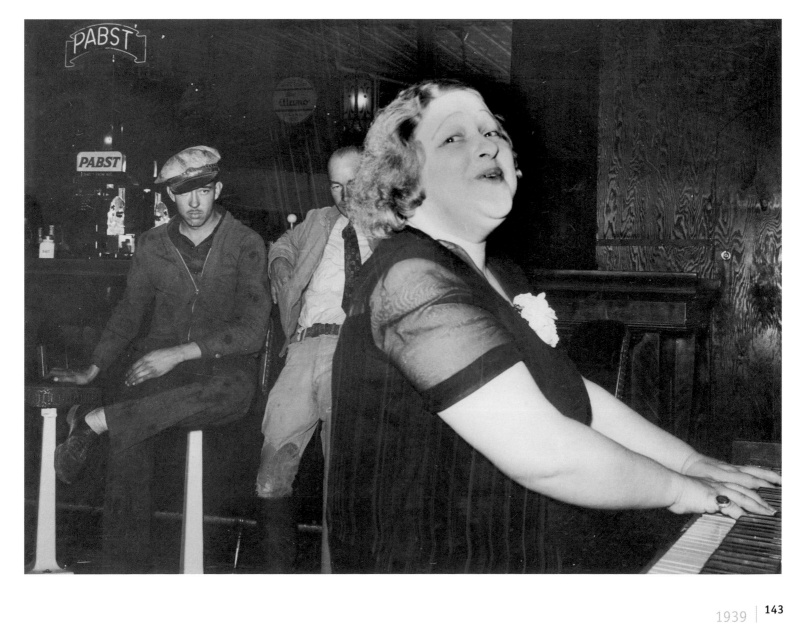

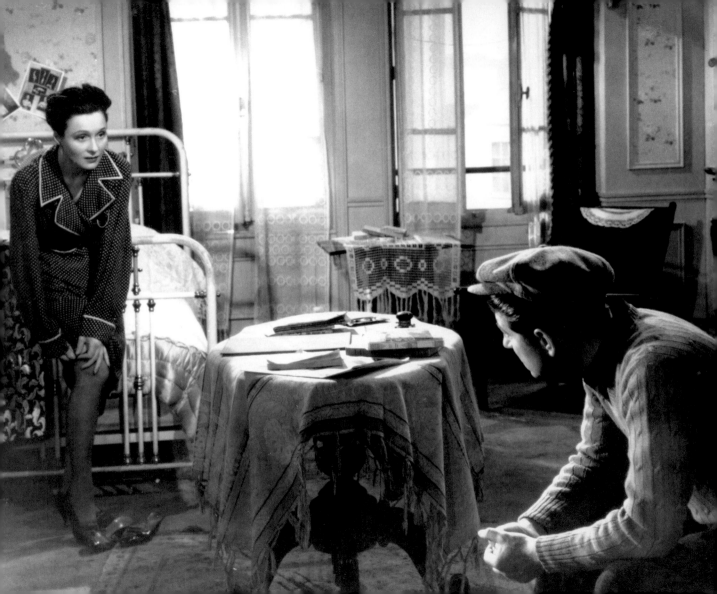

◄ **Marcel Carné** (French, 1909–1996). *Daybreak (Le Jour se lève)*. 1939. 35mm, black and white, sound, 93 minutes. Acquired from Cinémathèque Française. Arletty, Jean Gabin

▼ **Walker Evans** (American, 1903–1975). *Subway Portrait*. 1938–41. Gelatin silver print, 6�5/16 x 7½" (17.6 x 19.1 cm). Purchase

Jean Renoir (American, born France. 1894–1979). *The Rules of the Game (La Règle du jeu)*. 1939. 35mm, black and white, sound, 106 minutes. Gift of Janus Films. Jean Renoir, Nora Grégor, Paulette Dubost

Pablo Picasso (Spanish, 1881–1973). *Night Fishing at Antibes*. 1939. Oil on canvas, 6' 9" x 11' 4" (205.8 x 345.4 cm). Mrs. Simon Guggenheim Fund

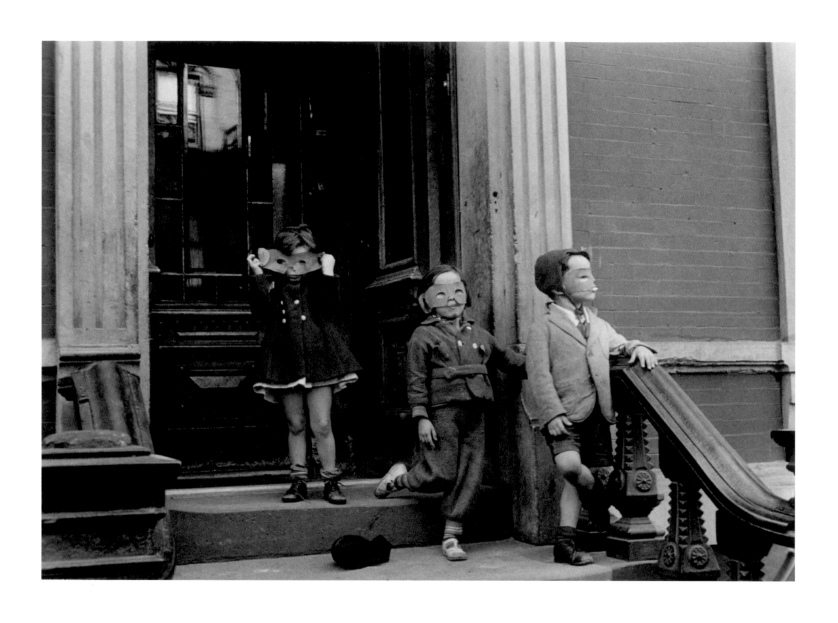

◀ **Helen Levitt** (American, born 1913). *New York*. 1939. Gelatin silver print, 6 ½ x 8 ⅞" (16.6 x 22.5 cm). Anonymous gift

▼ **Bill Traylor** (American, 1854–1947). *Arched Drinker*. c. 1939–42. Watercolor and pencil on cardboard, 14 x 13 ¾" (35.6 x 35 cm) (irreg.). Gift of Mr. and Mrs. Henry R. Kravis

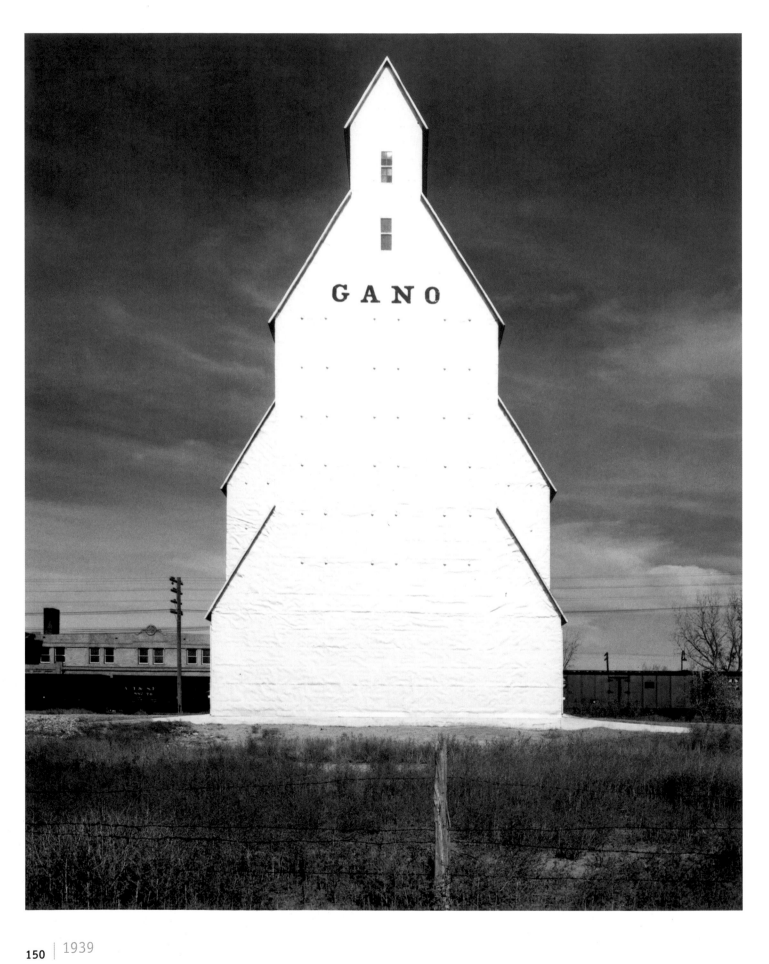

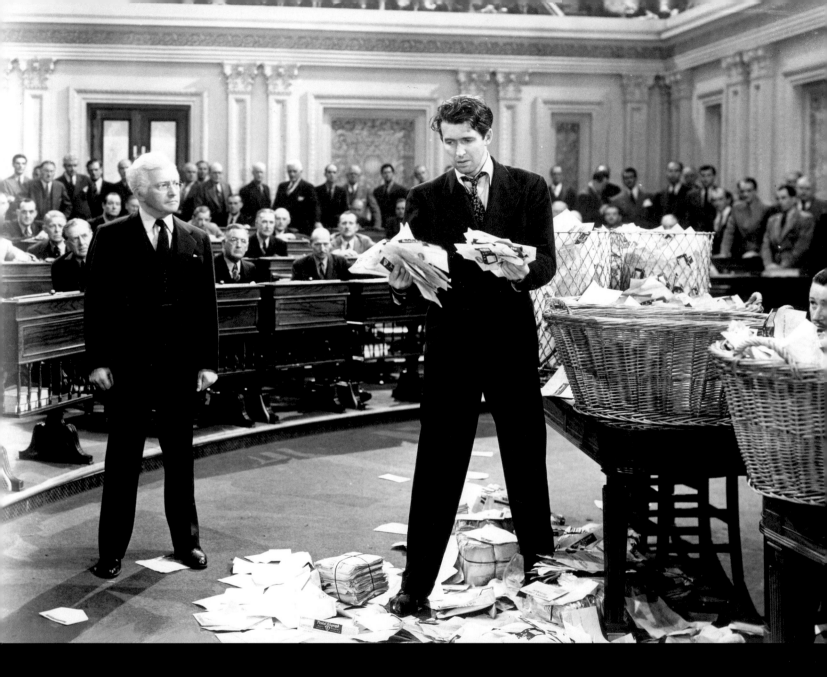

Frank Capra (American, born Italy. 1897–1991). *Mr. Smith Goes to Washington*. 1939. 35mm, black and white, sound, 120 minutes. Acquired from Columbia Pictures. Claude Rains, James Stewart

◄ **Wright Morris** (American, 1910–1998). *Gano Grain Elevator, Western Kansas*. 1939. Gelatin silver print, 9½ x 7¾" (24.1 x 19.7 cm). Purchase

Frank Lloyd Wright (American, 1867–1959). Desk. 1936–39. Wood and painted metal, 28 x 66 x 32" (71.2 x 167.6 x 81.3 cm). Manufacturer: Metal Office Furniture Co. (presently Steelcase, Inc.), New York. Designed for S. C. Johnson & Son, Inc. Administration Building, Racine, Wisconsin. Lily Auchincloss Fund

Charles Sheeler (American, 1883–1965). *Wheels.* 1939. Gelatin silver print, 6⅝ x 9⅝" (16.8 x 24.4 cm). Anonymous gift

Piet Mondrian (Dutch, 1872–1944). *Composition in Red, Blue, and Yellow*. 1937–42. Oil on canvas, 23¾ x 21⅞" (60.3 x 55.4 cm). The Sidney and Harriet Janis Collection

► **Morris Graves** (American, born 1910). *Bird Singing in the Moonlight*. 1938–39. Tempera and watercolor on Japanese paper, 26¾ x 30⅛" (68 X 76.5 cm) (irreg.). Purchase

▼ **Eugen Wiškovský** (Czech, 1888–1964). *Hill*. 1939. Gelatin silver print, 10½ x 15⁷⁄₁₆" (26.7 x 39.2 cm). Purchase

◀ **Len Lye** (New Zealander, 1901–1980). *Swinging the Lambeth Walk*. 1939. 35mm, color, sound, 4 minutes. Acquired from Travel and Industrial Development Association of Great Britain and Ireland

▼ clockwise from top left:
Ad Reinhardt (American, 1913–1967). *Study for a Painting*. 1939. Gouache on paper, 3⅞ x 5" (10 x 12.6 cm). Gift of the artist

Ad Reinhardt. *Study for a Painting*. 1939. Gouache and pencil on paper, 3⅞ x 4⅞" (10 x 12.5 cm). Gift of the artist

Ad Reinhardt. *Study for a Painting*. 1939. Gouache on paper, 3⅞ x 4⅞" (10 x 12.5 cm). Gift of the artist

◁ **Alexander Calder** (American, 1898–1976). *Lobster Trap and Fish Tail.* 1939. Hanging mobile: painted steel wire and sheet aluminum, about 8' 6" h. x 9' 6" diam. (260 x 290 cm). Commissioned by the Advisory Committee for the stairwell of the Museum, 1939

▽ **Harold E. Edgerton** (American, 1903–1990). *Swirls and Eddies of a Tennis Stroke.* 1939. Gelatin silver print, 6¾ x 9¾" (17.2 x 24.7 cm). Gift of the photographer

▶ **Morris Hirshfield** (American, born Russian Poland. 1872–1946). *Beach Girl.* 1937–39 (dated on canvas 1937). Oil on canvas, 36 ¼ x 22 ¼" (91.8 x 56.3 cm). The Sidney and Harriet Janis Collection

▼ **Milton Avery** (American, 1893–1965). *Sally with Beret.* 1939. Drypoint, 8 x 6 ½" (20.4 x 16.5 cm). Edition: 100. Lily Auchincloss Fund in honor of Joanne Stern

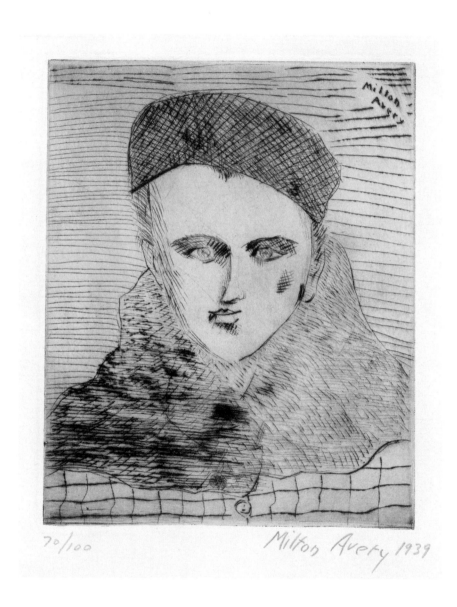

70/100 Milton Avery 1939

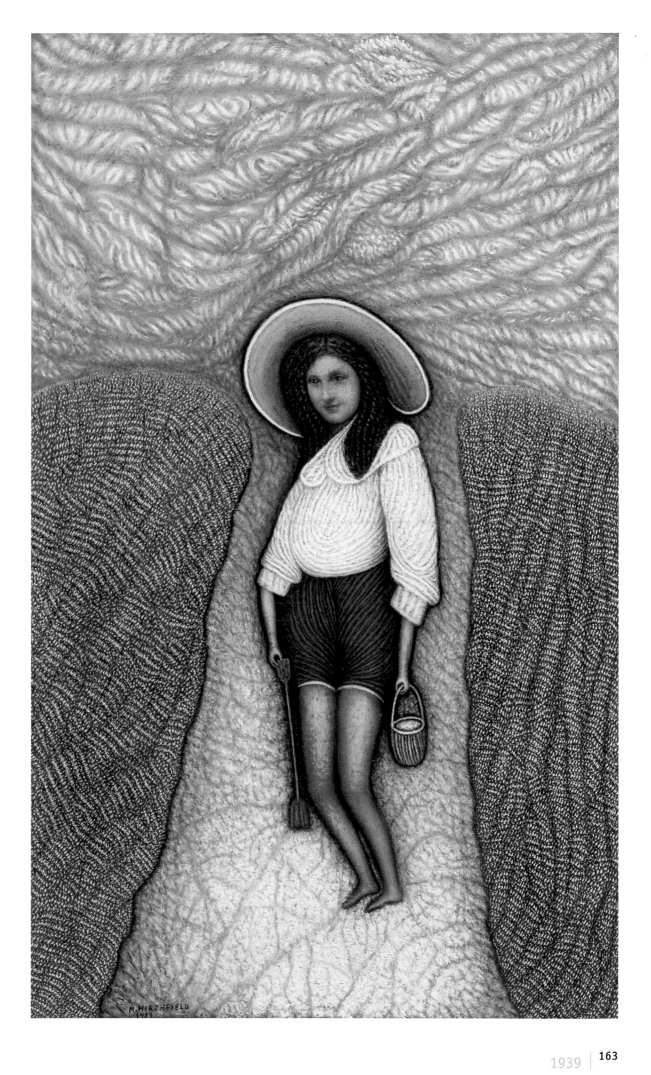

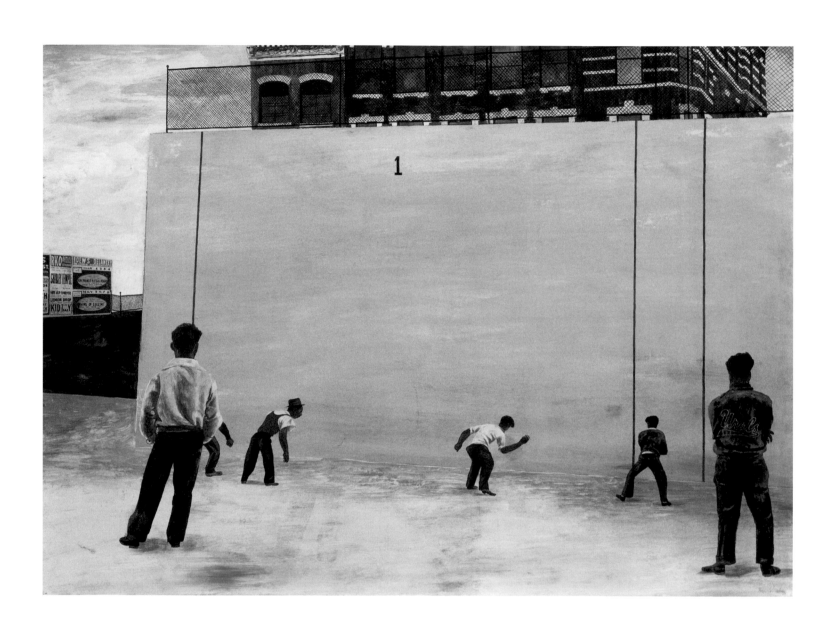

Ben Shahn (American, born Lithuania. 1898–1969). *Handball.* 1939. Tempera on paper mounted on composition board, 22¾ x 31¼" (57.8 x 79.4 cm). Abby Aldrich Rockefeller Fund

Grant Wood (American, 1892–1942). *In the Spring.* 1939. Lithograph, 9 x 11¹⁵⁄₁₆" (22.9 x 30.4 cm). Publisher: Associated American Artists, New York. Printer: George Miller, New York. Edition: 250. Gift of Kathleen L. Westin

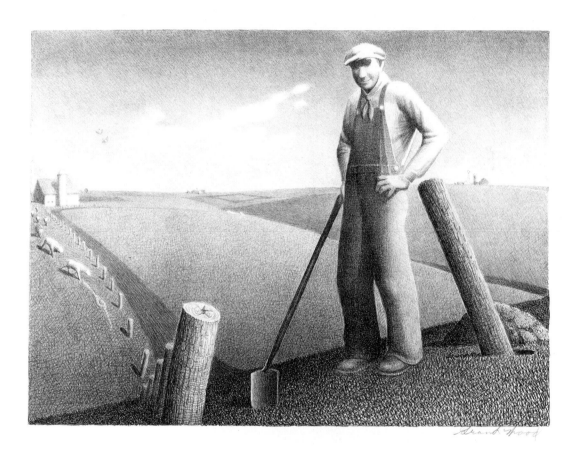

▶ **Yves Tanguy** (American, born France. 1900–1955). *The Furniture of Time*. 1939. Oil on canvas, 46 x 35¼" (116.7 x 89.4 cm). James Thrall Soby Bequest

▼ **Edward Weston** (American, 1886–1958). *Rubber Dummies, Metro Goldwyn Mayer, Hollywood*. 1939. Gelatin silver print, 7 9/16 x 9 5/8" (19.3 x 24.4 cm). Gift of Edward Steichen

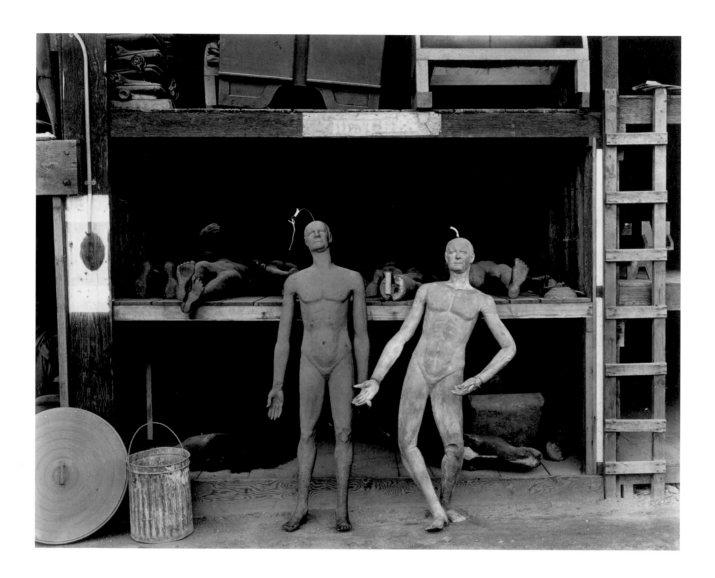

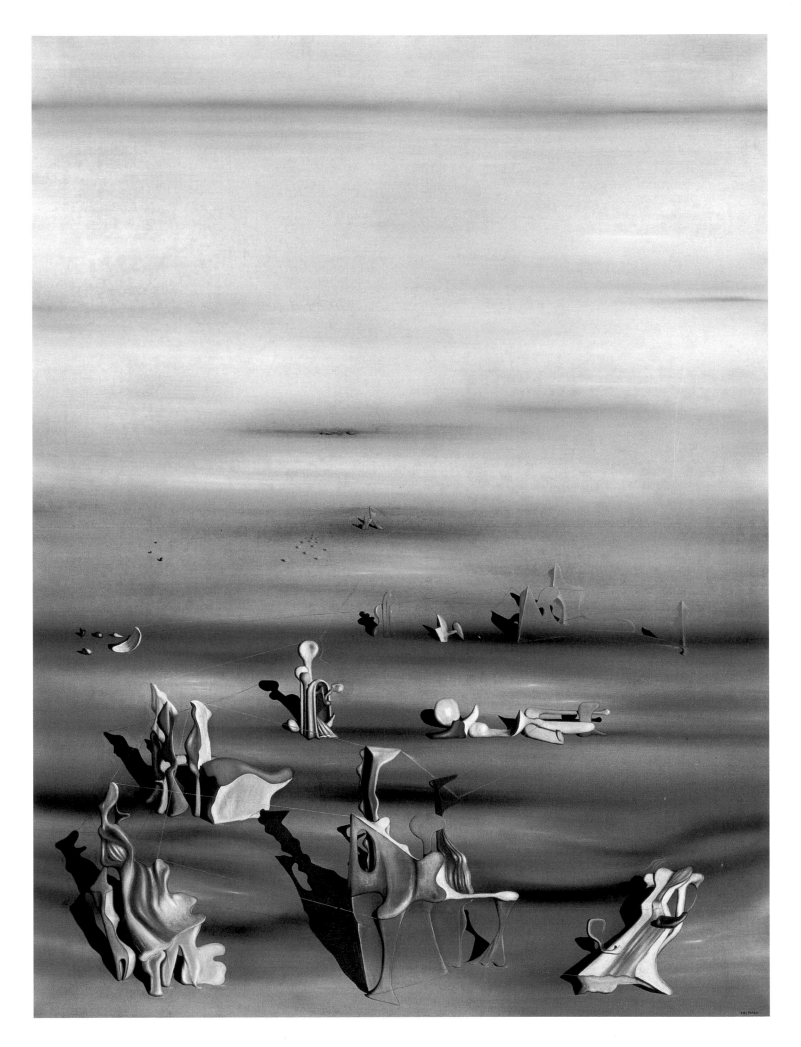

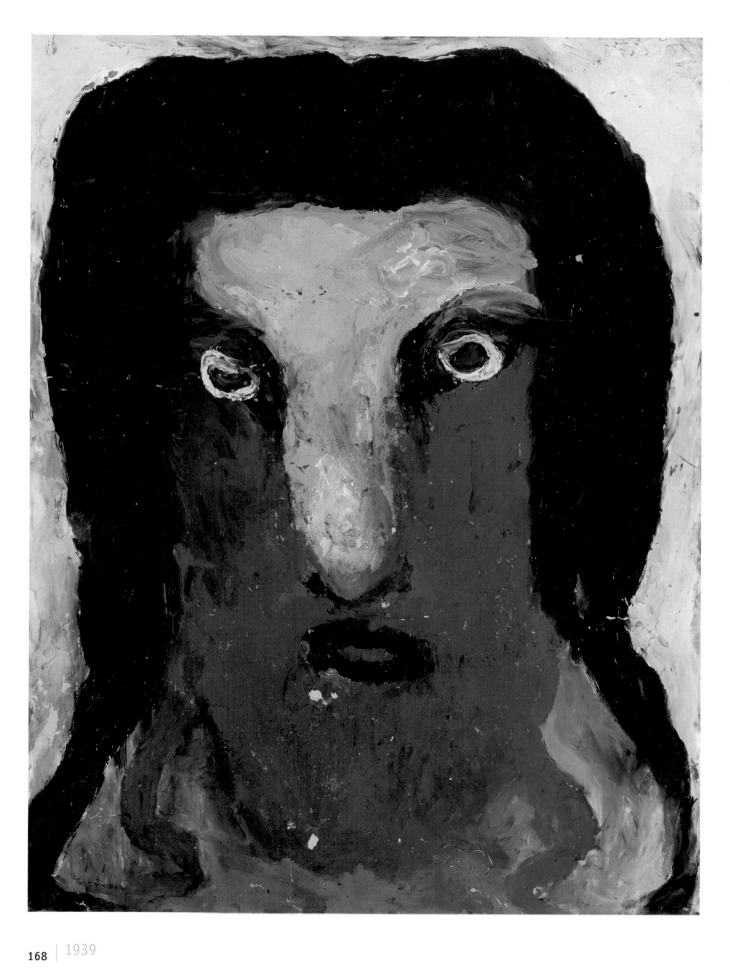

▲ **Arthur Dove** (American, 1880–1946). *War.* 1939. Gouache and aluminum leaf on paper, 7 x 5" (17.8 x 12.7 cm). Given anonymously (by exchange)

◄ **Louis Soutter** (Swiss, 1871–1942). *Head.* 1939. Oil on paper, 25⅝ x 19¾" (65.7 x 50.2 cm). Gift of the artist

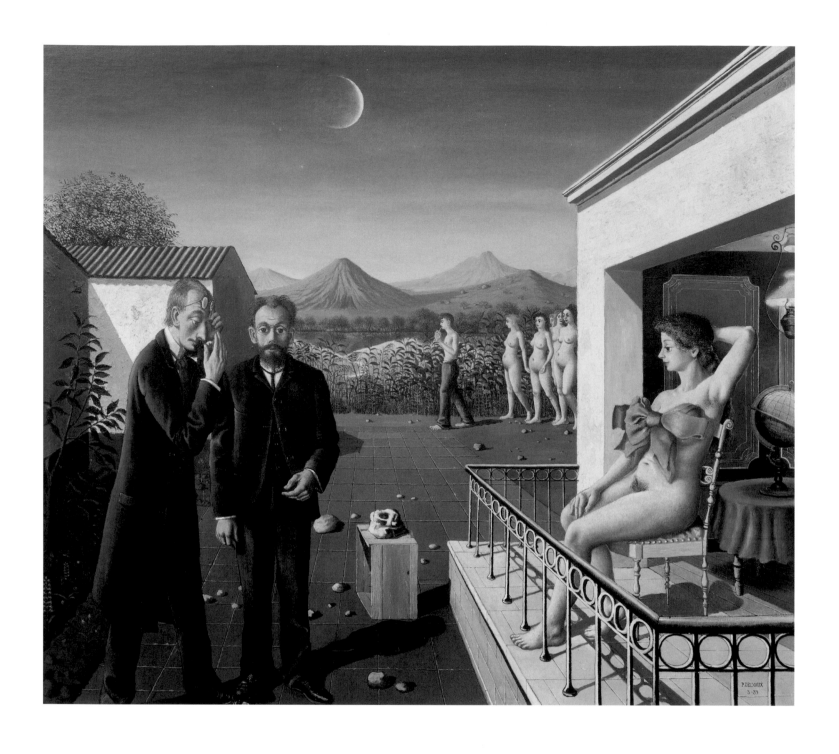

Paul Delvaux (Belgian, 1897–1994). *Phases of the Moon*. 1939. Oil on canvas, 55 x 63" (139.7 x 160 cm). Purchase

Irving Penn (American, born 1917). *Optician's Window, New York*. 1939. Gelatin silver print, 9⅜ x 7⅜" (23.9 x 18.8 cm). Purchase

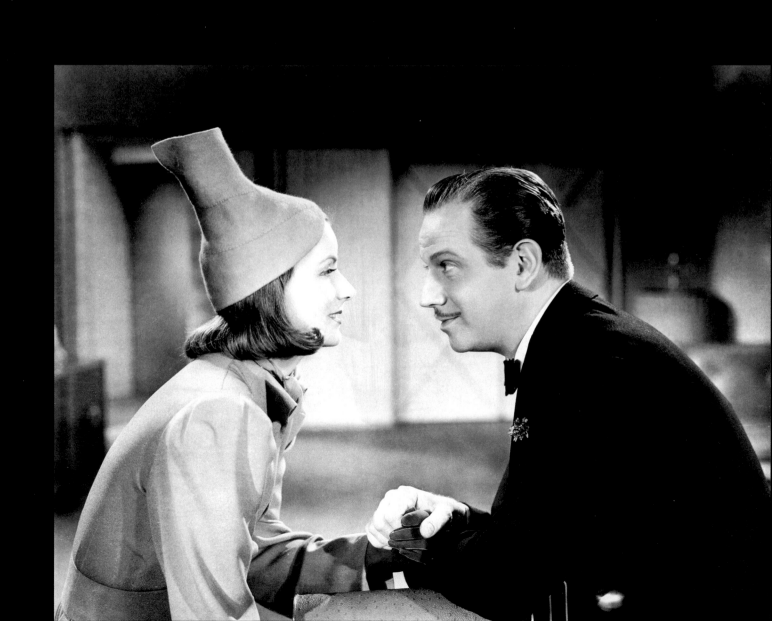

▶ **Asger Jorn** (Danish, 1914–1973). *Untitled*. 1939. Etching, 5 7⁄16 x 3 13⁄16" (13.8 x 9.7 cm). Printer: the artist, Copenhagen. Edition: 15. Gift of the artist

▼ **André Masson** (French, 1896–1987). *Prisoner of the Mirror: Transfiguring Your Death*. 1939. Pen and ink on paper, 18 7⁄8 x 24 3⁄4" (47.9 x 82.9 cm). Purchase

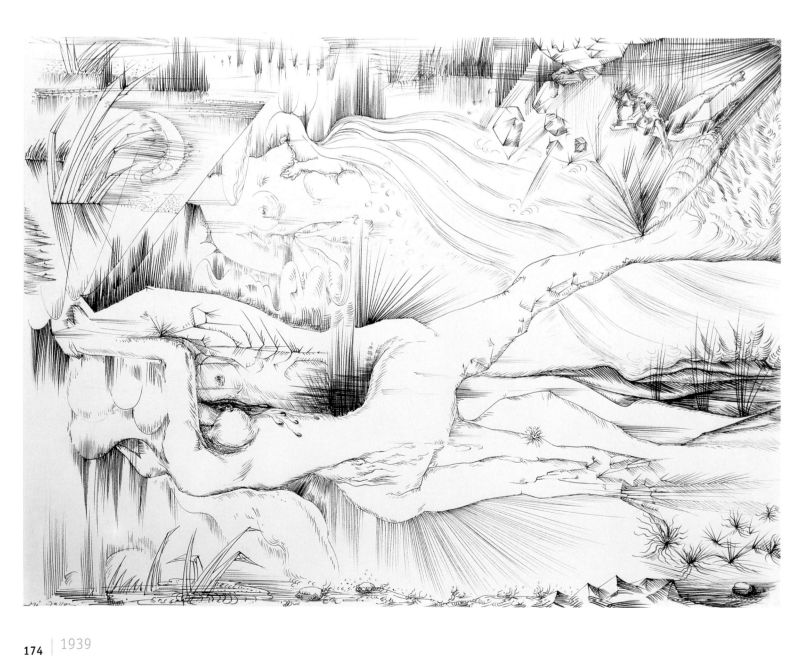

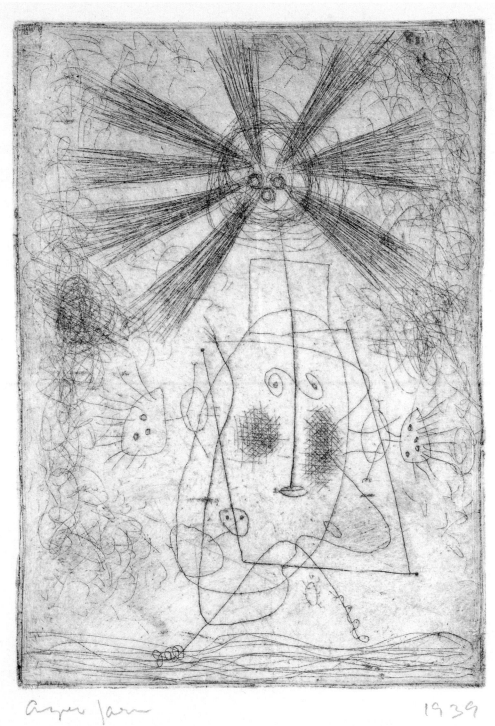

Asger Jorn 1939

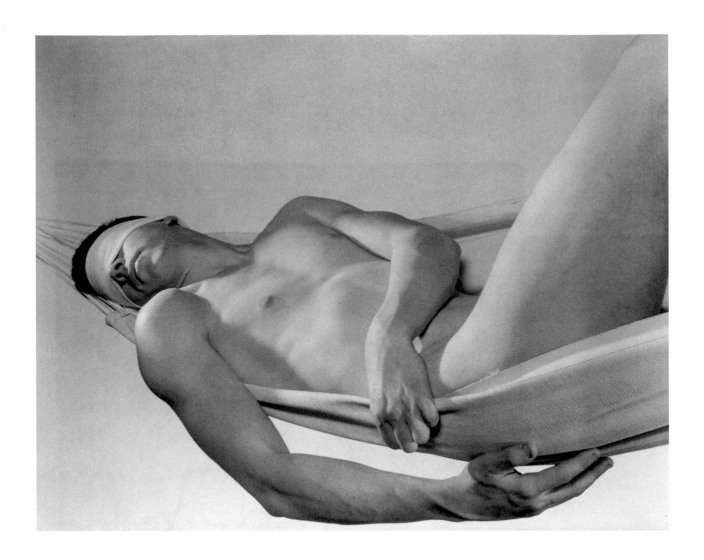

▲ **George Platt Lynes** (American, 1907–1955). *Untitled.* c. 1939. Gelatin silver print, 7⅜ x 9½" (18.8 x 24.1 cm). Anonymous gift

▶ **Pavel Tchelitchew** (American, born Russia. 1898–1957). *Tree into Hand and Foot* (Study for *Hide and Seek*). 1939. Watercolor and ink on green paper, 13⅞ x 9¾" (35.5 x 24.7 cm). Mrs. Simon Guggenheim Fund

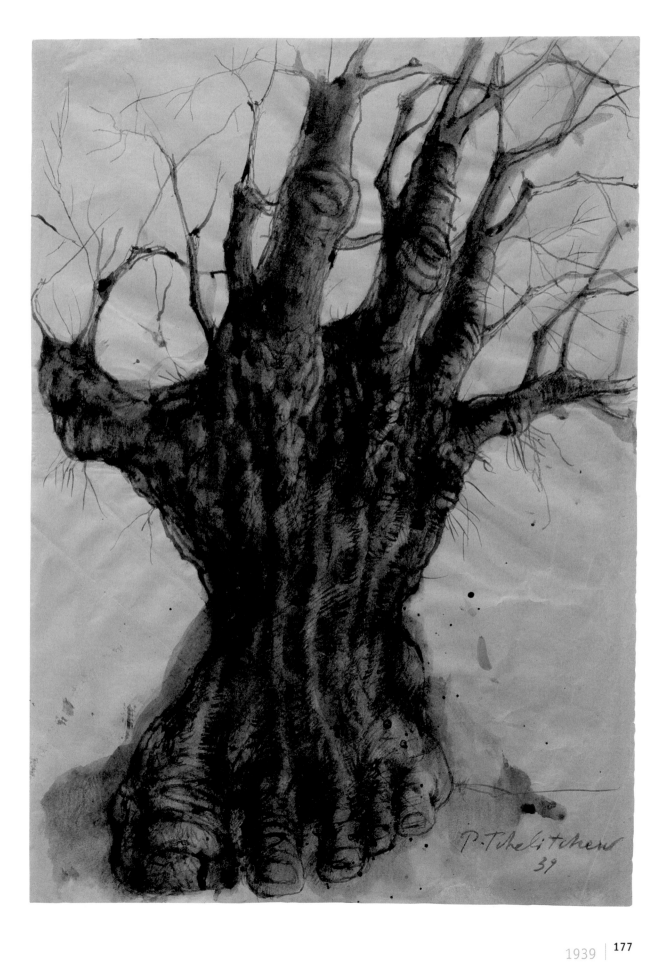

◀ **Ernesto Bruno La Padula** (Italian, 1902–1968), with Giovanni Guerrini (Italian), and Mario Romano (Italian). Palace of Italian Civilization, Rome, Italy. Perspective, preliminary version. 1939. Tempera on wood, 35⁷⁄₁₆ x 35³⁄₈" (90 x 89.9 cm). Purchase Fund

▼ **Aristide Maillol** (French, 1861–1944) *The River.* 1943 (begun 1938–39, completed 1943). Lead (cast 1948), 53¾" x 7' 6" x 66" (136.5 x 228.6 x 167.7 cm), on lead base designed by the artist, 9¾ x 67 x 27¾" (24.8 x 170.1 x 70.4 cm). Cast 2. Mrs. Simon Guggenheim Fund

David Alfaro Siqueiros (Mexican, 1896–1974). *Ethnography.* 1939. Enamel on composition board, 48⅛ x 32⅜" (122.2 x 82.2 cm). Abby Aldrich Rockefeller Fund

David Smith (American, 1906–1965). *Death by Gas* from the Medals for Dishonor series. 1939–40. Bronze medallion, 11⅜" (28.9 cm) diam. (irreg.). Given anonymously

Herbert Kline (American, 1909–1999). *Crisis*. 1939. 35mm, black and white, sound, 71 minutes

Joris Ivens (Dutch, 1898–1989). *The 400 Million*, 1939. 35mm, black and white, sound, 56 minutes. Acquired from Brandon Films

Philip L. Goodwin (American, 1885–1958) and **Edward D. Stone** (American, 1902–1978). The Museum of Modern Art, New York. 1939. Model: wood, acrylic, and linoleum, 15¾ x 24 x 39½" (40 x 61 x 100.4 cm). Building Fund

Marcel Duchamp (American, born France. 1887–1968). *Box in a Valise*. 1935-41. Leather valise containing pochoir reproductions with autograph correction, miniature replicas, photographs, and color reproductions of works by Duchamp, 16 x 15 x 4" (40.7 x 38.1 x 10.2 cm). Deluxe Edition: 9 of 20. James Thrall Soby Fund

1948

Three years after the end of World War II, an equilibrium of sorts had reasserted itself in world affairs and in art. On both sides of the Atlantic, developments interrupted or redirected by the five-year conflict began to unfold in a context which included politics but was not to the same extent dominated by it. Nevertheless, a readily discernible tension between radical possibility and a more conservative pursuit of long-standing conventions remained. No starker examples of this exist than the two paintings made in 1948 that were mentioned in the introduction to this album of images. The paintings are Jackson Pollock's *Number 1, 1948* and Andrew Wyeth's *Christina's World* (pp. 192, 193). As was also mentioned, one could begin to see in these postwar years correspondences as well as contrasts that anticipated the dramatic changes that were to occur in art a decade hence.

After years of relative obscurity, Marcel Duchamp—who was well known to denizens of the then still small American art world, and vaguely remembered as the author of artistic scandals in the 1910s and 1920s—began to be recognized as a symbol of a resurgent ironical spirit in modernism even though he seemed to be resting on his Dada laurels and gave the appearance of no longer working himself. Irving Penn's photograph of the always dapper artist celebrated Duchamp's status as a puckish elder statesman of the Dada sensibility, picturing him without the usual embellishments of magazine portraiture, in the stripped-down style that Penn was then establishing as the hallmark of urbane sophistication (p. 195). In the early 1960s Andy Warhol would rise to prominence as one of Duchamp's Neo-Dada offspring, but in the late 1940s Warhol was still a budding illustrator, heavily influenced by Ben Shahn. Nevertheless, his drawing Untitled (Roy Rogers) (p. 194) clearly prefigures his own Pop imagery by more than ten years; never before or since has such graphic delicacy and charm gone into transcribing a publicity photograph of an American singing cowboy, and in that aestheticizing of a mass-culture icon one discerns an unmistakable trace of Warhol's camp sensibility.

The main event of American art in the mid-1940s, however, was Abstract Expressionism, and the main event of European art was the last blaze of glory for the School of Paris. The first is epitomized by Pollock and his principal collaborator in the development of Abstract Expressionism, Willem de Kooning, the second by Duchamp's rival as the most influential artist of high modernism, Pablo Picasso. It is striking, in this regard, how similar the linear armatures of Picasso's *The Kitchen* and de Kooning's *Painting* (pp. 264, 265) are, as well as how different these two black-and-white paintings are in their painterly execution. Picasso's work is Cubism stripped to the bone; de Kooning's work is, as a critic once said, Cubism "liquefied." The wafting veils of color in Mark Rothko's painting (p. 262) represent another spatial dimension of Abstract Expressionism, against which the dramatic superimpositions that Louis Faurer discovered among the shadows and reflections of the city scene (p. 263) stand as a reminder that, no matter how lyric or sublime Abstract Expressionism could be—and in Rothko's hands it was both—painting in New York was an urban, not a pastoral, thing.

Like Rothko, Barnett Newman believed that painting was as much a metaphysical pursuit as a physical or perceptual phenomenon. With *Onement I* (p. 201), Newman gave his transcendental vision an absoluteness, unmatched by any of his colleagues. Politics was no longer a central concern for artists such as Pollock, de Kooning, Rothko, or Newman, all of whom had, in different ways, been marked by their experiences of the Depression and the war years. This is not meant to imply that American politics had reached a state of equilibrium, or, as the sociologist

Daniel Bell asserted, a situation in which "the end of ideology" was at hand. George Tames's photograph of Representative Richard M. Nixon of the House Un-American Activities Committee pretending to examine microfilms that were alleged to have been part of a spy operation involving Whittaker Chambers and Alger Hiss (p. 200) recalls the fear of Communism that overcame this country at the same time as America's cultural horizons had begun to open to an unprecedented degree. The picture, made for *The New York Times*, is a fine example of what was not yet called the "photo opportunity," in which news photographers and their subjects learned to collaborate so that each got what he or she needed. Nixon could have studied the enlargements that sit in a pile on the desk without the magnifying glass, but then he would not have appeared as such an intrepid sleuth.

Representing another aspect of Abstract Expressionism are Richard Pousette-Dart's *Untitled* and Adolph Gottlieb's *Ashes of Phoenix* (pp. 216, 217). The work of these two artists constitutes the synthesis of surrealistic dream shapes and "primitive" hieroglyphs. Although replete with subtle linear pleasures, both of these drawings have a brooding quality typical of the mood of much art in the immediate postwar period. This uneasiness is even more apparent in Seymour Lipton's spiky, caged sculpture *Imprisoned Figure* (p. 210) just as it is in the drypoint personage drawn as a frontispiece for Jean-Paul Sartre's *Visages* (p. 211) by the German-born Parisian artist Wols (Otto Alfred Wolfgang Schulze). Frederick J. Kiesler, whose early career as an architect and designer was in Europe in the 1920s and 1930s, became a prominent figure in the burgeoning New York School in the 1940s and 1950s. Close to the European Surrealists in exile in the United States during World War II as well as to the emerging American Abstract Expressionists, his work as a sculptor was influenced by both. Kiesler's fishbone-like *Galaxy* (p. 209)—originally created as a set for an American production of Jean Cocteau's and Darius Milhaud's *Le Pauvre Matelot* of 1948—is an early instance of what we would now call installation art.

While Kiesler's work is fantastic and disconcerting, Lucian Freud's *Girl with Leaves* (pp. 186, 208) is the very picture—in heightened realist terms—of postwar anxiety. The alienation expressed by this solitary face is recast as a collective emotion by the spectral figures of Alberto Giacometti's *City Square* (p. 205). Concentrating on the psychological and spatial realities of their situation, the artist has stripped away all other descriptive detail. Only their positioning and posture remain to tell us of their simultaneous convergence and isolation. The more abstract and full-bodied figures in Louise Bourgeois's *Quarantania, I* (p. 204) huddle together for protection. In contrast to Giacometti's human filaments with their disproportionately large feet, Bourgeois's carved "totems" are not firmly anchored to the ground but balance like needles or rigid dancers on point. Also in contrast to Giacometti's dispersed figures, Bourgeois's surrogates form a community of kindred souls, but it is a precarious one, and as much as the members of it seem to stand in support of one another, the implicit kinetics of the ensemble leave open the chance that if one were to lose its balance the rest would fall like ninepins. This sense of tenuous unity and shared jeopardy is specifically identified with the decade by the piece's title, *Quarantania, I.*

Bourgeois's *Le Grand Regard Greeting* (p. 244) features a constellation of ovals, the center of which holds a draped banner. This anthropomorphic cluster of forms seems innocent enough at first, as if they were heads and represented a sympathetic group or family. Soon, however, the near flurry of the short, hatched lines that compose the image becomes unsettling. This is

art on the edge of hysteria. Anatole Litvak's *The Snake Pit* (p. 245) is the rare example of a commercial film that attempted to describe the clinical treatment of those who, in fact, went mad or were thought to have gone mad. Surrealism, of course, had made a cult out of insanity, and postwar art continued to look to the subconscious for inspiration and to mimic the look of art made by those given to miraculous visions or suffering from extreme mental disorders. Victor Brauner, a veteran Surrealist, represents this tendency at its most decorative in *Pantacular Progression* (p. 240). Pierre Alechinsky, one of the leaders of the northern European CoBrA group, updates the same approach with equal elegance (p. 241).

Jean Dubuffet, as a theoretician and collector of *art brut*—a term encompassing both the art of the untutored and the art of the insane—was a past master at primitivistic draftsmanship. Despite his best efforts to offend good taste, Dubuffet nevertheless ended up the most charming of aesthetic contrarians. His graffiti-like *Footprints in the Sand* from the *Sketchbook: El Golea II* (p. 242) is a barefoot stampede—or a barefoot tap dance in pen and ink that cartoonishly recalls the allover gesturalism of Pollock's *Number 1, 1948*, the margins of which are emblazoned with handprints much as Dubuffet's drawings are covered by footprints. A contemporary of Dubuffet, Henri Michaux sought a similar kind of unfettered poetry through hallucination. Using frayed strokes to summon up the ephemeral/fleeting images in his mind, Michaux, in his lithograph from *Meidosems*, accompanied his own texts with some of the simplest and most haunting lithographs of the period (p. 243).

In the 1940s, Willem de Kooning said that Pablo Picasso was the man to beat. The head-to-head comparison between de Kooning's *Painting* and Picasso's *The Kitchen* shows that it was possible to do so. Among the European artists who came into their own after World War II, Picasso's challenge was no less keenly felt, but the competition did not only play itself out in paint on canvas. The wonderfully bold, broad brushwork Picasso used to embellish his stylish calligraphic transcription of Pierre Reverdy's *Les Chants des morts* (p. 239) is an example of the artist's extraordinary accomplishments as a printmaker and illustrator of deluxe *livres d'artiste* in this period. True to his "anti-cultural" theories, Dubuffet did not meet Picasso on his own ground, but rather marked out his own creative terrain. Thus, Dubuffet's unluxurious artist's book, complete with a title in argot (*Ler dla canpane*; p. 238), matches Picasso's distinctive typography and graphic imagery, but does so with a defiant poverty of means—cheap paper, flimsy binding, simple block printing.

Other veteran members of the School of Paris whose careers took off again after the war included Fernand Léger and Salvador Dali. The populist Léger devoted his energies to a robust mix of abstraction and highly simplified figuration (p. 234). The antithesis of Léger in every way, Dali, the Surrealist dandy, and, in his perversely academic way, proto-Pop artist, is seen in Philippe Halsman's photograph *Dali Atomicus* (p. 235) as the consummate showman that he was. But by this time Dali's persona outshone his work, and his signature pictorial tricks and mannerisms had become staples of mass culture. The European-born Halsman—who had witnessed the unfolding of Surrealism in Paris and, after emigrating to the United States, made more *Life* covers than any other photographer in the magazine's salad days—was the perfect man for the job. The art of Henri Matisse was also transformed and renewed in the immediate aftermath of World War II, achieving an unprecedented boldness and brevity, as can be seen in *Nadia, Smiling Face* (p. 232). The wonder of this image is that it strikes the eye with the same

flourish as a brush drawing with liquid ink, even though it was achieved by an indirect process, aquatint, and did not result from a single brisk gesture but rather was enriched in stages by a master technician who etched the artist's plate and proofed the prints. Robert Motherwell's ink drawing *Elegy to the Spanish Republic No. 1* (p. 233) might just as well be an homage to Matisse. Indeed, to the extent that de Kooning and Pollock looked to Picasso as their model, Motherwell, the most overtly Francophile of the Abstract Expressionists, looked to Matisse, as did other "color field" painters like Rothko. Still, Picasso remained the emblem of French art for the remainder of the 1940s and on into the 1950s. E. McKnight Kauffer's *American Airlines to Europe* poster advertising transatlantic travel for the middle-class American tourist shows a kiosk plastered with signs identifying the various destinations in Europe to which one could fly (p. 231). By the time this advertisement was made, most travelers would have recognized Picasso's *Third Vallauris Poster* (p. 230) as a kind of trademark image, and many would also have regarded it as a symbol of all things artistic in France.

One consequence of World War II had been the mass exodus of European artists from Europe. If, after the end of hostilities, many of those artists returned home, others remained in their adopted countries. Of all the groups to have been part of this wartime influx, none had a more lasting impact on America than did the refugees from the Bauhaus. Having occupied three cities in Germany between its founding in 1919 and its closing in 1933 following the triumph of the Nazis, the Bauhaus was partially reconstituted in Chicago, Illinois, where, under varying auspices, its teaching and experimentation were carried on. Chief among the figures associated with this aesthetic transplantation was the architect Ludwig Mies van der Rohe, who, in the years between his arrival in the United States in 1938 and his death in 1969, changed the look of American cities. Best known for his spare, gridded office towers, Mies also was a master builder of private residences. His Farnsworth House, Plano, Illinois (1945–51; p. 203), is among the most perfect of these buildings. Ideal for those unafraid to live in glass houses, its open floor plan, transparent external walls, breathtaking structural economy, and inspired adaptation to the flatlands of the Midwest set a model that many others would follow. Among them was Philip Johnson, whose Glass House in New Canaan, Connecticut (p. 260), almost instantly became a touchstone of International Style modernism upon its completion in 1949.

Perhaps Mies's most brilliant stroke as leader of the new Bauhaus was to offer a teaching position to the untutored Detroit photographer Harry Callahan. Callahan's work (p. 202) achieved an improbable fusion of the American idealist tradition of Alfred Stieglitz (p. 96) and Ansel Adams (p. 259) with the Bauhaus aesthetic of abstract form clarified through ceaseless experimentation. Another member of the modernist academy's Diaspora was Anni Albers (p. 218), whose most important contribution to mid-century modernism was her textile works. It is interesting to compare the delicate shimmer of her woven grid to the linear skeins and tufts of Hans Hartung's *Painting* (p. 219). Albers, who remained in America for the rest of her life, brought a severity to what had generally been thought of as a traditional craft that aligns her textiles with the efforts made by contemporary painters; Hartung, who rose to prominence in France and his native Germany in the 1940s and 1950s, responded to the lush gesturalism of much abstraction in this period with a dry but emphatic touch that aligns his work more closely with the Bauhaus sensibility than with Abstract Expressionism.

The original idea of the Bauhaus had been to break down the distinction between the fine

and applied arts, and to create objects for use that would have the aesthetic quality of first-rate contemporary sculptures or paintings. In the context of postwar reconstruction and prosperity, artists in many countries picked up where the Bauhaus left off. The Museum of Modern Art, eager to inform the public of newly available examples of good design, avidly collected and energetically exhibited their work. The Lexikon 80 Manual Typewriter (p. 229) by Marcello Nizzoli is a beautiful tool of just this sort. Among the numerous Scandinavians who contributed to this renaissance was Kaj Franck, whose Kilta Covered Containers (p. 196) are typical of his modest but finely honed forms.

If the housewares of Franck and the typewriter of Nizzoli represent the best in easily affordable goods, Pininfarina's Cisitalia 202 GT (p. 197) identifies the luxury end of the design continuum, though the automobile's streamlining curiously resembles the typewriter's carapace. No longer utopians in the sense that Russian Constructivist, De Stijl, and early Bauhaus designers had been, the new generation nevertheless aimed to create a rationalized, standardized, but also hospitable man-made environment. The New Realist tendencies in film and photography portray a gritty, conflicted world. Jules Dassin's *The Naked City* (p. 198), a police procedural drama, has the overall feel of a straight documentary, and the hard-boiled dame in Louis Faurer's photograph (p. 199) would have fit perfectly into Dassin's no-nonsense New York City. A similar kind of comparison can be made between Gordon Parks's photograph of street toughs fighting in Harlem (p. 215) and Robert Siodmak's classic film *Criss Cross* (p. 214), though *Criss Cross*, with its theatrical chiaroscuro lighting, has a baroque quality not found in *The Naked City*. Even more stylized than *Criss Cross*, Orson Welles's *The Lady from Shanghai* (p. 255) is a film full of extreme cinematic foreshortenings, exaggerated close-ups, and disorienting optical effects. The final scene, which involves a chase, a kiss, and a shoot-out (the kiss is represented here by a film still), takes place in a hall of mirrors. In contrast to the moral certainties of 1930s crime dramas, 1940s film noir in general and Welles's masterpiece in particular are all ambiguity. Meanwhile, Ted Croner's streaking New York taxicab (p. 254) has all the sinister glamour of Welles's film and all the razzle-dazzle of a Wurlitzer jukebox. If there is narrative to this picture, it is about postwar car culture taking off. But that is really a story of the 1950s.

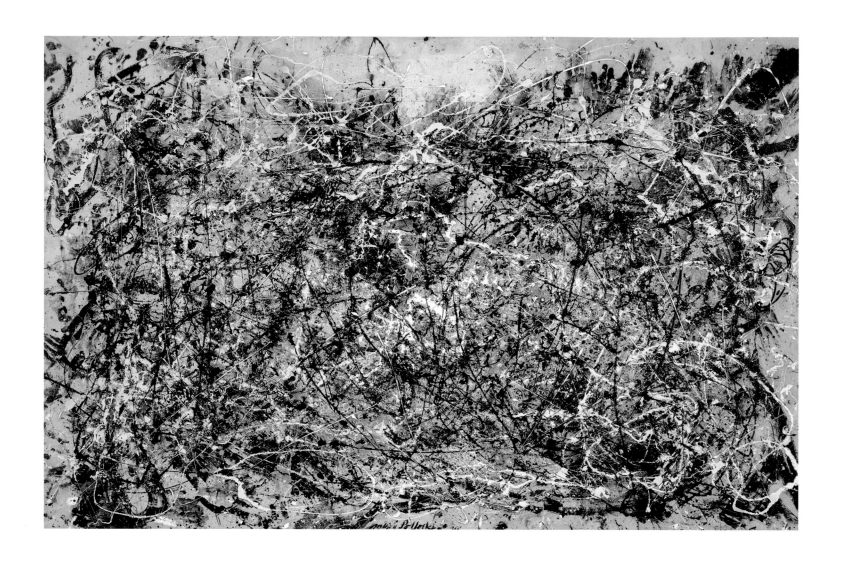

◄ **Jackson Pollock** (American, 1912–1956). *Number 1, 1948*. 1948. Oil and enamel on unprimed canvas, 68" x 8' 8" (172.7 x 264.2 cm). Purchase

▼ **Andrew Wyeth** (American, born 1917). *Christina's World*. 1948. Tempera on gessoed panel, 32¼ x 47¾" (81.9 x 121.3 cm). Purchase

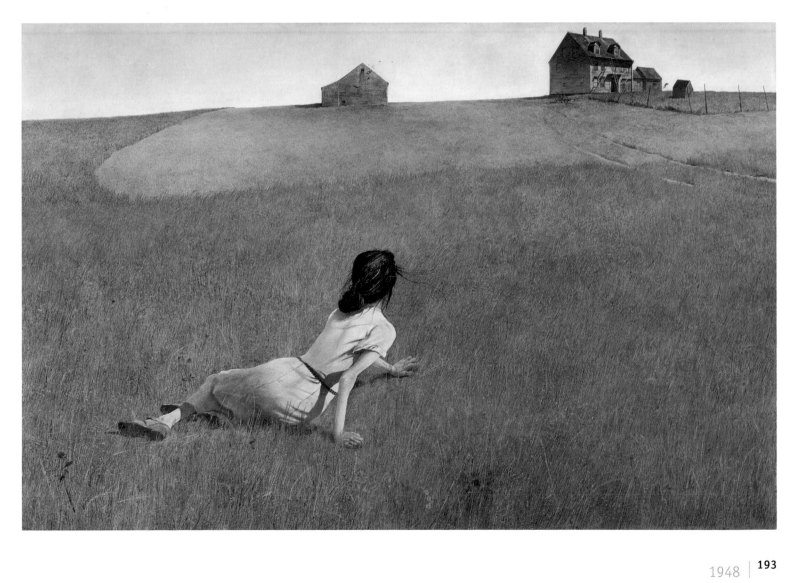

▲ **Andy Warhol** (American, 1928–1987). Untitled (Roy Rogers). c. 1948. Pencil on paper, 11 x 8½" (28 x 22 cm). Chief Curator Discretionary Fund

▶ **Irving Penn** (American, born 1917). *Marcel Duchamp, New York*. 1948. Gelatin silver print, 9½ x 7⅜" (24.1 x 18.8 cm). Gift of the photographer

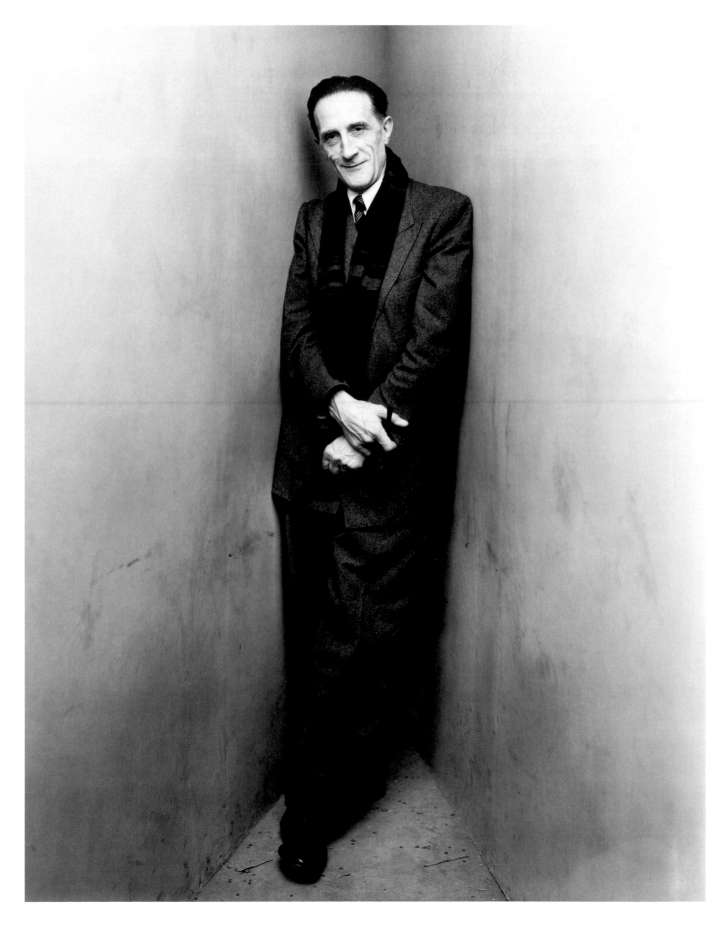

▶ **Pininfarina** (Italian, 1893–1966). Cisitalia 202 GT. 1946 (manufactured 1948). Aluminum body, 49" x 57⅝" x 13' 2" (125 x 147 x 401 cm). Manufacturer: S.p.A. Carrozzeria Pininfarina, Turin, Italy. Gift of the manufacturer

▼ **Kaj Franck** (Finnish, 1911–1989). Kilta Covered Containers. 1948. Glazed earthenware, 4" (10.2 cm) high (with lid) x 8¼" (21 cm) diam.; 4⅝" (11.7 cm) high x 4⅛" (10.5 cm) diam.; 2¼" (5.7 cm) high x 4⅛" (10.5 cm) diam. Manufacturer: Arabia/Wartsila, Finland. Gift of Nina and Gordon Bunshaft (left); gift of Wartsila Corp. (center and right)

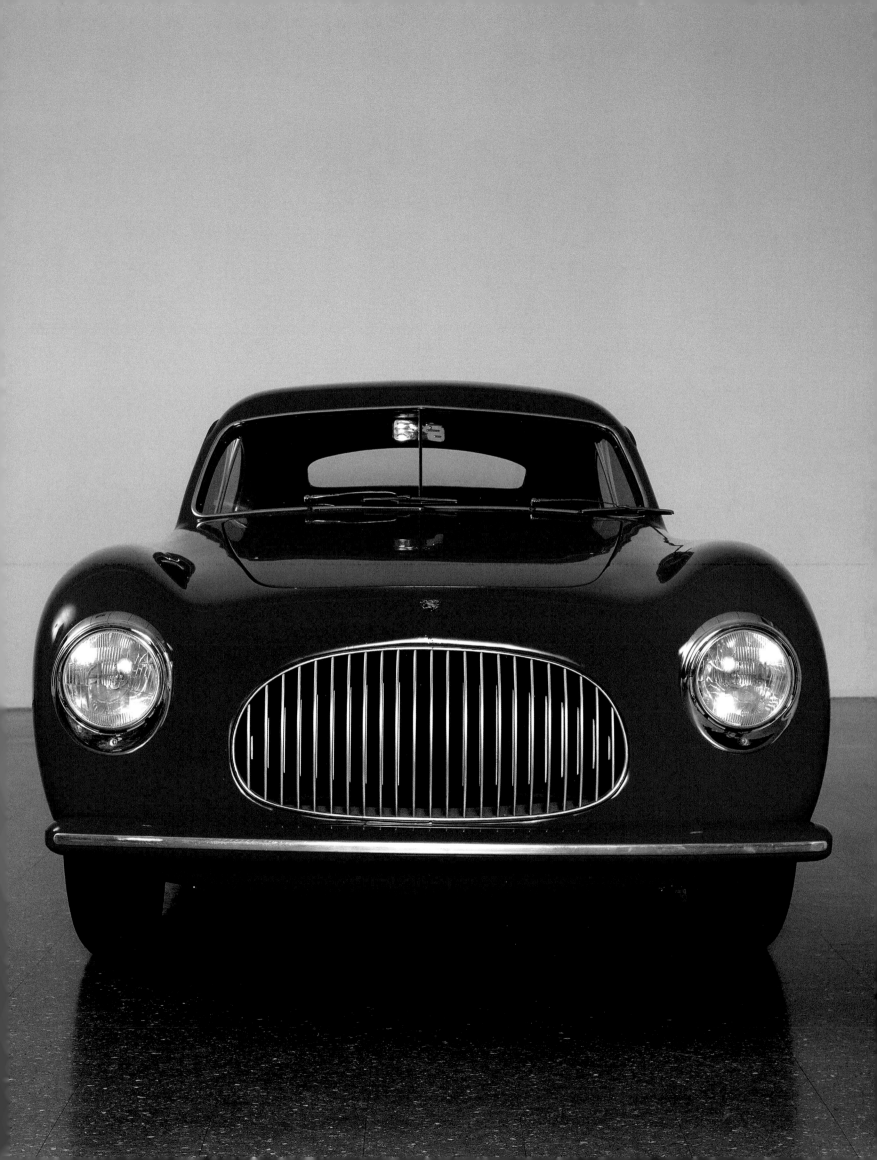

Louis Faurer (American, born 1916). Untitled. 1948. Gelatin silver print, 12⅝ x 8⁹⁄₁₆" (32.1 x 21.7 cm). Nelson A. Rockefeller Fund

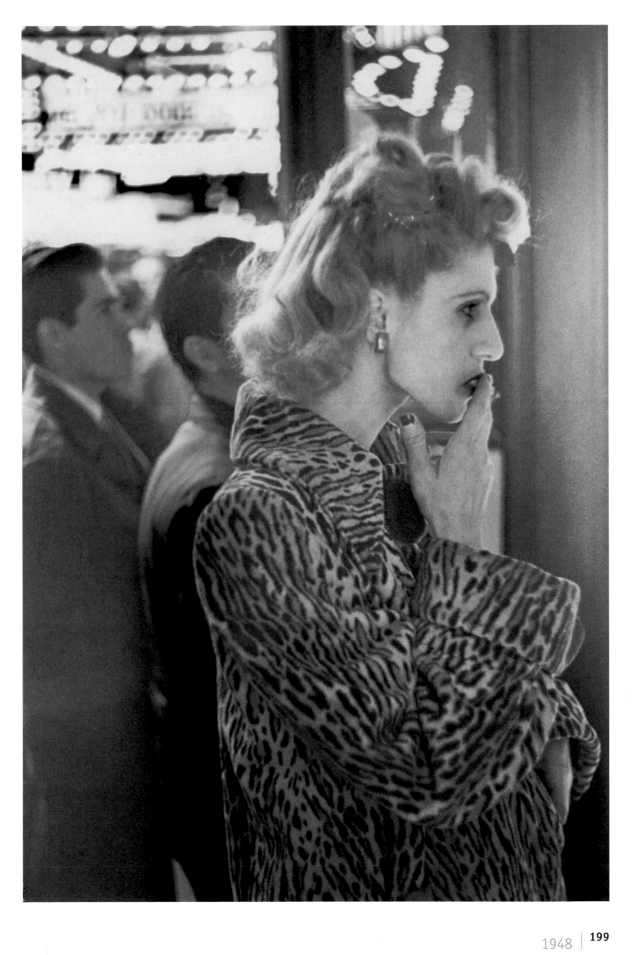

▲ **George Tames** (American, 1919–1994). *Representative Richard M. Nixon of the House Un-American Activities Committee.* 1948. Gelatin silver print, 9 ⁷⁄₁₆ x 7 ⁵⁄₈" (24 x 19.4 cm). The New York Times Company Collection

▶ **Barnett Newman** (American, 1905–1970). *Onement I.* 1948. Oil on canvas and oil on masking tape on canvas, 27 ¼ x 16 ¼" (69.2 x 41.2 cm). Gift of Annalee Newman

▲ **Harry Callahan** (American, 1912–1999). *Eleanor*. 1948. Gelatin silver print, 3¼ x 4⁵⁄₁₆" (8.3 x 11 cm). Purchase

▶ **Ludwig Mies van der Rohe** (American, born Germany. 1886–1969). Farnsworth House, Plano, Illinois. 1945–51. Model: wood, acrylic, and brass, 30¼ x 60 x 42" (76.8 x 152.3 x 106.7 cm). Modelmakers: Paul Bonfilio with Edith Randel and Lenon Kaplan (1985). Purchase

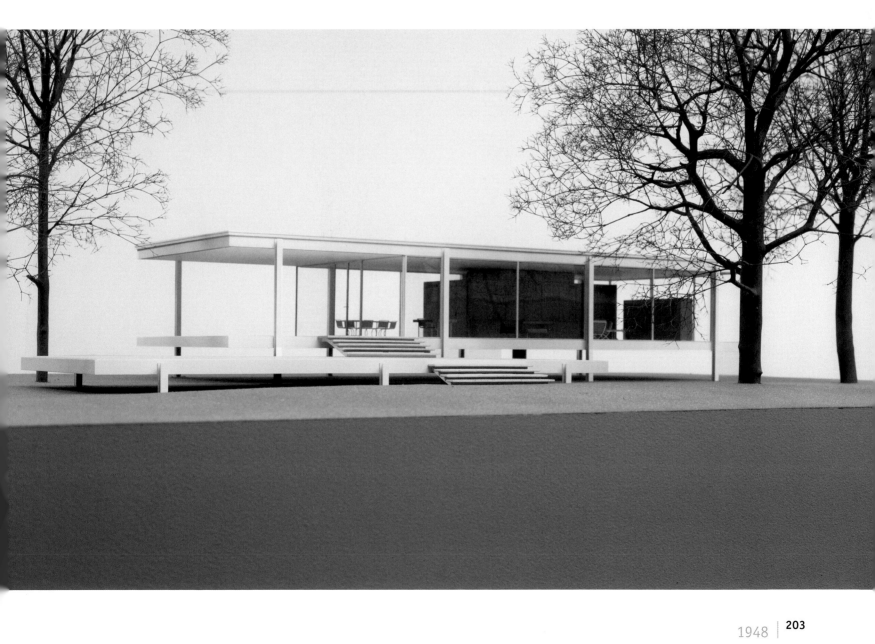

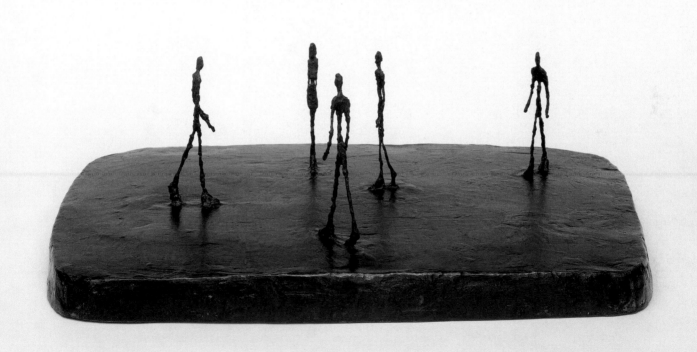

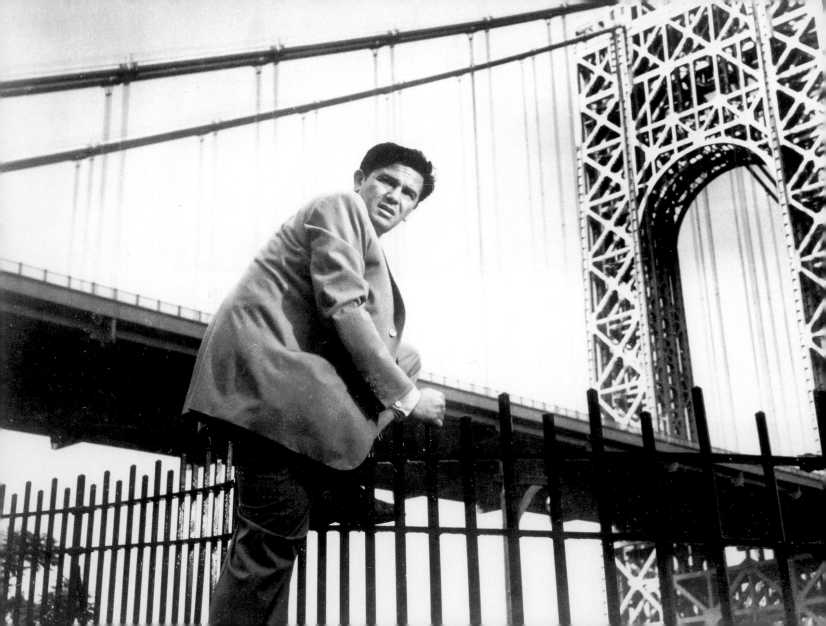

Roberto Rossellini (Italian, 1906–1977). *A Human Voice (Una voce umana)*. Segment of the two-part film *Love (L'amore)*. 1948. 35mm, black and white, sound, 30 minutes. Anna Magnani

▲ **Lucian Freud** (British, born Germany 1922). *Girl with Leaves*. 1948. Pastel on gray paper, 18⅞ x 16½" (47.9 x 41.9 cm). Purchase

▶ **Frederick J. Kiesler** (American, born Austria. 1890–1965). *Galaxy*. 1947–48 (base remade 1951). Wood and rope, 11' 11" x 13' 10" x 14' 3" (363.2 x 421.6 x 434.3 cm). Gift of Mrs. Nelson Rockefeller

▲ **Wols** (Otto Alfred Wolfgang Schulze; German, 1913–1951). Frontispiece from *Visages* by Jean-Paul Sartre. Paris: Pierre Seghers, 1948. Drypoint, 5½ x 3¹⁄₁₆" (13.9 x 7.8 cm). Printers: plates by R. Haazen, Paris; text by Imprimerie Union, Paris. Edition: 925. Henry Church Fund

◄ **Seymour Lipton** (American, 1903–1986). *Imprisoned Figure*. 1948. Wood and sheet-lead construction, 7' ¾" x 30⅞" x 23⅝" (215.2 x 78.3 x 59.9 cm), including wood base, 6⅛ x 23⅛ x 20⅛" (15.3 x 58.6 x 51 cm). Gift of the artist

Wanda Jakubowska (Polish, 1907–1998). *The Last Stop (Ostatni etap)*. 1948. 35mm, black and white, sound, 130 minutes

José Clemente Orozco (Mexican, 1883–1949). *Clenched Fist*. 1948. Crayon and charcoal on paper, 24⅜ x 19"
(61.7 x 48.1 cm). The Joan and Lester Avnet Collection

Gordon Parks (American, born 1912). *Harlem Gang Wars*. 1948. Gelatin silver print, 10¹⁵⁄₁₆ x 10½" (27.9 x 26.7 cm). Gift of the photographer in honor of Edward Steichen

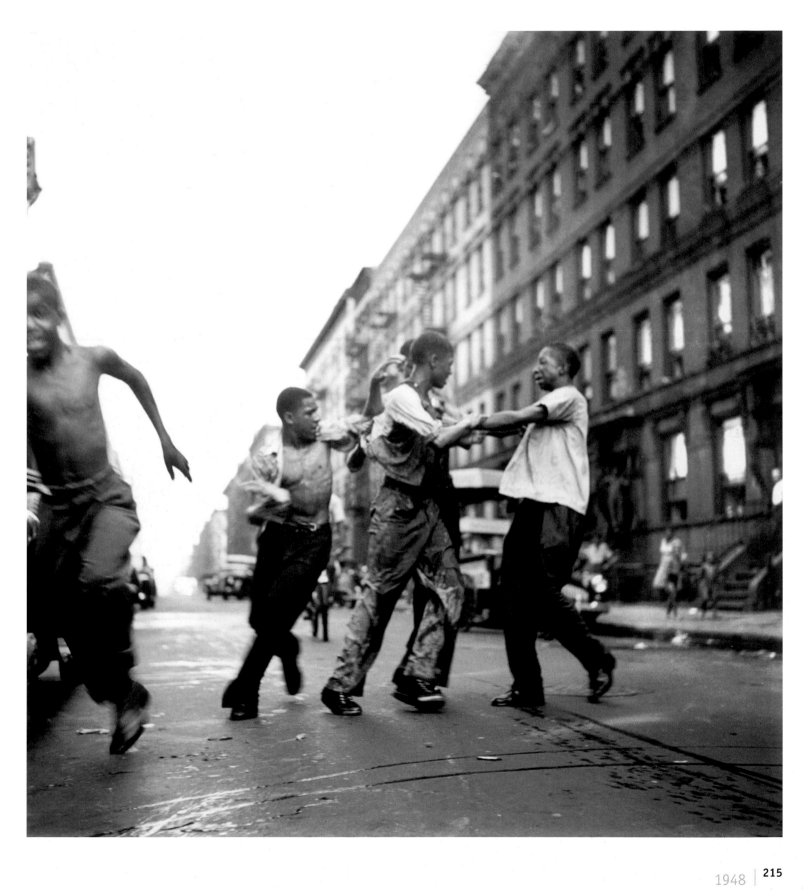

▲ **Adolph Gottlieb** (American, 1903–1974). *Ashes of Phoenix*. 1948. Gouache on paper, 18 x 23 ¾" (45.8 x 60.3 cm). Purchased with funds given by Leon D. Black

◀ **Richard Pousette-Dart** (American, 1916–1992). *Untitled*. 1948. Pencil, gouache, pen and ink and gesso on composition board, 20 x 24" (50.1 x 60.1 cm). Acquired with matching funds from The Edward John Noble Foundation and the National Endowment for the Arts

Anni Albers (American, 1899–1994). Tapestry. 1948. Linen and cotton, 16½ x 18¾" (41.9 x 47.6 cm). Edgar Kaufmann, Jr. Purchase Fund

Hans Hartung (French, born Germany. 1904–1989). *Painting.* 1948. Oil on canvas, 38¼ x 57½" (97.2 x 146 cm). Gift of John L. Senior, Jr.

▲ **Fritz Buhler** (American, 1909–1963) and **Ruodi Barth** (Swiss, born 1921). *Nivea.* 1948. Lithograph, sheet 50⅛ x 35⅜" (127.3 x 89.9 cm). Don Page Fund

▶ **Eero Saarinen** (American, born Finland. 1910–1961). Womb Chair. 1946 (manufactured 1948). Upholstered latex foam on fiberglass-reinforced plastic shell; chrome-plated steel rod base, 36½" (92.7 cm) high. Manufacturer: Knoll Associates, Inc., New York. Gift of the manufacturer

◄ **Robert Frank** (American, born Switzerland 1924). *Untitled (Peru)*. 1948. Gelatin silver print, 10⅛ x 9⁵⁄₁₆" (25.8 x 23.7 cm). Purchase

▲ **Leopoldo Méndez** (Mexican, 1902–1969). *Torches* from the portfolio *Rio Escondido*. 1948. Wood engraving, 12 x 16⅜" (30.4 x 41.6 cm). Edition: 150. Inter-American Fund

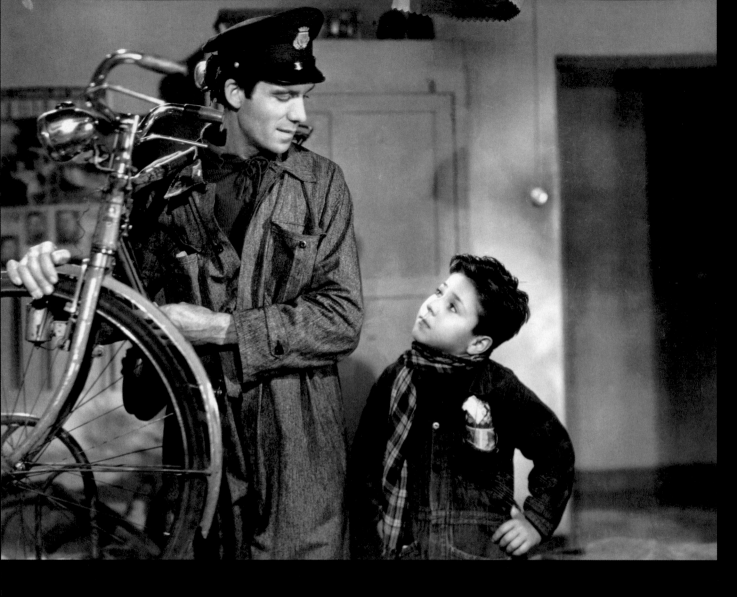

Vittorio De Sica (Italian, 1902–1974). *Bicycle Thief (Ladri di biciclette)*. 1948. 35mm, black and white, sound, 91 minutes. Exchange with Ceskoslovensky Filmovy Archiv. Lamberto Maggiorani, Enzo Stajola

▲ **Unknown designer**. Melting Crucible. 1948. Graphite, 6¾" (17.2 cm) high x 5½" (14 cm) diam. Gift of Mrs. V. Henry Rothschild

▶ **Marcello Nizzoli** (Italian, 1887–1969). Lexikon 80 Manual Typewriter. 1948. Enameled aluminum housing, 9 x 15 x 15" (22.8 x 38.1 x 38.1 cm). Manufacturer: Ing. C. Olivetti & C., S.p.A., Ivrea, Italy. Gift of Olivetti Corporation of America, New York

▲ **Pablo Picasso** (Spanish, 1881–1973). *Third Vallauris Poster.* 1948. Lithograph, sheet 23 9/16 x 15 13/16" (59.8 x 40.2 cm). Edition: 300. Gift of Daniel-Henry Kahnweiler

▶ **E. McKnight Kauffer** (American, 1890–1954). *American Airlines to Europe.* 1948. Lithograph, sheet 39 1/2 x 29 3/4" (100.4 x 75.6 cm). Gift of the artist

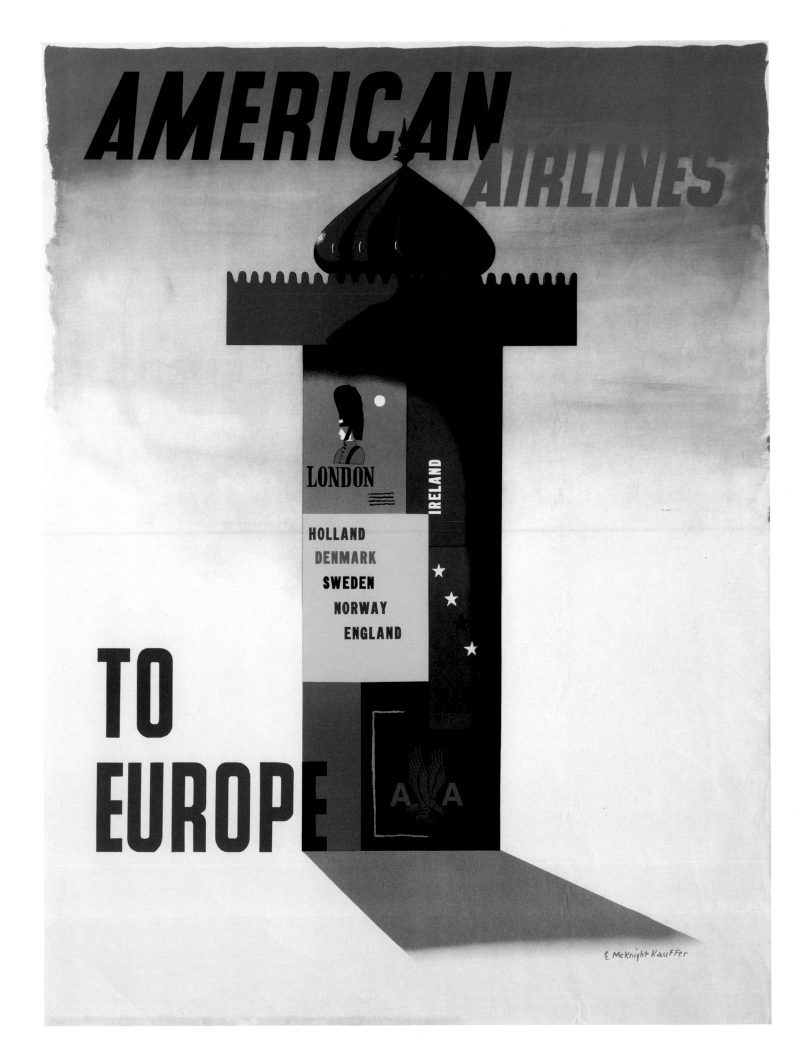

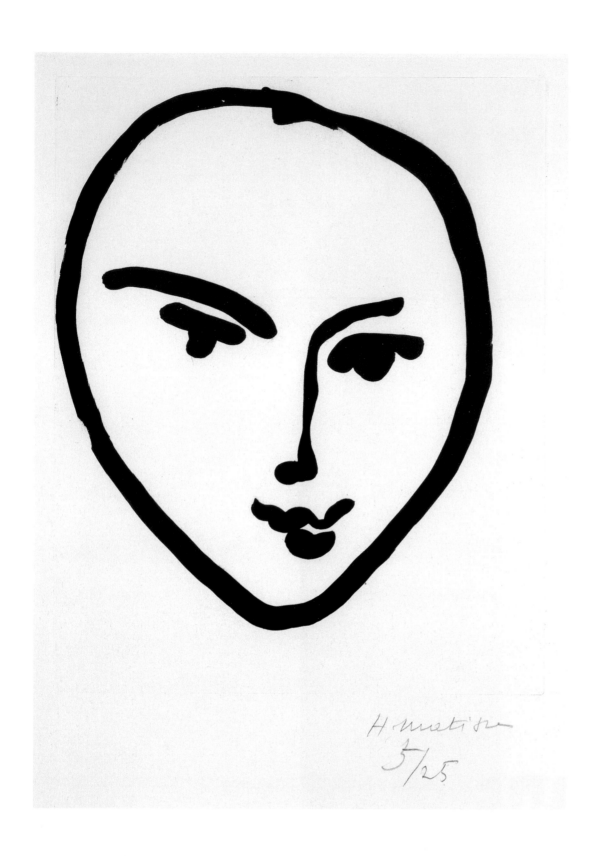

Henri Matisse (French, 1869–1954). *Nadia, Smiling Face*. 1948. Aquatint, 12 ⅜ x 9 ⅞" (31.4 x 25.1 cm). Edition: 25.
Curt Valentin Bequest

Robert Motherwell (American, 1915–1991). *Elegy to the Spanish Republic No. 1.* 1948. Ink on paper, 10¾ x 8½" (27.3 x 21.8 cm). Gift of the artist

29/75

◄ **Fernand Léger** (French, 1881–1955). *The Black Root*. 1948. Lithograph, 14⅝ x 18⁵⁄₁₆" (37.2 x 46.5 cm). Publisher: Galerie Louise Leiris, Paris. Printer: Mourlot Frères, Paris. Edition: 75. Gift of Victor S. Riesenfeld

▼ **Philippe Halsman** (American, born Latvia. 1906–1979). *Dali Atomicus*. 1948. Gelatin silver print, 10⅛ x 13⅛" (25.8 x 33.3 cm). Gift of the photographer

▲ **Édouard Boubat** (French, born 1923). *Brittany*. 1948–49. Gelatin silver print, 8 ⁷⁄₁₆ x 5 ⁷⁄₈" (21.5 x 15 cm).
Gift of the photographer

◄ **Pierre Soulages** (French, born 1919). *Painting*. 1948–49. Walnut stain on canvas, 6' 4 ¼" x 50 ⅞" (193.4 x 129.1 cm).
Acquired through the Lillie P. Bliss Bequest

Jean Dubuffet (French, 1901–1985). Two-page spread from *Ler dla canpane* by Dubufe J. [Jean Dubuffet]. Paris: the artist, 1948. Linoleum cut, page 7¼ x 5⅛" (18.5 x 13 cm), 14½ x 10¼" (18.5 x 26 cm) overall. Edition: 165. Given anonymously

Une aile palpite
à ma tempe
Je pars demain

Et dans le train bleu
qui déraille
Le feuillage des souvenirs
La lampe plus basse que
la nuit
Une rancune inconsolable

25

C'est tout dans le couleur
des songes
Mentir pour plaire
sans faiblir
Il n'y aura jamais
plus de monde
Au détour pour nous
voir mourir

Pablo Picasso (Spanish, 1881–1973). Two-page spread from *Les Chants des morts* by Pierre Reverdy. Paris: Tériade Éditeur, 1948. Prints executed 1946–48. Lithograph, page 16½ x 12⁹⁄₁₆" (42 x 32 cm), 16½ x 25⅛" (42 x 64 cm) overall. Printers: plates by Mourlot Frères, Paris; text by Draeger Frères, Paris. Edition: 270. The Louis E. Stern Collection

▲ **Victor Brauner** (Rumanian, 1903–1966). *Pantacular Progression*. 1948. Encaustic on cardboard, 19¾ x 27½" (50.2 x 69.8 cm). Gift of D. and J. de Menil

▶ **Pierre Alechinsky** (Belgian, born 1927). *The Hairdresser*. 1948. Etching and drypoint, 5¹¹⁄₁₆ x 3¹⁵⁄₁₆" (14.4 x 7.4 cm). Printer: Imprimerie Leblanc, Paris. Edition: 12. Gift of the artist

le coiffeur 2/6 Alechinsky 58

Jean Dubuffet (French, 1901–1985). *Footprints in the Sand* from *Sketchbook: El Golea II*. 1948. Pen and ink on paper, 7⅞ x 6¼" (19.9 x 15.7 cm). Gift of the artist

Henri Michaux (French, born Belgium. 1899–1984). Untitled from *Meidosems* by Henri Michaux. Paris: Les Éditions du Point du Jour, 1948. Lithograph, 9 15/16 x 7 1/2" (25.2 x 19.1 cm) (irreg.). Printers: lithographs by Desjobert, Paris; text by E. Aulard, Paris. Edition: 297. Abby Aldrich Rockefeller Fund

▶ **Anatole Litvak** (American, born Russia. 1902–1974). *The Snake Pit*. 1948. 35mm, black and white, sound, 108 minutes. Acquired from Twentieth Century-Fox. Olivia de Havilland

▼ **Louise Bourgeois** (American, born France 1911). *Le Grand Regard Greeting*. 1948. Soft ground etching, with pencil additions, sheet 7 ¹⁵⁄₁₆ x 10¼" (20.3 x 26. cm). Gift of the artist

▲ **Stanley William Hayter** (British, 1901–1988). *Death by Water*. 1948. Engraving, 13 13/16 x 23 13/16" (35.1 x 60.5 cm). Publisher: the artist, New York. Printers: the artist and Raymond Haasen, New York. Edition: 50. John S. Newberry Fund

◄ **Henry Moore** (British, 1898–1986). *Family Group*. 1948–49. Bronze (cast 1950), 59 1/4 x 46 1/2 x 29 7/8" (150.5 x 118 x 75.9 cm), including base. Cast 2 of 4. Conger Goodyear Fund

GARDEN by, ROBERTO BURLE MARX

◄ **Roberto Burle-Marx** (Brazilian, 1909–1994). Garden Design. 1948. Gouache on paper, 56¼ x 34" (142.9 x 86.3 cm). Gift of Philip L. Goodwin

▶ **Eva Zeisel** (American, born 1906). Folding Chair. 1948–49. Chrome plated tubular steel, and cotton, 28½ x 26 x 26½" (72.4 x 66.2 x 67.4 cm). Manufacturer: Hudson Fixtures, USA. Gift of the designer

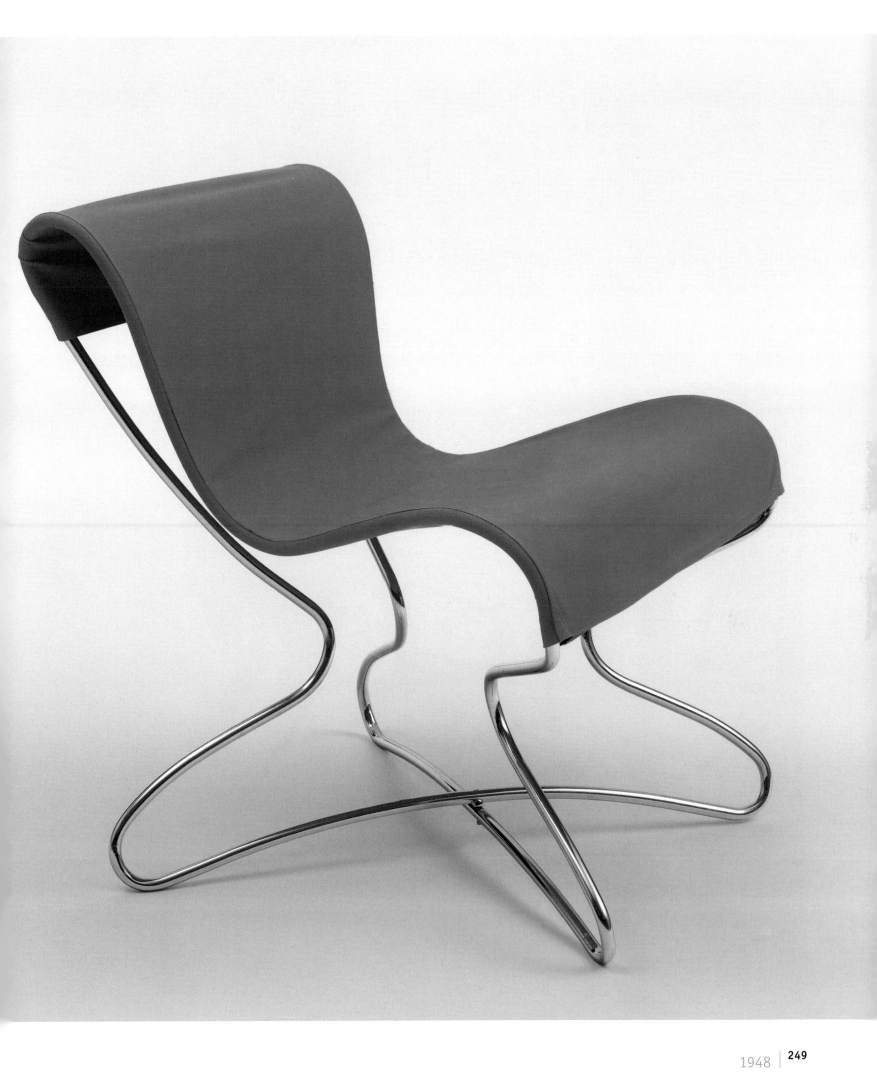

▶ **Charles Eames** (American, 1907–1978). Chaise Longue. 1948. Prototype for a stressed-skin shell: hard rubber foam, plastic, wood, and metal, 32½ x 59 x 34¼" (82.6 x 149.9 x 87 cm). Gift of the designer

▼ **Ralston Crawford** (American, born Canada. 1906–1978). *Red and Black*. 1948. Screenprint, 12 15/16 x 16" (31.3 x 40.6 cm). Gift of Mrs. Edith Gregor Halpert

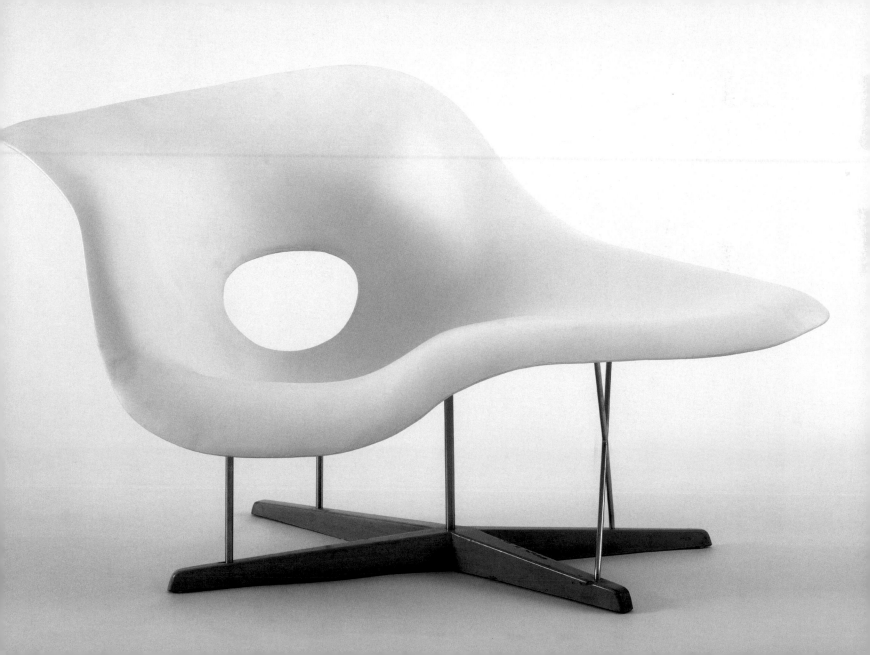

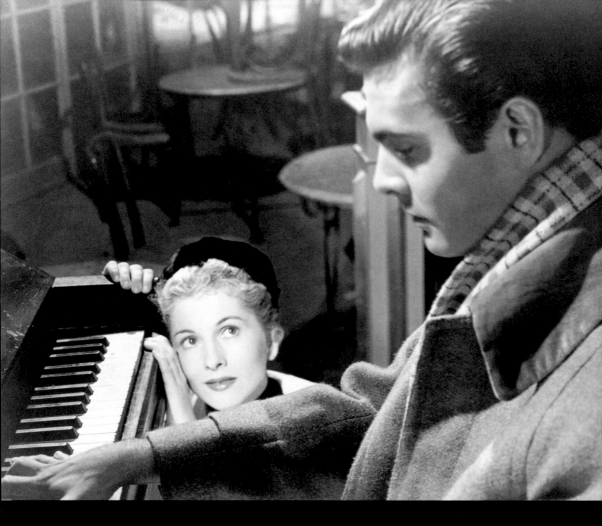

▲ **Max Ophüls** (American and French, born Germany 1927). *Letter from an Unknown Woman*. 1948. 35mm, black and white, sound, 87 minutes. Joan Fontaine, Louis Jourdan

▶ **Michael Powell** (British, 1905–1990). *The Red Shoes*. 1948. 35mm, color, sound, 134 minutes. Léonide Massine, Moira Shearer

▶ **Orson Welles** (American, 1916–1985). *The Lady from Shanghai*. 1948. 35mm, black and white, sound, 87 minutes. Orson Welles, Rita Hayworth

▼ **Ted Croner** (American, born 1922). *Taxi—New York—Night*. 1947–48. Gelatin silver print, 15¹³⁄₁₆ x 15⁹⁄₁₆" (40.2 x 39.6 cm). The Family of Man Fund

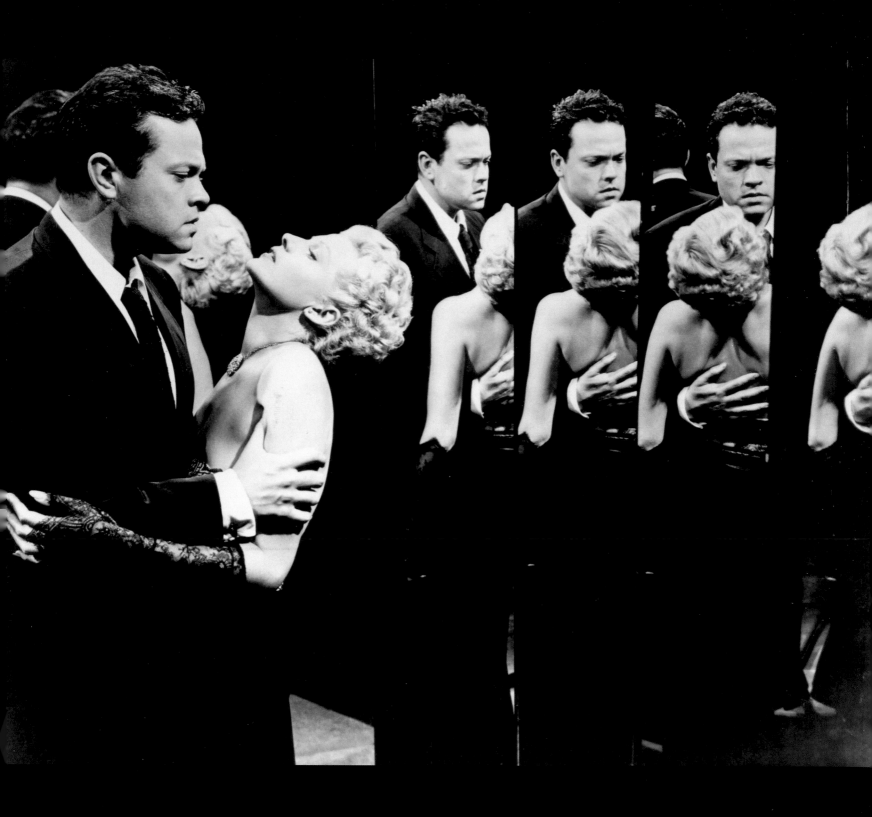

▲ **Göran Hongell** (Finnish, 1902–1973). Aarne Glasses. 1948. Turn mold-blown glass, 3 ⅛" (7.8 cm) high x 3 ½" (8.9 cm) diam. Manufacturer: Karhula-Iittala Glassworks, Finland. Phyllis B. Lambert Fund

◄ **George Nelson** (American, 1908–1986). Tray Table. 1948. Molded walnut plywood with steel rod base, 19 ½ x 15 3/16 x 15 3/16" (49.5 x 38.5 x 38.5 cm). Manufacturer: Herman Miller Furniture Co., Zeeland, Michigan. Gift of Fifty/50

▲ **Bradley Walker Tomlin** (American, 1899–1953). *Number 3.* 1948. Oil on canvas, 40 x 50⅛" (101.3 x 127.2 cm). Gift of John E. Hutchins in memory of Frances E. Marder Hutchins

▶ **Ansel Adams** (American, 1902–1984). *Oak Tree, Snow Storm, Yosemite.* 1948. Gelatin silver print, 9¼ x 7⁵⁄₁₆" (23.5 x 18.6 cm). Gift of the photographer

▲ **Wladyslaw Strzeminski** (Russian, 1893–1952). Study for Textile Design. 1946-48. Gouache on paper, 13 ¾ x 19 ¾" (35 x 50 cm).
The Riklis Collection of McCrory Corporation

◄ **Philip Johnson** (American, born 1906). The Glass House, Philip Johnson House, New Canaan, Connecticut. 1947–49. Model: 67 x 55 ½ x 42 ½"
(170.2 x 141 x 108 cm). Modelmakers: Paul Bonfilio with Edith Randel and Lenon Kaplan (1985). Gift of the architect

▶ **Louis Faurer** (American, born 1916). Untitled. 1948. Gelatin silver print, 7 ¹⁵⁄₁₆ x 10 ⁵⁄₁₆" (20.1 x 26.2 cm). The Ben Schultz Memorial Collection. Gift of the photographer

▽ **Mark Rothko** (American, born Latvia. 1903–1970). Untitled. c. 1948. Oil on canvas, 8' 10 ⅜" x 9' 9 ¼" (270.2 x 297.8 cm). Gift of the artist

◄ **Pablo Picasso** (Spanish, 1881–1973). *The Kitchen.* 1948. Oil on canvas, 69" x 8' 2 ½" (175.3 x 250 cm). Acquired through the Nelson A. Rockefeller Bequest

▼ **Willem de Kooning** (American, born The Netherlands. 1904–1997). *Painting.* 1948. Enamel and oil on canvas, 42 ⅝ x 56 ⅛" (108.3 x 142.5 cm). Purchase

1955

The 1950s were widely seen as marking, in the famous phrase, "the triumph of American painting." The chauvinistic ring of this claim has prompted much criticism in recent years, and for good reason. What or whom, one may fairly ask, had American artists triumphed over? And what authority did that purported victory impart to the victors? Since the end of World War II, the United States' status as a world power was apparent to allies as well as adversaries, but aligning political, military, and economic might with cultural hegemony does little service to the artists whose work contributed so much to postwar artistic growth and change internationally, and reinforces the misconception that their aesthetic ambitions coincided with the aims of those who made use of their legitimate renown for nationalist purposes. Regardless of the ideological shadings one gives to the New York School of painting of the 1940s and 1950s, the fact remains that the best of it was sublime, and a good deal of it was about the sublime.

Mark Rothko's *Red on Orange* (p. 278) is a case in point. An aurora borealis of color washes, Rothko's picture is physically grand and chromatically expansive. Abstract Expressionism was not, in fact, landscape painting, but it did evoke an American experience of virtually unlimited space. Minor White's *Two Barns and Shadow* (p. 279) is not the photographic equivalent of Rothko's painting, but, just as Rothko found open territory in the tangibilities of paint on canvas, White reinvigorated a romantic vision of the American land with the precisions of photographic description. Where Rothko's painting is optically fathomless and diffuse, Jasper Johns's work is dense and opaque. Choosing, in his own words, "something the mind already knows"—in this case, a target—Johns painted simple emblems in complex and estranging ways, the result being things the mind can never be quite sure about. A comparatively large painting for Johns, especially in this early stage of his career, *Green Target* (p. 325) is absolute not in a symbolic sense but in a physical one. It is both an object and an image, every compositional element of which has been bluntly delineated even as every inch of its surface has been subtlely stroked. Willem de Kooning, an artist Johns much admired, once said that skin was the reason oil painting had been invented. The skin of Johns's iconoclastic painting is simultaneously seductive and off-putting, silken, and, in its welts and often livid or off-key hues, slightly uncanny.

Johns arrived at his radical redirection of modern art without a standard art education or long studio apprenticeship. Taking a giant step away from the apparent emotionalism and spontaneity of Abstract Expressionism, he found his own point of departure in formal detachment and systematic procedures. Robert Ryman, like Johns a southerner who came north and more or less skipped school, did very much what Johns did and at exactly the same time, by stripping painting down to its physical essentials and most basic conventions and starting over from there. Ryman's not quite monochrome *Untitled (Orange Painting)* (p. 324) is, in its way, the twin of Johns's *Green Target*. While Johns's canvas presaged conceptual art and minimalism, Ryman's showed a new way to make abstraction, one based not on the reduction of complex images, but on starting from scratch with no image and doing only what was necessary to make a visually arresting, self-sufficient visual object. Surprisingly, perhaps, Ryman's role model was Mark Rothko, but everything that borders on the immaterial in Rothko's work is emphatically material in Ryman's.

The American flag is another of the things Johns painted because the mind already knows it (p. 338). Indeed, every schoolchild knows the stars and stripes, but Johns's version is anything but an unambiguously patriotic insignia or symbol. On the contrary, it is a question

Jasper Johns (American, born 1930). *Green Target* (detail). 1955. Encaustic on newspaper and cloth over canvas, 60 x 60" (152.4 x 152.4 cm). Richard S. Zeisler Fund. See plate on p. 325

disguised as a categorical statement—after all, what is a flag that is not a flag but a painting of a flag? What sentiments does it stir? What allegiance does it command? What entity does it stand for when it has ceased to be itself and has become a rigid, dead-ringer abstraction of a flag? Robert Frank's photograph *Trolley, New Orleans* (p. 339) is a reminder of something the American mind knew and preferred to ignore. The picture's frontal address, its bright white vertical accents, and the dreamlike reflections in the windows above the riders all suggest an eye schooled in modern painting. But its blunt indictment of racism makes plain that, while American painters were brilliantly reinventing their art in the studio, the essential school for American photographers was the street outside. Arriving in the United States from Switzerland in 1947, Frank examined the country's contradictions like a camera-carrying Alexis de Tocqueville, redirecting the documentary tradition by observing large-scale social realities from a distinctly personal, indeed impassioned, point of view. His *Covered Car, Long Beach, California* (p. 277), captures all the pathos of prosperity, while Cy Twombly's pencil drawing (p. 276) appropriates the graphic slang of graffiti and puts it at the service of Pollock-like spatial dynamics, demonstrating that painters, too, could tap the energy of the street.

A third member of the circle to which Johns and Twombly belonged was Robert Rauschenberg. As protean as Johns was consistent and methodical, Rauschenberg remade painting from the outside in while Johns and Twombly remade it from the inside out. Transforming Dada collage into an unmistakably American idiom, Rauschenberg created paintings, objects, and reliefs out of the detritus around him. Parallel to Johns's dissociative strategies, the effect was to render the familiar unfamiliar. Thus Rauschenberg "made" his *Bed* (p. 341) on the wall, shifting a horizontal plane to a vertical surface and covering it with dripped paint and scribbled, Twomblyesque pencil lines. In place of a traditional stretched canvas, Rauschenberg worked on a pillow, a sheet, and an old quilted blanket that is as American and as ambiguously abstract as Johns's *Flag*.

Both Johns and Rauschenberg were much influenced by Marcel Duchamp. Duchamp also made a fundamental impact on the German artist Joseph Beuys, but Beuys's response was to negate Duchamp's ironic negativity. Speaking of the Dada master's much publicized retirement from art making in the 1920s, Beuys thus declared, "The silence of Marcel Duchamp is overrated." Reacting against Duchamp's personification of the artist as a passive dilettante, Beuys became a kind of holy fool and jack-of-all-aesthetic trades whose combined activities as a draftsman, sculptor, installation maker, teacher, performer, and anarchist organizer he christened "Social Sculpture." Perhaps the most important figure in Europe to emerge after the war, Beuys came to epitomize avant-garde art in the 1960s, 1970s, and 1980s. Despite its multimedia permutations and weighty theoretical superstructure, the essence of his sensibility can nevertheless be found in some of the most poetic and beautifully ephemeral drawings to have been made in our time. *Girl in Conversation with a Seal* (p. 340) is a case in point; what at first glance resembles a childlike scrawl or an oil stain is, in fact, a lovely silhouette enveloped by a golden aura. This is turn-of-the-nineteenth-century Symbolist art reconfigured at mid-twentieth century.

While certain affinities exist between Twombly's flickering drawings and Beuys's, comparisons can also be made between the stripped-down classical draftsmanship of Beuys and Giacometti's reconstruction of traditional academic modes of spatial representation in *An Interior* (p. 327). Giacometti's images are woven from graphite filaments erased and rewoven until the tone of the untouched paper and that of smeared and reiterated lines becomes a perfectly paired balance of indefinite spaces and things. Like Giacometti, Ellsworth Kelly also reduced observed reality to elemental contour. *White Plaque: Bridge Arch and Reflection* (p. 326) is, in a sense, just what it says it is, a rendering in opaque planar forms of the spaces under one of the bridges crossing the Seine in Paris, and of the shadow cast on the water by it. With the horizontal band between these two curves representing the waterline, Kelly's *White Plaque* is also the meeting point between reductive abstraction and the modular constructivist aesthetic, a European tradition and an American reinvention of it.

Takis (Takis Vassilakis) and Barbara Hepworth explored two divergent aspects of sculpture in postwar Europe. Hepworth's *Hollow Form (Penwith)* (p. 296) is the marriage of amalgamated Surrealist form and geometric abstraction with traditional woodcarving and polychromy. Like Henry Moore, with whom her work shares many qualities, Hepworth was a conservative among modernists, a modernist among conservatives. Taking constructivist welded metal sculpture of the 1930s and 1940s to the limits of attentuation, Takis's slight, almost wavering *Signal Rocket* (p. 297) was a harbinger of kinetic sculpture to which he and others would devote themselves in the 1960s. Abstract painting in Europe in the 1950s followed two broadly defined directions. One paralleled American gestural painting and, in the hands of the English painter Alan Davie (p. 287), assumed a strong graphic or pictographic presence; the other, represented here by Auguste Herbin's *Project for a Painting* (p. 286), is the equivalent of what Americans would call hard-edged abstraction—a not-so-simple compound of basic, simple, geometric forms.

Jean Dubuffet exemplifies another tendency in postwar European painting, one character-ized by a seemingly childlike yet sophisticated graphic caprice (p. 328). Like Beuys's, Dubuffet's stance was atavistic, yet his execution was anything but crude. The cartoonish quality of the Dubuffet is also present in Ben Shahn's *Self-Portrait* (p. 329). Dubuffet was a self-made "out-sider" artist, Shahn a left-wing humanist, but both understood the uses—and succumbed to the temptations—of a seductive line and ingratiating caricature. In every way more forthright and graphic in an entirely different sense, Franz Kline's *White Forms* (p. 323) is a synthesis of Piet Mondrian's grid and Abstract Expressionist gesture. Working bold black lines against each other and against the frame containing them, Kline's painting seems to flex and buckle simulta-neously. William Klein's *Gun, Gun, Gun, New York* (p. 322) employs similarly bold lights and darks and tense diagonal movements. Even as it evokes the ways in which the structural ten-sions of New York School painting corresponded to the compositional dynamics of New York photography, Klein's embrace of the vulgar energy of the newsstand looks back to Weegee's demotic street theater and forward to the serial sensations of Andy Warhol.

As Abstract Expressionism's influence spread and took root, younger practitioners not only adopted the methods of their precedessors but altered them as well. From Pollock's drip painting it is a short leap of the imagination to the stain paintings of Helen Frankenthaler (p. 283), but it was an important leap inasmuch as Frankenthaler's decision to soak the canvas rather than cover it opened the way for countless Color Field painters in the late 1950s and early 1960s. Although a second-generation gestural painter, Frankenthaler was a full-fledged member of the New York School. Of an age with Frankenthaler, Richard Diebenkorn made the pilgrimage to New York and became acquainted with Franz Kline and Willem de Kooning, but he spent as much or more time in Illinois and New Mexico, where he went to teach. Except for these sojourns he was in every other way a quintessentially California artist. Diebenkorn's ges-ture is never as ferocious or expansive as that of his New York contemporaries, but the color in his painting and the light it emits is like nothing known on the east coast (p. 282). As strongly influenced by Matisse as he was by the Abstract Expressionists, Diebenkorn found Mediter-ranean light on the Pacific coast, and that light permeates and aerates his landscape-like pictures.

At the other extreme is Tony Smith, most of whose paintings and virtually all of whose sculpture is hard-edged and geometric. Looking something like short lengths of a bicycle chain or self-reproducing cells or linked molecules, Smith's drawing *Untitled* (p. 311) recalls the work of his friend Pollock in its even distribution of pictorial incident, but Smith's use of contoured shape rather than contouring line could not be more different from Pollock's linear webs. In Smith's case, perceived similarities between works of art and examples of industrial design seem natural. An architect first and a painter and sculptor second, Smith understood geometry in ways that few studio artists do. He would, no doubt, have found the Truck Safety Brake Spring (p. 310), produced by Associated Spring Raymond Barnes Group Inc., a beautifully simple and formally variable structure.

With its oblique angles and circular format, Fritz Glarner's *Relational Painting, Tondo 37* (p. 308) is a snare-drum-tight variation on the armatures of Piet Mondrian. Modernist but also within a tradition, it is not a paradigm-setting work, but one that manipulates and transforms an existing paradigm to vivid effect. Eero Saarinen's Armchair (p. 309), with its round seat and round base, is of a similarly refined contemporaneity. Neither of these works was conceived with the other in mind, but the harmony between them is very much of the period. Joe Colombo's Tube Chair of Nesting and Combinable Elements (p. 302) is the fantastic extension of Saarinen's classical geometric design. It is rigorous reductivism at the service of a Baroque wit. Joseph Newman's film *This Island Earth* (p. 303) shares that extravagantly futuristic quality, yet on a set that included what then seemed high-tech amenities and in costumes that must have appeared otherworldly, the actors sport outlandish versions of a 1950s pompadour, dating the ensemble effect and giving it a high camp quality Colombo's Tube Chair does not have.

Sooner or later, most science fiction taps into apocalyptic fears, and *This Island Earth* was no exception. In the 1950s those fears centered on the atomic bomb and America's ambivalence toward it. Erik Nitsche's 1955 poster design for General Dynamics' Atoms for Peace campaign graphically celebrates a future in which atomic energy will play an unqualifiedly positive role (p. 298). The clean design of the poster implies a clean use of this resource. One of the darkest of the decade's film noir classics was Robert Aldrich's *Kiss Me Deadly* (p. 299), and if the gun-toting seductresses and muscular toughs constituted the average threat to the wise-guy hero of such movies, the ultimate weapon in *Kiss Me Deadly* was a lead-lined Pandora's box filled with incandescent uranium that explodes to the sound of manic voices in the final doomsday scene of the film. Anxiety that all was not well in America was also a theme of Otto Preminger's film *The Man with the Golden Arm* (p. 305). In it the erstwhile teen idol, Broadway crooner, movie-musical lead Frank Sinatra takes the dramatic role of a junkie based on a title character in the eponymous novel by social realist Nelson Algren. This was mainstream Hollywood looking at the dark side of the "American Dream," and one of the few 1950s films to address the reality of a growing drug culture. Saul Bass's publicity poster for *The Man with the Golden Arm* is a graphic homage to Abstract Expressionism—Kline with the edges trimmed—and like the film, it injected a potent subculture into the mainstream (p. 304).

Although set in the early part of the century, Elia Kazan's film made from John Steinbeck's book *East of Eden* (p. 336) was another naturalist drama about alienation in a conservative and hypocritical America. Starring James Dean, who that same year appeared in Nicholas Ray's *Rebel without a Cause* (p. 284), Kazan's movie focused on a character whose heroism was derived from an innate sense of not belonging. Much like Leonardo DiCaprio today, Dean was a universal but sexually ambiguous version of the "All-American boy." Larry Rivers's *Double Portrait of Frank O'Hara* (p. 337) shows two faces of an alternately sensitive and defiant young man in the James Dean mode. Only a few years after Rivers's portrait was completed, O'Hara, a well-known New York School poet, became a curator at The Museum of Modern Art, where he acted as the spokesman for the artists in his downtown circles, among them Rivers, Frankenthaler, and de Kooning. Brassaï's photograph of Jean Genet (p. 335) depicts another incarnation of the social outcast or, to be more exact in the case of Genet, outlaw. Genet, author of *The Miracle of the Rose* (1946) and *Thief's Journal* (1949) was, in the estimation of philosopher Jean-Paul Sartre, the archetypal of the sinner as existentialist saint. In Henri-Georges Clouzot's *Les Diaboliques* (p. 334), Simone Signoret and Vera Clouzot play the parts of two women, one the lover, the other the wife of a cruel man, who are, as far as he is concerned, femmes fatales in the fullest sense of the term.

Both *Les Diaboliques* and Brassaï's iconic, no-nonsense image of the writer Genet exude the apprehensive mood of France in the 1950s. Jean Renoir's *French CanCan* (p. 281) is a bright, nostalgic evocation of Belle Epoque Paris and of a demimonde where exuberance wins out over anxiety. Alfred Hitchcock's *To Catch a Thief* (p. 280) is a similarly glamorous fiction complete

with travelogue landscape, high fashion decor, and sophisticated sexual banter. What makes it work is Hitchcock's stylish amorality and Cary Grant's and Grace Kelly's cool complicity with their director. Dan Weiner's photograph *El Morocco, New York* (p. 314) casts a doubting eye on the world of the beautiful people. Everyone in the photograph, from the society woman seated in the trademark zebra-stripe banquette of this famous New York watering hole to the waiters poised behind her and the bellhop on sentinel duty, seems to be waiting for something, and though everyone likewise seems to know his or her place and part, for the moment, nobody is making a move. The photograph by Ikko (Ikko Narahara; p. 315) that faces Weiner's picture gives us a glimpse of another world altogether; this time, we look down on the corridor of a Japanese women's prison, where an enraged prisoner has thrown her meal. Electing her gesture as a symbol of postwar social turbulence and matching it with the graphic violence of his picture, Ikko states the terms of subject and style in which both Japanese and American photography thrived in the 1950s and 1960s.

Garry Winogrand's photograph was also shot at the El Morocco (p. 273), and all that is frozen and wary in the demeanor of Weiner's characters is fiercely animated, even grotesque, in the look of Winogrand's female protagonist, as if the evening had finally gotten under way and the pent-up energies of Weiner's picture had been unleashed in Winogrand's. Pairing Winogrand's encapsulation of what used to be called the battle between the sexes with the formal purity and equipoise of Ludwig Mies van der Rohe's Seagram Building (p. 272) creates a balance—or imbalance?—between modern classicism and frantic animation that defines a basic cultural polarity of the 1950s. That tension played itself out socially and aesthetically in countless variations during the remainder of the decade, and well into the next. For now, though, we will stop and leave readers with this confrontation of images in the hope that it will spur them to look elsewhere in this anthology for other, comparable examples, or will inspire them to identify contrasts or correspondences based on completely different criteria. Either way, they will be entering into the spirit in which this selection was made.

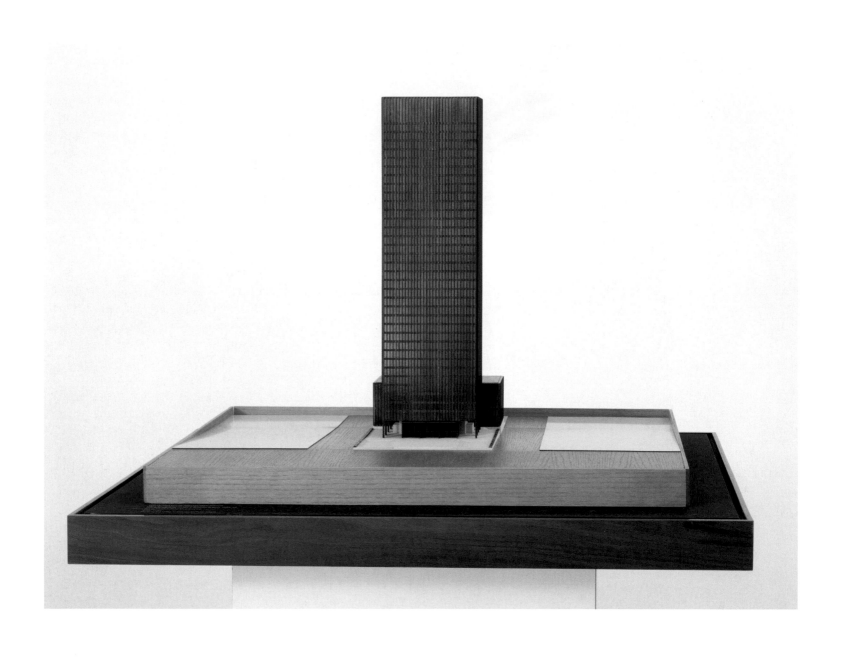

◄ **Ludwig Mies van der Rohe** (American, born Germany. 1886–1969). Seagram Building, New York City. 1954–58. Model: bronze, composition stone, plastic marbling, and blond hardwood, 26½ x 35⅜ x 26⅜" (67.3 x 89.8 x 67 cm). Modelmaker: Office of Mies van der Rohe (1954). Gift of Joseph E. Seagram & Sons Inc. and Philip Johnson

▼ **Garry Winogrand** (American, 1928–1984). *El Morocco*. 1955. Gelatin silver print, 9¹⁄₁₆ x 13⁷⁄₁₆" (23.1 x 34.1 cm). Purchase and gift of Barbara Schwartz in memory of Eugene M. Schwartz

▲ **IBM Company Design (USA).** Ferrite Memory Core. c. 1955. Copper wiring, ferrite, and plastic, 11 ¾ x 6 ¹³⁄₁₆" (29.8 x 17.3 cm). Manufacturer: IBM, East Fishkill, New York. Gift of the manufacturer

▶ **Hans Wegner** (Danish, born 1914). Side Chair. c. 1955. Teak, 29 ½ x 20 x 16 ½" (75 x 50.8 x 41.9 cm). Manufacturer: Carl Hansen and Son, Odense, Denmark. Gift of Carol Lynn Crocker

▲ **Cy Twombly** (American, born 1928). Untitled. 1955. Pencil on buff paper, 24⅜ x 36⅛" (62 x 91.7 cm). Gift of Ronald S. Lauder

▶ **Robert Frank** (American, born Switzerland 1924). *Covered Car, Long Beach, California*. 1955–56. Gelatin silver print, 13⅛ x 19³⁄₁₆" (33.3 x 48.8 cm). John Spencer Fund

◄ **Mark Rothko** (American, born Latvia. 1903–1970). *Red on Orange*. 1955. Oil on canvas, 69⅛ x 55¾" (175.5 x 141.5 cm). Mary Sisler Bequest

▼ **Minor White** (American, 1908–1976). *Two Barns and Shadow*. 1955. Gelatin silver print, 7¼ x 9⅝" (18.5 x 24.4 cm). Gift of Robert M. Doty

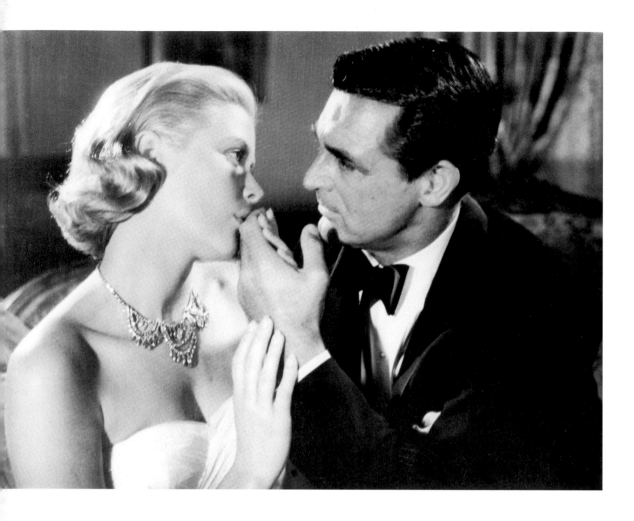

▲ **Alfred Hitchcock** (American, born Great Britain. 1899–1980). *To Catch a Thief*. 1955. 35mm, color, sound, 106 minutes. Grace Kelly, Cary Grant

▶ **Jean Renoir** (American, born France. 1894–1979). *French CanCan*. 1955. 35mm, color, sound, 104 minutes

▶ **Helen Frankenthaler** (American, born 1928). *Trojan Gates*. 1955. Oil and enamel on canvas, 6' x 48⅞" (182.9 x 124.1 cm). Gift of Mr. and Mrs. Allan D. Emil

▼ **Richard Diebenkorn** (American, 1922–1993). *Berkeley, 46*. 1955. Oil on canvas, 58⅞ x 61⅞" (149.6 x 157.2 cm). Gift of Mr. and Mrs. Gifford Phillips

Michael Cacoyannis (Greek, born 1927). *Stella.* 1955. 35 mm, black and white, sound, 92 minutes. Melina Mercouri

▼ **Nicholas Ray** (American, 1911–1979). *Rebel without a Cause*. 1955. 35mm, color, sound, 111 minutes. Sal Mineo, James Dean, Natalie Wood

▶ **Alan Davie** (British, born 1920). *Magic Box.* 1955. Oil on composition board, 60 x 48⅛" (152.2 x 122 cm). Gift of Mr. and Mrs. Allan D. Emil

▼ **Auguste Herbin** (French, 1882–1960). *Project for a Painting.* c. 1955. Recto: Pencil, crayon, and ink on transparent paper, 13⅝ x 10½" (34.6 x 26.7 cm). The Riklis Collection of McCrory Corporation

Orson Welles (American, 1916–1985). *Mr. Arkadin*. 1955. 35mm, black and white, sound, 95 minutes. Orson Welles

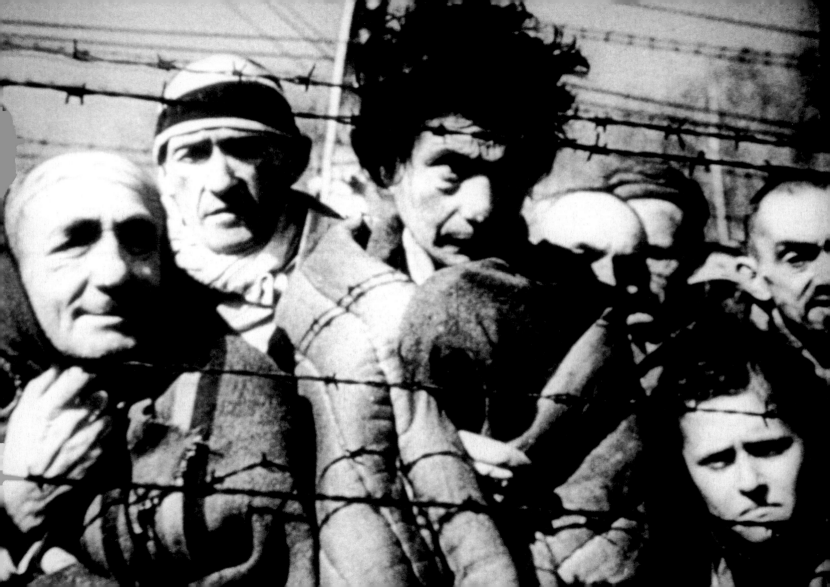

Georges Braque (French, 1882–1963). Plate from *Théogonie* by Hesiod. Paris: Maeght Editeur, 1955. Prints executed 1932–35. Etching, 11⅞ x 8¾" (30.2 x 22.2 cm). Printer: Fequet et Baudier, Paris. Edition: 150. The Louis E. Stern Collection

Bill Brandt (British, born Germany. 1904–1983). Untitled from *Perspective of Nudes*. 1955. Gelatin silver print, 24¼ x 20⁹⁄₁₆" (61.6 x 52.2 cm). The Family of Man Fund

53/150 Bellmer

◀ **Hans Bellmer** (German, born Upper Silesia. 1902–1975). Untitled plate from *Madame Edwards* by Pierre Angelique [Georges Bataille]. 1955. Engraving, 7¼ x 3³⁄₁₆"
(18.4 x 8.1 cm). Publisher: Éditions Georges Visat, Paris, 1965. Edition: 150. Gift of Alicia Legg

▼ **Pablo Picasso** (Spanish, 1881–1973). *Portrait of a Woman II*. 1955. Transfer lithograph, sheet 25³⁄₈ x 14¾" (64.5 x 37.5 cm) (irreg.). Edition: 50. Gift of Mr. and Mrs.
Daniel Saidenberg

▲ **Satyajit Ray** (Indian, 1921–1992). *Pather Panchali*. 1955. 35mm, black and white, sound, 112 minutes. Subir Banerjee

◄ **Anthony Mann** (American, 1907–1967). *The Man from Laramie*. 1955. 35mm, black and white, sound, 104 minutes. James Stewart

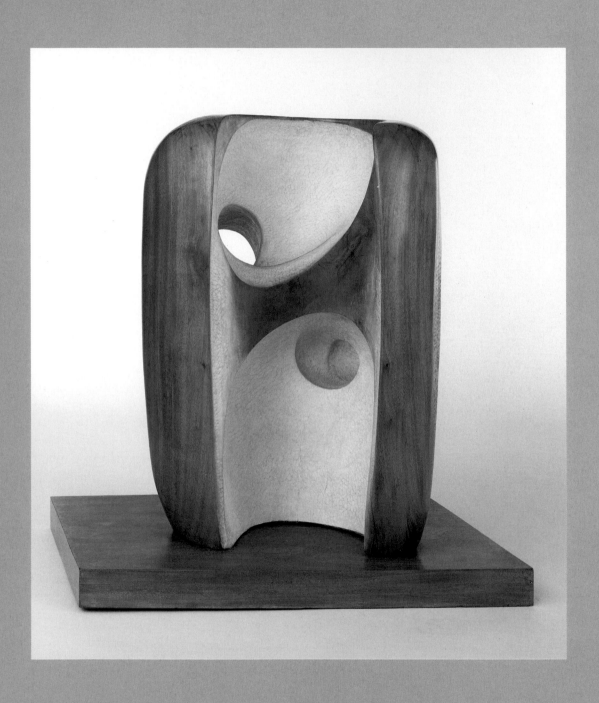

Barbara Hepworth (British, 1903–1975). *Hollow Form (Penwith)*. 1955–56. Lagos wood, partly painted, 35⅜ x 25⅞ x 25⅝" (89.8 x 65.7 x 64.8 cm) attached to base 35⅞ x 23½" (91.1 x 59.7 cm). Gift of Dr. and Mrs. Arthur Lejwa

Takis (Takis Vassilakis; French, born Greece 1925). *Signal Rocket*. 1955. Painted steel rods and iron, 48" (121.9 cm) high, at base 5¼ x 5" (13.2 x 12.5 cm). Mrs. Charles V. Hickox Fund

Robert Aldrich (American, 1918–1983). *Kiss Me Deadly*. 1955. 35mm, black and white, sound, 105 minutes. Gaby Rodgers

Erik Nitsche (American, born 1908). *Atoms for Peace*. 1955. Offset lithograph, sheet 50 x 35¼" (127 x 90.1 cm). Gift of the General Dynamics Corporation

▲ **Timo Sarpaneva** (Finnish, born 1926). Ball Glass. 1955. Blown glass, 2⅞" (7.3 cm) high x 2¾" (7 cm) diam. Manufacturer: Iittala, Finland. Mr. and Mrs. Walter Hochschild Purchase Fund

▶ **Isamu Noguchi** (American, 1904–1988). *Bird C (Mu)*. 1952–58. Greek marble, 22¾ x 8⅛ x 12" (57.8 x 20.5 x 5.7 cm). In memory of Robert Carson, architect (given anonymously)

▶ **Joseph Newman** (American, born 1909). *This Island Earth*. 1955. 35mm, color, sound, 87 minutes. Rex Reason, Faith Domergue, Jeff Morrow

▼ **Joe Colombo** (Italian, 1930–1971). Tube Chair of Nesting and Combinable Elements. 1955. PVC plastic tubes, padded with polyurethane and covered in fabric, 23¾ x 23 x 41" (60.3 x 58.5 x 104.2 cm). Manufacturer: Flexform, Italy. Gift of the manufacturer

FRANK SINATRA · ELEANOR PARKER · KIM NOVAK

THE MAN WITH THE GOLDEN ARM

A FILM BY OTTO PREMINGER

With Arnold Stang, Darren McGavin, Robert Strauss, John Conte, Doro Merande, George E. Stone, George Mathews, Leonid Kinskey, Emile Meyer, Shorty Rogers, Shelly Manne,
Screenplay by Walter Newman & Lewis Meltzer, From the novel by Nelson Algren, Music by Elmer Bernstein, Produced & Directed by Otto Preminger, Released by United Artists

△ **Otto Preminger** (American, born Austria. 1905–1986). *The Man with the Golden Arm*. 1955. 35mm, black and white, sound, 119 minutes. Gift of the artist. Frank Sinatra

◁ **Saul Bass** (American, 1921–1996). *The Man with the Golden Arm*. 1955. Offset lithograph, sheet 40½ x 27" (102.4 x 68.5 cm). Gift of Otto Preminger Productions, United Artists

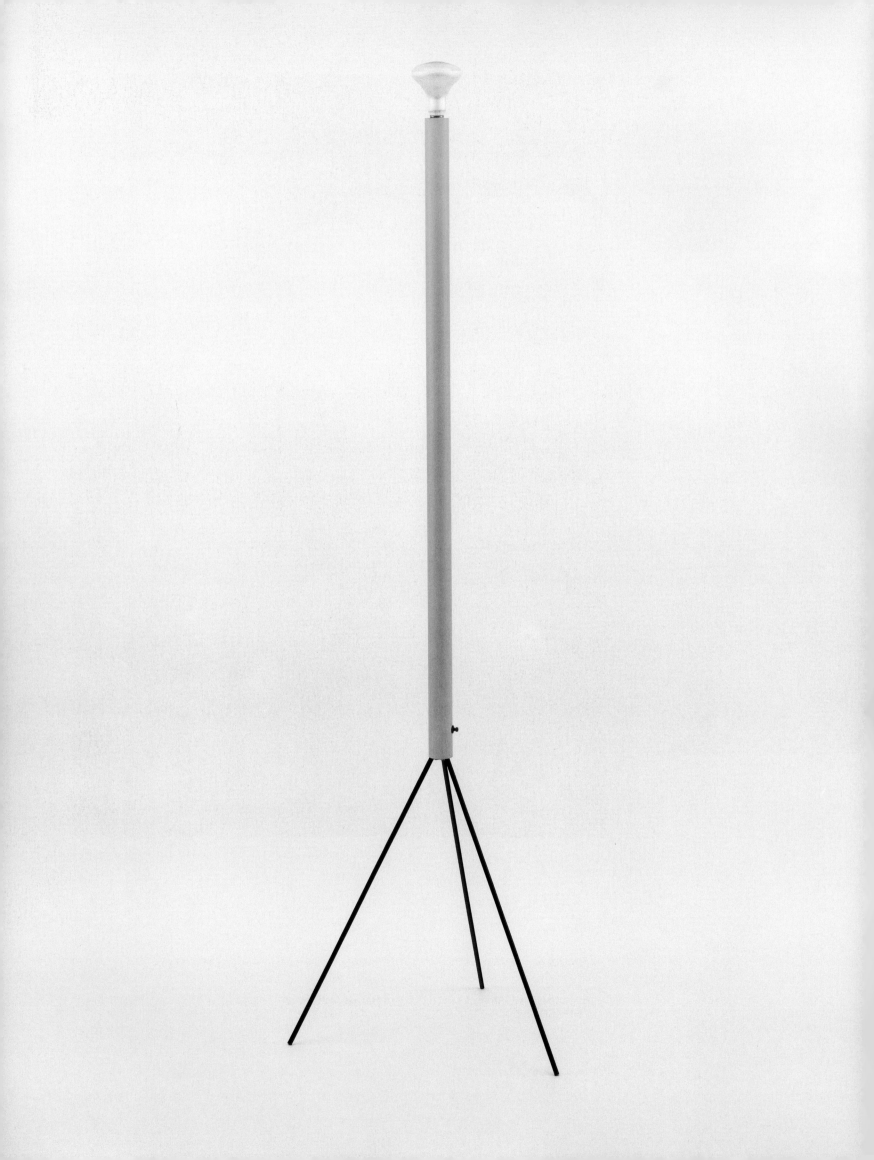

▲ **Takashi Kono** (Japanese, born 1906). *Ideal Relationship*. 1955. Silkscreen, sheet 28⅝ x 20¼" (73 x 51.5 cm).
Gift of the designer

◄ **Achille Castiglioni** (Italian, born 1918) and **Pier Giacomo Castiglion**i (Italian, 1913–1968). Luminator Floor Lamp. 1955.
Enameled metal, 72 x 21 x 17½" (183 x 53.3 x 44.4 cm). Manufacturer: Gilardi & Barzaghi, Italy. Purchase

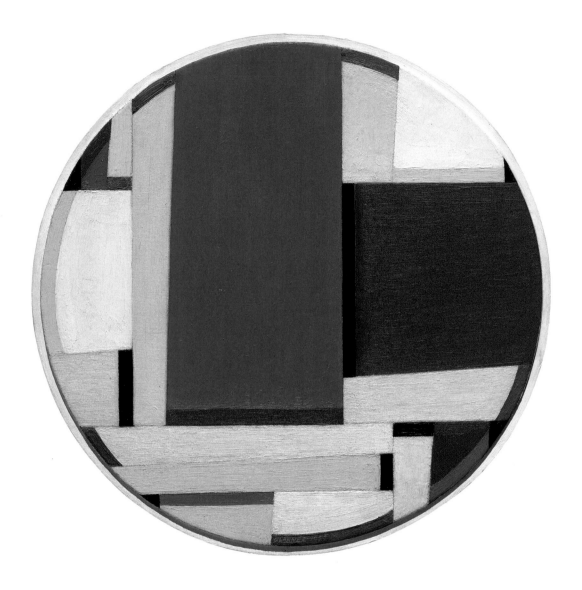

▲ **Fritz Glarner** (American, born Switzerland. 1899–1972). *Relational Painting, Tondo 37*. 1955. Oil on composition board, 19" (48 cm) diam. Gift of Mr. and Mrs. Armand P. Bartos

▶ **Eero Saarinen** (American, born Finland. 1910–1961). Armchair. 1955–56. Fiberglass-reinforced plastic shell; cast aluminum base with fused plastic finish; wool-upholstered foam rubber cushion, 32" (81.3 cm) high. Manufacturer: Knoll International, New York. Gift of the manufacturer

▲ **Tony Smith** (American, 1912–1980). Untitled. c. 1953–55. Charcoal on paper, 31½ x 39⅛" (80 x 99.4 cm). Purchased with funds given by Agnes Gund

◄ **Associated Spring Raymond Barnes Group Inc. (USA)**. Truck Safety Brake Spring. 1955. Chrome silicon spring wire, 9" (23 cm) high x 5⅞" (15 cm) diam. Gift of the manufacturer

Gottfred Kirk Christiansen (Danish, 1920–1995). LEGO Building Bricks. 1954–58. Plastic, 7⁄16 x 1¼ x 5⁄8" (1.2 x 3.2 x 1.6 cm); 7⁄16 x 15⁄16 x 5⁄8" (1.2 x 2.4 x 1.6 cm); 7⁄16 x 5⁄8 x 5⁄8" (1.2 x 1.6 x 1.6 cm). Manufacturer: LEGO Group, Denmark. Gift of the manufacturer

Johannes Potente (German, 1908–1987). Door Handle. 1955. Aluminum, 1 x 5¼ x 2⁹⁄₁₆" (2.5 x 13 x 6.5 cm). Manufacturer: Franz Schneider Brakel G.m.b.H. Gift of the manufacturer

◀ **Dan Weiner** (American, 1919–1959). *El Morocco, New York*. 1955. Gelatin silver print, 9 1/16 x 13 3/8" (23.1 x 34 cm). The Family of Man Fund

▼ **Ikko** (Ikko Narahara; Japanese, born 1931). *Room No. 9, Women's Prison, Wakayama*. 1955. Gelatin silver print, 9 13/16 x 14" (24.9 x 35.6 cm). Gift of Nihon Keizai Shimbun

▲ **Richard Avedon** (American, born 1923). *Marian Anderson*. 1955. Gelatin silver print, 15⁵⁄₁₆ x 19⅛" (38.9 x 48.6 cm). Gift of the photographer

▶ **Le Corbusier** (Charles-Edouard Jeanneret; French, born Switzerland. 1887–1965). Untitled from *Poème de l'angle droit* by Le Corbusier. Paris: Tériade Éditeur, 1955. Prints executed 1947–53. Lithograph, page 16½ x 12¹¹⁄₁₆" (42 x 32.2 cm) (irreg.). Printer: Mourlot Frères, Paris. Edition of book: 270; edition of portfolio without text: 60. The Louis E. Stern Collection

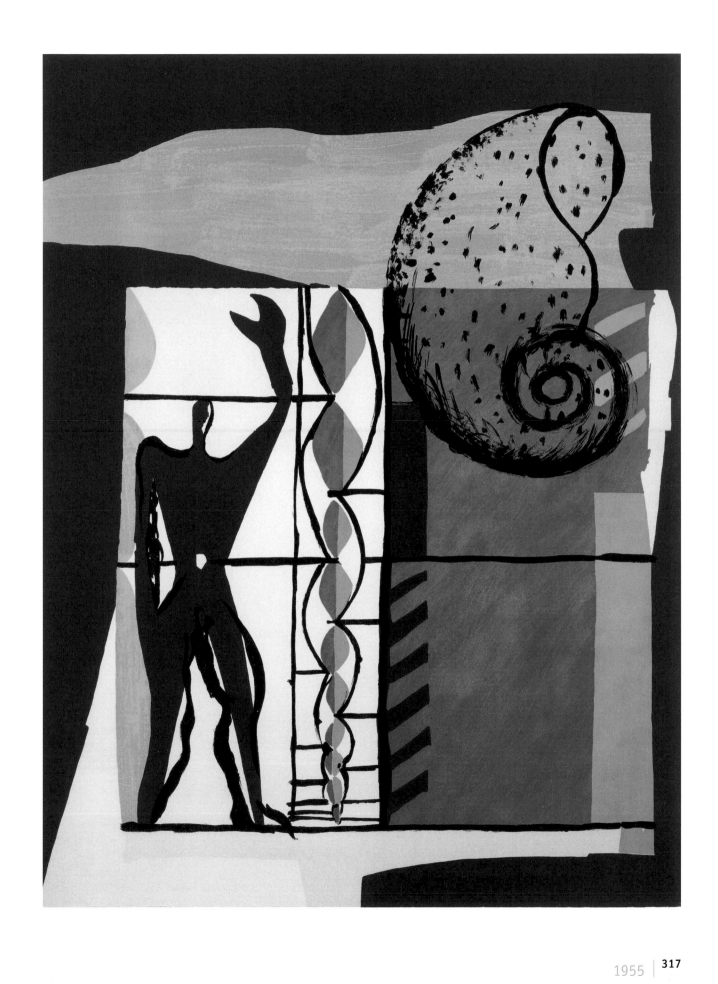

▲ **Aaron Siskind** (American, 1903–1991). *Uruapan 4*. 1955. Gelatin silver print, 13 1/16 x 16 5/16" (33.2 x 41.5 cm). John Parkinson III Fund

▶ **David Smith** (American, 1906–1965). *Untitled 5/28/55*. 1955. Gouache on paper, 29 3/4 x 42 3/8" (75 x 107.6 cm). Gift of Barbara G. Pine in memory of Morris Goldman

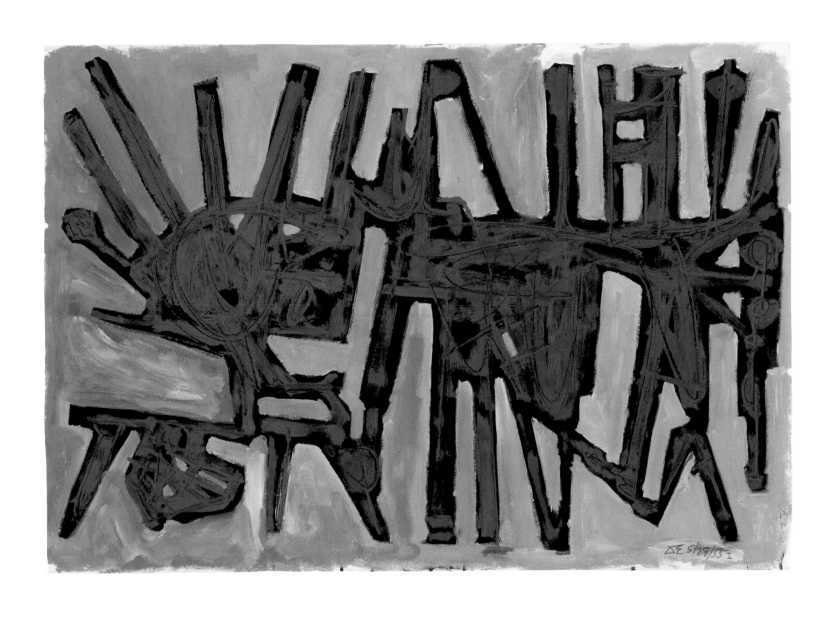

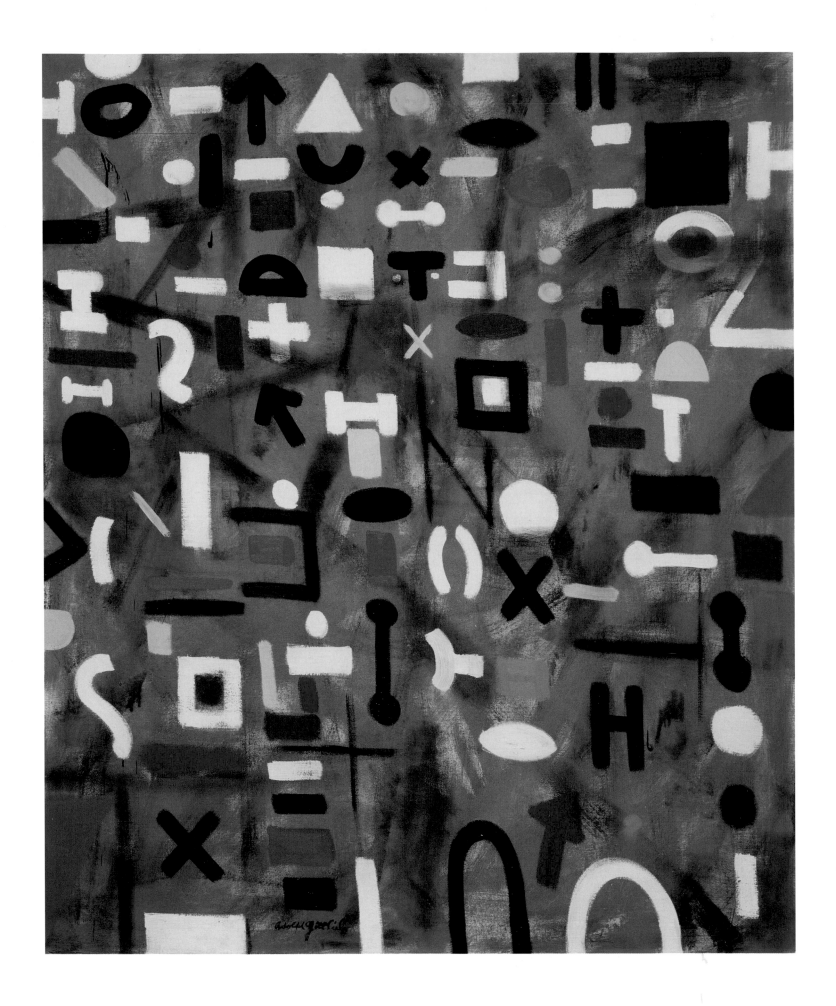

◀ **Adolph Gottlieb** (American, 1903–1974). *Composition.* 1955. Oil on canvas, 6' 1⁄8" x 60 1⁄8" (183.3 x 152.5 cm). Gift of the artist

▽ **Frederick Sommer** (American, born Italy. 1905–1999). *The Thief Greater Than His Loot.* 1955. Gelatin silver print, 8 1⁄8 x 5" (20.6 x 12.7 cm). Purchase

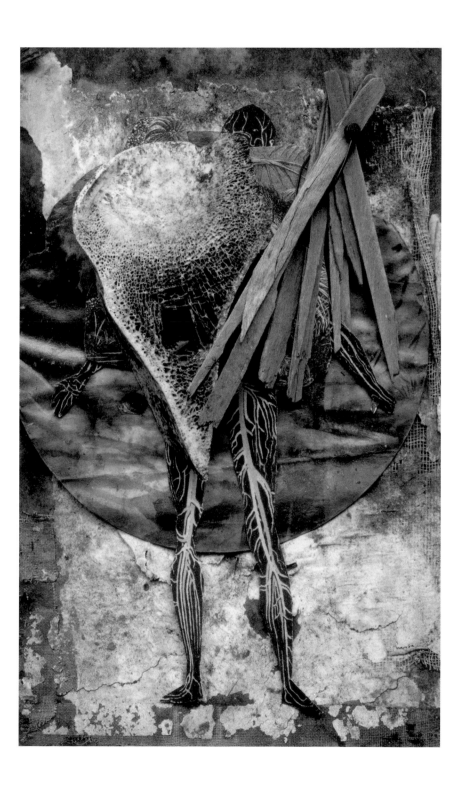

▶ **Franz Kline** (American, 1910–1962). *White Forms.* 1955. Oil on canvas, 6' 2⅜" x 50¼" (188.9 x 127.6 cm). Gift of Philip Johnson

▼ **William Klein** (American, born 1928). *Gun, Gun, Gun, New York.* 1955. Gelatin silver print, 10⁵⁄₁₆ x 13¹¹⁄₁₆" (26.2 x 34.7 cm). Gift of Arthur and Marilyn Penn

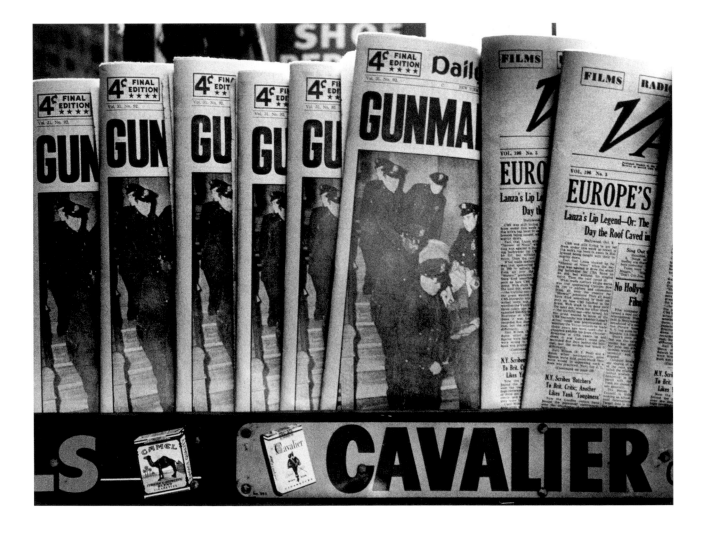

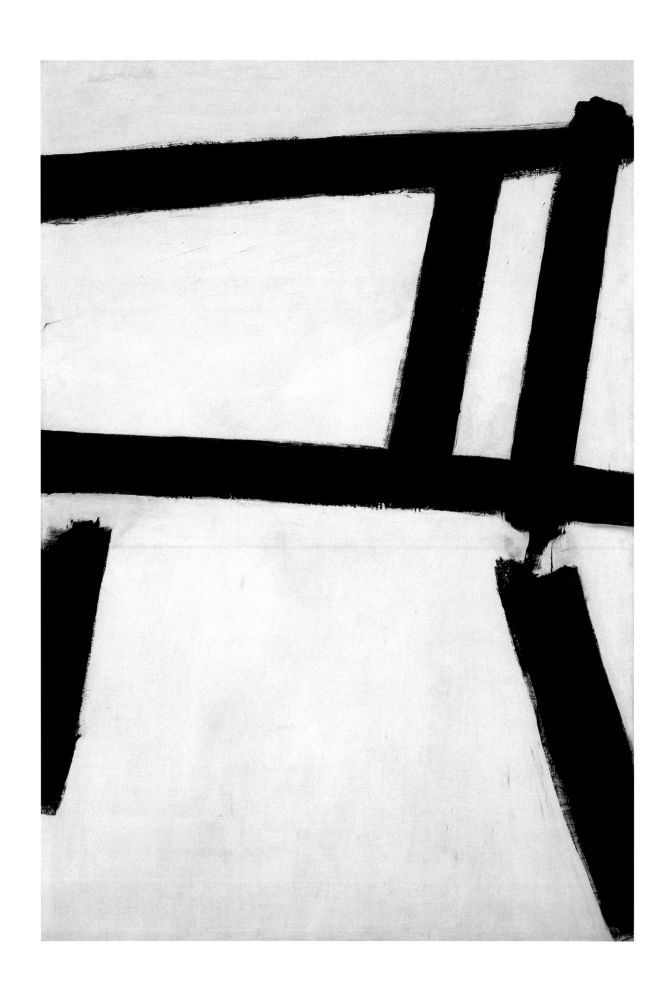

▶ **Jasper Johns** (American, born 1930). *Green Target*. 1955. Encaustic on newspaper and cloth over canvas, 60 x 60" (152.4 x 152.4 cm). Richard S. Zeisler Fund

▼ **Robert Ryman** (American, born 1930). *Untitled (Orange Painting)*. 1955 and 1959. Oil on canvas, 28⅛ x 28⅛" (71.4 x 71.4 cm). Fractional and promised gift of Ronald S. Lauder

▲ **Alberto Giacometti** (Swiss, 1901–1966). *An Interior.* 1955. Pencil on paper, 19¾ x 12⅞" (50 x 32.6 cm) (irreg.). The Joan and Lester Avnet Collection

◄ **Ellsworth Kelly** (American, born 1923). *White Plaque: Bridge Arch and Reflection.* 1952–55. Oil on wood, 64⅞ x 47⅞" (164.6 x 121.6 cm). Promised gift of Emily Rauh Pulitzer, Vincent D'Aquila and Harry Soviak Bequest Fund, and Enid A. Haupt Fund

▶ **Ben Shahn** (American, born Lithuania. 1898–1969). *Self-Portrait*. c. 1955. Brush and ink on paper, 9¾ x 6⅛" (24.7 x 15.4 cm). Given anonymously

▼ **Jean Dubuffet** (French, 1901–1985). *My Cart, My Garden* from the Charrettes, jardins, personnages monolithes series. 1955. Oil on canvas, 35⅛ x 45¾" (89.2 x 115.9 cm). James Thrall Soby Bequest

Robert Doisneau (French, 1912–1994). *Rue de Nantes, Bastille Day.* 1955. Gelatin silver print, 11¹³⁄₁₆ x 9³⁄₈" (30 x 23.9 cm). Purchase

▶ **Max Ophüls** (German, 1902–1957). *Lola Montès*. 1955. 35mm, black and white, sound, 22 minutes. Martine Carol

▼ **O. Winston Link** (American, born 1914). *Norfolk and Western Train No. 2, North through Lithia, Virginia. July 13, 1955, 7:11 p.m.* 1955. Gelatin silver print, 10¾ x 13½" (27.4 x 34.3 cm). Purchase

Henri-Georges Clouzot (French, 1907–1977). *Les Diaboliques*. 1955. 35mm, black and white, sound, 116 minutes. Vera Clouzot, Simone Signoret.

Brassaï (Gyula Halász; French, born Hungary. 1899–1984). *Jean Genet.* 1955. Gelatin silver print, 15¾ x 11¼" (40 x 28.6 cm). David H. McAlpin Fund

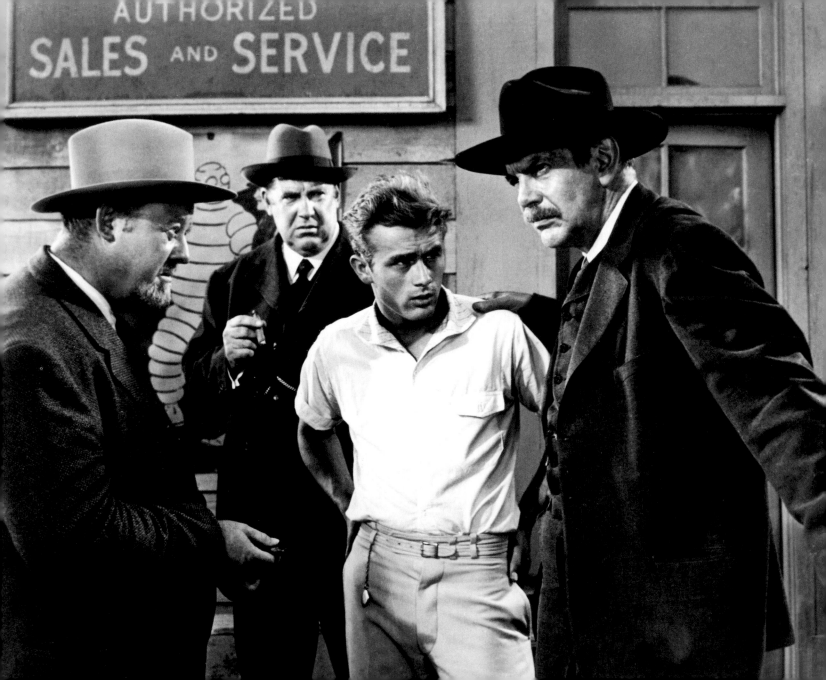

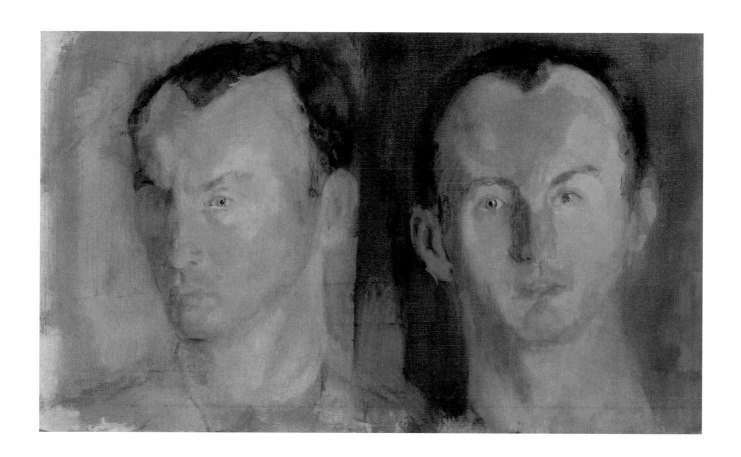

▲ **Larry Rivers** (American, born 1923). *Double Portrait of Frank O'Hara*. 1955. Oil on canvas, 15¼ x 25⅛" (38.4 x 63.6 cm). Gift of Stuart Preston

◄ **Elia Kazan** (American, born Turkey 1909). *East of Eden*. 1955. 35mm, color, sound, 114 minutes. Acquired from Warner Brothers. Burl Ives, Richard Garrick, James Dean, Raymond Massey

◄ **Jasper Johns** (American, born 1930). *Flag*. 1954–55 (dated on reverse 1954). Encaustic, oil, and collage on fabric mounted on plywood, 42¼ x 60⅝" (107.3 x 153.8 cm). Gift of Philip Johnson in honor of Alfred H. Barr, Jr.

▼ **Robert Frank** (American, born Switzerland 1924). *Trolley, New Orleans*. 1955. Gelatin silver print, 9 1/16 x 13⅜" (23.1 x 34 cm). The Fellows of Photography Fund, The Family of Man Fund, and Anonymous Purchase Fund

▲ **Joseph Beuys** (German, 1921–1986). *Girl in Conversation with a Seal*. c. 1955. Pencil and watercolor on paper, 8¼ x 11"
(21 x 28.2 cm). Purchased with funds given by Mr. and Mrs. Henry R. Kravis and Agnes Gund

▶ **Robert Rauschenberg** (American, born 1925). *Bed*. 1955. Combine painting: oil and pencil on pillow, quilt, and sheet on
wood supports, 6' 3¼" x 31½" x 8" (191.1 x 80 x 20.3 cm). Gift of Leo Castelli in honor of Alfred H. Barr, Jr.

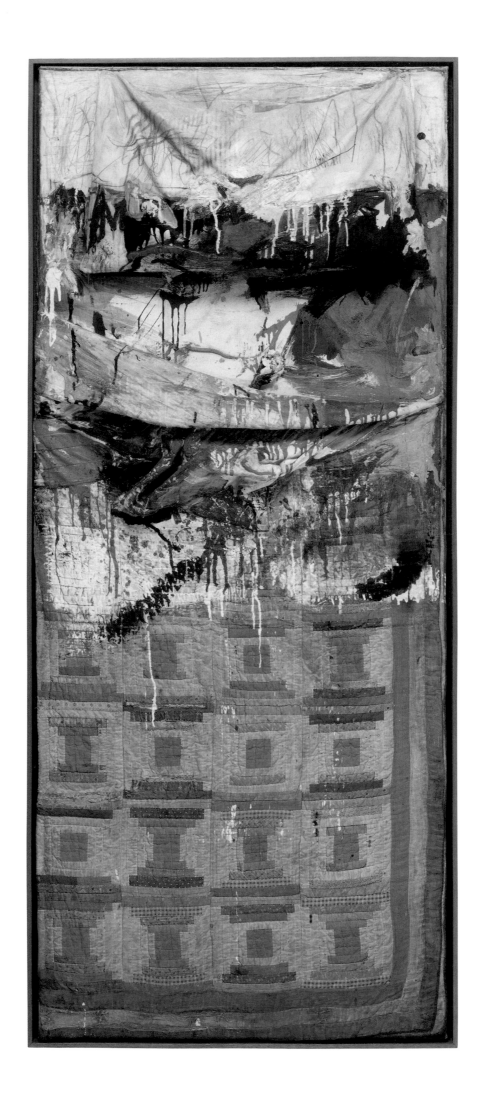

Photograph Credits

© 2000 Artists Rights Society (ARS), New York: 130, 159, 162, 167, 194, 201, 262, 265, 278.

© 2000 Artists Rights Society (ARS), New York/ADAGP, Paris: 37, 47, 68, 72, 76, 82, 83, 86, 88, 89, 112, 118, 123, 160, 174, 179, 185, 205, 211, 219, 236, 238, 240, 241, 242, 243, 247, 286, 290, 292, 297, 317, 327, 328.

© 2000 Artists Rights Society (ARS), New York/ Beeldrecht, Amsterdam: 24, 105, 154.

© 2000 Artists Rights Society (ARS), New York/DACS, London: 132.

© 2000 Artists Rights Society (ARS), New York/Demart Pro Art, Paris: 48.

© 2000 Artists Rights Society (ARS), New York/Pro Litteris, Zurich: 126.

© 2000 Artists Rights Society (ARS), New York/SIAE, Rome: 98.

© 2000 Artists Rights Society (ARS), New York/VG Bild-Kunst, Bonn: front cover, 32, 35, 36, 41, 46, 91, 95, 103, 340.

© T. H. Benton and R. P. Benton Testamentary Trusts/Licensed by VAGA, New York, N.Y.: 115.

© Estate of Peter Blume/Licensed by VAGA, New York, N.Y.: 78.

© 1981 Center for Creative Photography, Arizona Board of Regents: 12, 40, 166.

Courtesy Cheim & Read, New York: 204, 244.

© Commerce Graphics: 67.

Ted Croner–Howard Greenberg Gallery: 254.

© Daedalus Foundation, Inc./Licensed by VAGA, New York, N.Y.: 233.

Alan Davie: 287.

© Estate of Stuart Davis/Licensed by VAGA, New York, N.Y.: 77.

© P. Delvaux Foundation–St. Idesbald, Belgium/Licensed by VAGA, New York, N.Y.: 170.

Estate of Richard Diebenkorn. Courtesy Lawrence Rubin · Greenberg Van Doren · Fine Art: 282.

Robert Doisneau/RAPHO: 330.

© Walker Evans Archive, The Metropolitan Museum of Art: 28, 102, 145.

© Robert Frank: 224, 277, 339.

© 2000 Helen Frankenthaler: 283.

© Adolph and Esther Gottlieb Foundation/Licensed by VAGA, New York, N.Y.: 217, 320.

Copyright Alan Bowness, Hepworth Estate: 296.

© 2000 Charly Herscovici/Artists Rights Society (ARS), New York/ADAGP, Paris: 25.

© Estate of Morris Hirshfield/Licensed by VAGA, New York, N.Y.: 163.

© 2000 Jasper Johns/Licensed by VAGA, New York, N.Y.: 266, 325, 338.

Copyright The Dorothea Lange Collection, Oakland Museum of California, City of Oakland, Gift of Paul S. Taylor: 139.

© 2000 Estate of Fernand Léger/Artists Rights Society (ARS), New York: 136, 234.

© Estate of Jacques Lipchitz/Licensed by VAGA, New York, N.Y./Marlborough Gallery, N.Y.: 87.

© 2000 Succession H. Matisse/Artists Rights Society (ARS), New York: 69, 121, 232.

© 2000 Estate of Joan Miró/Artists Rights Society (ARS), New York: 43.

Photographs © 2000 The Museum of Modern Art, New York. David Allison: 219; Thomas Griesel: 27, 29, 33, 68, 69, 72, 76, 79, 82, 93, 98, 119, 120, 123, 130, 141, 159, 165, 168, 175, 211, 213, 216, 218, 230, 232, 234, 238, 239, 241, 243, 244, 247, 250, 261,

Index of Illustrations

Trustees of The Museum of Modern Art